Bellini and The East

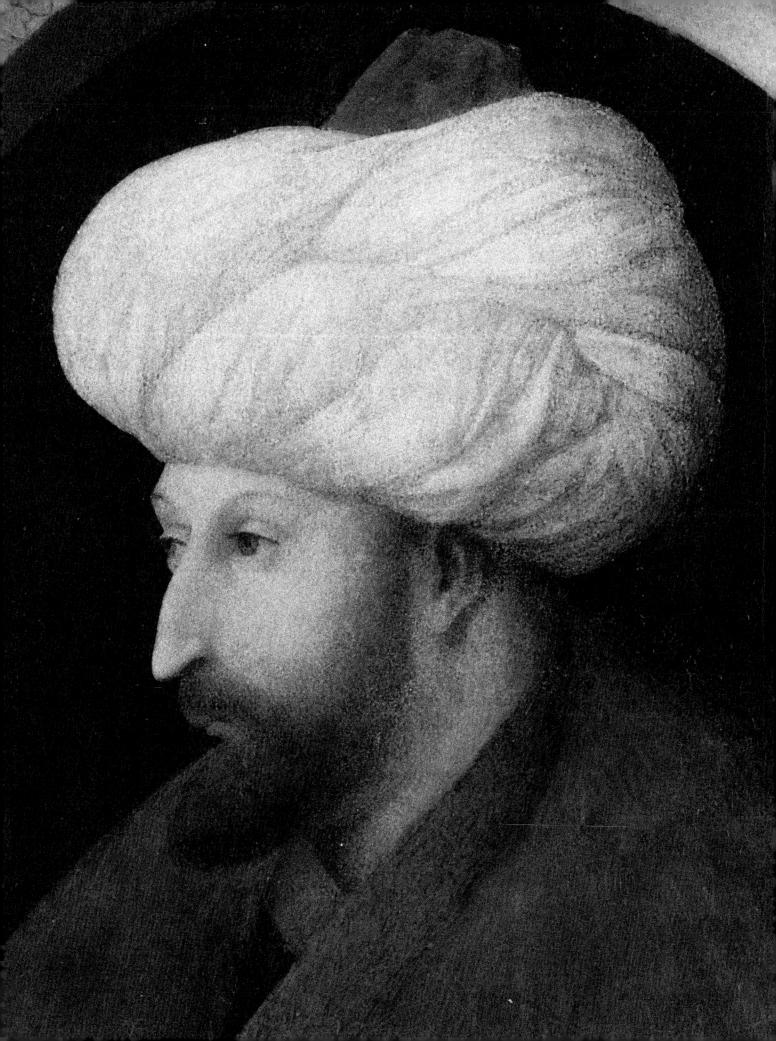

Bellini and The East

Caroline Campbell and Alan Chong

WITH CONTRIBUTIONS FROM
Deborah Howard and J. M. Rogers

AND ADDITIONAL ENTRIES BY
Sylvia Auld, Emine Fetvacı, Angeliki Lymberopoulou
and Susan Spinale

NATIONAL GALLERY COMPANY, LONDON
ISABELLA STEWART GARDNER MUSEUM, BOSTON
DISTRIBUTED BY YALE UNIVERSITY PRESS

This book was published to accompany the exhibition

Bellini and The East

at the Isabella Stewart Gardner Museum, Boston
from 14 December 2005 – 26 March 2006 and
The National Gallery, London from
12 April 2006 – 25 June 2006

First published in Great Britain in 2005
by National Gallery Company Limited
St Vincent House, 30 Orange Street,
London WC2H 7HH
www.nationalgallery.co.uk

ISBN 1 85709 376 3
525103

British Library Cataloguing-in-Publication Data
A catalogue record is available from the British Library

Library of Congress Catalog Card Number
2005934076

PUBLISHER Kate Bell
PROJECT EDITOR Tom Windross
EDITOR Paul Holberton
DESIGNER Philip Lewis
PRODUCTION Jane Hyne, Penny Le Tissier
PICTURE RESEARCHER Kim Klehmet

Colour reproduction, printing and binding in Belgium
by Die Keure

All measurements give height before width

COVER Gentile Bellini, *Seated Scribe* (detail), 1479–81, cat. 32
FRONTISPIECE Gentile Bellini, *Portrait of Mehmed II*
(detail), 1480, cat. 23

Contributors to the catalogue:

SA Sylvia Auld
CC Caroline Campbell
AC Alan Chong
EF Emine Fetvacı
AL Angeliki Lymberopoulou
SS Susan Spinale

Contents

Directors' Foreword

When Gentile Bellini sailed from Venice to Constantinople in September 1479, it must have been with some trepidation, for he was going to work for Sultan Mehmed II. Considered Christendom's greatest threat, Mehmed had been at war with Europe almost continually since his conquest of Constantinople in 1453. Despite this, he had a strong personal interest in Christianity and Italian art, and when peace was negotiated between Venice and the Ottomans, the Sultan immediately asked for a Venetian painter. It is no exaggeration to say that Gentile Bellini played a significant role in bringing the former adversaries closer together, and in fostering dialogue between the Christian and Islamic worlds.

We hope to focus new attention on Gentile Bellini, a painter long overshadowed by his famous brother Giovanni. While Giovanni Bellini's rich colouring predicts the developments of Giorgione and Titian, Gentile's coolly observant eye belongs to an earlier, more sober phase of the Renaissance. He achieved enormous fame in both Italy and Turkey. Regrettably his most important paintings were destroyed in a fire in the Doge's Palace, so Gentile's Turkish works are important examples from his strongest period, the 1470s and 1480s. This exhibition presents all of the works thought to have been made by Gentile Bellini while in Constantinople, as well as the artist's other eastern subjects, including depictions of the Greek theologian Cardinal Bessarion and Queen Caterina Cornaro of Cyprus.

This exhibition has been a happy collaboration between our museums. First, the histories of our collections are intertwined since two works made by Bellini in Constantinople were owned by nineteenth-century collectors who knew each other in Venice. Sir Austen Henry Layard displayed the *Portrait of Mehmed II*, now in London, in his palace on the Grand Canal. Isabella Stewart Gardner saw it there during her long sojourns in Venice, and it inspired the purchase of the *Seated Scribe* in 1906. Our museums also share a commitment to organising intimate, focused exhibitions which not only allow us to study less familiar aspects of art history, but also encourage our visitors to look closely at a smaller number of objects. On behalf of the Isabella Stewart Gardner Museum, thanks are due to The Andrew W. Mellon Foundation for supporting this work.

We are grateful for the close collaborative work of the exhibition curators, Alan Chong of the Gardner Museum and Caroline Campbell, now at the Courtauld Institute of Art Gallery. In 2002 Alan Chong proposed that the two museums bring together works made in Constantinople by Gentile Bellini and his circle, in part to reconsider issues of attribution. At the same time, Caroline Campbell was examining the relationship between Venetian painting and Byzantium in connection with the National Gallery's newly acquired painting by Gentile, *Cardinal Bessarion with the Bessarion Reliquary*. Their joint efforts have made *Bellini and the East* an innovative study of the multiple 'easts' in Venetian art of the late fifteenth century – Byzantine Greece, Ottoman Turkey, and Mamluk Egypt and Syria. The new evidence and interpretations presented in this catalogue allow us to reassess Gentile Bellini's inspired but often overlooked accomplishments.

ANNE HAWLEY
Norma Jean Calderwood Director, Isabella Stewart Gardner Museum, Boston

CHARLES SAUMAREZ SMITH
Director, The National Gallery, London

Curators' Introduction

Venice as we know it is inconceivable without the 'east' – the myriad of Jewish, Christian and Islamic cultures which bordered the eastern Mediterranean Sea and provided gateways to Asia and Africa beyond. This exhibition focuses on just one episode in this millenium-long exchange: Gentile Bellini's response to the east in the late fifteenth century. In his lifetime, Gentile was Venice's most prestigious painter and in 1479 he was sent by the Venetian Senate to work for Sultan Mehmed II in Constantinople. But Gentile also responded to other aspects of the east, including the Byzantine Greek Empire as well as Venice's other trading partners in North Africa and the Levant.

The second half of the fifteenth century witnessed a decisive power shift in the Mediterranean basin. The year 1453 saw the fall of Constantinople (later to be known as Istanbul), capital of the once mighty Byzantine Empire, to Ottoman forces led by Mehmed II, now styled 'the Conqueror'. Successive Ottoman campaigns threatened Europe, including the Italian states and their domains, and by 1500 much of the Balkan peninsula and many of the former Greek islands were in Turkish hands. Their only serious challenger was Venice.

Neither war nor religious fervour could destroy Venice's long-established relationships with the eastern Mediterranean. Her prosperity and identity derived from her role as mediator between western Europe and the much richer civilisations of the Near East, and her ability to exchange and assimilate goods and ideas from across the Mediterranean. Saint Mark, her patron, was martyred in the Egyptian city of Alexandria, and her cultural and spiritual centre – the basilica of San Marco – was built in his honour (and as his mausoleum) in the Greek Byzantine style. During the fifteenth century Venice's rich cultural and economic dialogue with other Mediterranean civilisations still shaped many characteristic aspects of her life and artistic production, including architecture, painting, glass, metalwork and textiles. The frequent representation of such goods in the works of Giovanni and Gentile Bellini demonstrates their considerable cultural value: their production in the region associated with early Christianity made them appropriate for inclusion in religious paintings.

The continuing impact of the Greek Byzantine world upon Venetian art and culture after 1453 is a major theme of this exhibition. Many Greeks fled to Venice or her colonies. Of these the most important were the islands of Crete and Cyprus, the latter passing into Venetian control through its widowed Venetian queen, Caterina Cornaro. Venice's Greek character was so pronounced that it seemed 'almost another Byzantium' to Cardinal Bessarion, the most famous of Constantinople's exiles. Some Greeks considered Bessarion a traitor for his advocation of union between the Eastern and Western Churches and for his conversion to the Roman Church. But no one could match Bessarion's devoted advocacy of the Greek cause, whether by agitating for Crusades against the Turks, or embedding Byzantine culture within Italian society. Perhaps the most precious of his donations was the reliquary bequeathed to the Venetian Scuola della Carità. We examine the continuing relationship between Venice and Byzantium in the late fifteenth century through the circumstances of this gift, and Gentile Bellini's painted evocation of it, made to decorate the tabernacle which housed the reliquary.

The final section of the exhibition reconsiders Gentile Bellini's visit to Constantinople. In 1479 he was sent to the Ottoman capital as part of the peace settlement between Venice and the Turks. He was not just a painter visiting an exotic locale, but also a cultural ambassador for Venice. Mehmed II was particularly interested in the art and culture of Italy, and seems to have desired portraits of himself by Italian artists. Our exhibition attempts to reconstruct Gentile's work in Turkey.

Our understanding of Gentile Bellini as an artist has been greatly obscured by the loss of his most important paintings – the monumental canvases in the Doge's Palace, Venice, destroyed by fire in 1577. His other large narrative canvases, *The Miracle at the San Lorenzo Bridge*, *The Procession in Piazza San Marco* and *Saint Mark preaching in Alexandria*, were produced in his final years. Little remains of Gentile's art from the 1470s and 1480s, except for the works made in Constantinople, and these have proved controversial in attribution. Moreover, many workshop paintings and drawings have been assigned to Gentile Bellini himself, which has unfortunately reinforced his reputation as an awkward artist, especially in comparison with his beloved brother Giovanni. Their talents were quite different, and we hope this exhibition will reveal Gentile's outstanding visual curiosity, especially in recording personalities.

We have of course relied heavily on the work of previous scholars. Much of the basic documentary work on these subjects was accomplished in the eighteenth and nineteenth centuries. In 1767 Giovanni Battista Schioppalalba published an essential account of Cardinal Bessarion's reliquary, recording many documents now lost. Gentile's sojourn in Constantinople was examined by Louis Thuasne in 1888, and many of the documents connected with Mehmed II's court were published in the early twentieth century. Recent scholars have made substantial contributions to the field. Julian Raby's dissertation and articles on Mehmed II's patronage of western artists have laid the groundwork for this project, although we occasionally disagree with his conclusions. The study of Greeks in Renaissance Venice has benefited greatly from the conference proceedings *I greci a Venezia* (2002) and the monumental catalogue of the exhibition *Bessarione e l'umanismo* (1994) held at the Biblioteca Nazionale Marciana. The only monograph on Gentile Bellini, by Jürg Meyer zur Capellen, valuably surveys the documents on the artist and attempts to catalogue his oeuvre, while Patricia Fortini Brown's analysis of narrative paintings by Gentile provides important insights into the social context of these works. We are grateful to these scholars, the authors of the catalogue, and our many colleagues who have advised us during the project.

ALAN CHONG AND CAROLINE CAMPBELL

Acknowledgements

The curators have depended on the help and suggestions of a core group of advisors: Gülru Necipoğlu, Jennifer Fletcher, Luke Syson, Hugo Chapman and Susan Spinale. We would also like to thank specially Sylvia Auld, Patricia Fortini Brown, Stephen Campbell, Emine Fetvacı, Paul Holberton, Deborah Howard, Philip Lewis, Angeliki Lymberopoulou, Michael Rogers and David Roxburgh.

Museums and research institutions have been unfailingly supportive of our work, and we recognise the help of the Courtauld Institute of Art, the Harvard University Libraries, the Topkapı Palace Museum, the British Library and the Warburg Institute. We owe much to the staffs, past and present, of the Isabella Stewart Gardner Museum, the National Gallery and the National Gallery Company, as well as our supportive friends and colleagues:

Meral Alpay, Philip Attwood, László Baán, Herbert Beck, Rachel Billinge, Malilka Bouabolallah, Amanda Bradley, Helen Braham, Julian Brooks, Beverly Brown, Christopher Brown, David Alan Brown, Michael Bury, Lorne Campbell, Stefano Carboni, Pieranna Cavalchini, Martin Clayton, Susan Connell, Maria Constantoudaki-Kitromilidou, Dominique Cordellier, Robin Cormack, Alexandra Corney, Rosemary Crill, Cynthia Damon, David Davies, Jill Dunkerton, Christopher Eimer, Chris Entwistle, Helen Evans, Sir David Goodall, Margaret and Simon Grey, Antony Griffiths, Jean Habert, Paul Hills, Catherine Jenkins, Mark Jones, Joli Kansil, Laurence Kanter, Trinita Kennedy, David Kim, Henry Kim, Richard Lingner, Adrian Locke, Henri Loyrette, John Lowden, Eleanora Luciano, Neil MacGregor, Mary McWilliams, Layla al-Musawi, Nicholas Mayhew, Lisa Monnas, Peta Motture, Rebecca Naylor, Giovanna Nepi Scirè, Charles Noble, Mark Norman, Susan North, Nicholas Penny, Gianfranco Pocobene, Vincent Pomarède, Venetia Porter, Earl A. Powell III, Julian Raby, The Hon. Lady Roberts, Mariam Rosser-Owen, Judy Rudoe, Sheikha Hussah Sabah al-Salim al-Sabah, Cécile Scailliérez, Hein.-Th. Schulze Altcappenberg, Martin Sonnabend, Jane Spooner, William Stoneman, Deborah Swallow, Valentine Talland, Vilmos Tátrai, Wheeler Thackston, Landon Thomas, Dora Thornton, Carel Van Tuyll, Ernst Vegelin van Claerbergen, Michael Vickers, Caroline Villiers†, Susan Walker, Catherine Whistler, Lauren Whitley, Paul Williamson, Timothy Wilson, Martin Wyld, Jan Ziolkowski, Marino Zorzi.

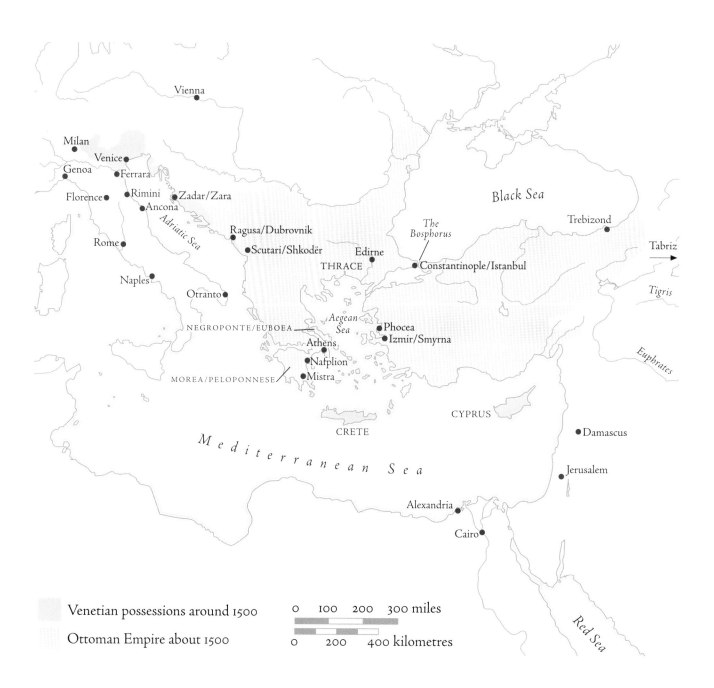

Vienna

Milan
Venice
Genoa
Ferrara
Florence
Rimini
Zadar/Zara
Ancona
Adriatic Sea
Rome
Naples
Otranto

Black Sea

Trebizond

Ragusa/Dubrovnik
Scutari/Shkodër
The Bosphorus
Edirne
Constantinople/Istanbul
THRACE

Tabriz

Tigris

NEGROPONTE/EUBOEA
Aegean Sea
Phocea
Izmir/Smyrna
Athens
Nafplion
MOREA/PELOPONNESE
Mistra

Euphrates

CYPRUS

CRETE

Damascus

Jerusalem

M e d i t e r r a n e a n S e a

Alexandria

Cairo

Red Sea

Venetian possessions around 1500

Ottoman Empire about 1500

| 0 | 100 | 200 | 300 miles |

| 0 | 200 | 400 kilometres |

Chronology

1438
Council of Ferrara and Florence convenes to discuss the union of the western and eastern churches. The Byzantine Emperor John VIII Palaiologos (fig. 26) and Archbishop Bessarion attend.

1440
Bessarion, now a Latin Cardinal, moves permanently to Italy.

1451
Mehmed II becomes Ottoman Sultan (first reign 1444–6).

1453
Mehmed II conquers Constantinople, later called Istanbul.

1459
Construction begins on the New Palace, or Topkapı Palace, in Constantinople.

1461
Sigismondo Malatesta of Rimini sends his court artist Matteo de' Pasti to work for Mehmed II in Constantinople, but he is arrested in Crete.

1463
War between Venice and the Ottoman Empire commences.

1468
Cardinal Bessarion presents his library to Venice.

1470
Turkish forces capture the Venetian colony of Negroponte.

1472
Cardinal Bessarion sends his reliquary cross (cat. 5) to the Venetian Scuola della Carità.

1474
Caterina Cornaro, widow of James II of Cyprus, becomes Queen of Cyprus.

Gentile Bellini is commissioned to paint large-scale canvases in the Great Council Hall of the Doge's Palace, Venice.

1478
Probable date of the visit of Costanzo di Moysis (also known as Costanzo da Ferrara) to Constantinople.

1479
January: A peace treaty between Venice and the Ottoman Empire is negotiated.
March: The Venetian Senate ratifies the peace treaty. Venice surrenders significant territory, and has to pay a large levy and an annual tribute.
April: A Turkish delegation arrives in Venice.
August: Mehmed II requests the services of a Venetian painter and sculptor.
September: Gentile Bellini departs for Constantinople along with two assistants. The artist's brother Giovanni Bellini is to continue work on the paintings for the Doge's Palace.
November: Date on Gentile Bellini's portrait of Mehmed II (cat. 23).

1480
January and March: Mehmed II requests a builder and another bronze sculptor from Venice, as well as wood carvers and sculptors from Florence.
August: The Turkish navy conquers the Apulian port of Otranto.

1481
January: Date of Mehmed II's letter commending Gentile Bellini (see fig. 43), who probably left Constantinople at this time.
May: Death of Mehmed II; succeeded by Bayezid II.

1489
Abdication of Queen Caterina Cornaro, who returns to Venice and is granted sovereignty of the town of Asolo. Cyprus becomes Venetian territory.

1496
Gentile Bellini completes *The Procession in Piazza San Marco* (fig. 16) for the Scuola di San Giovanni Evangelista, Venice.

1507
Death of Gentile Bellini. His almost-finished painting of the *Saint Mark preaching in Alexandria* (fig. 10) is completed by Giovanni Bellini.

1510
Death of Caterina Cornaro.

1517
Fall of the Mamluk Empire to the Ottomans as Cairo is captured.

DEBORAH HOWARD

Venice, the Bazaar of Europe

In 1479 Venice dispatched one of her best-known artists, Gentile Bellini, to the court of Mehmed the Conqueror in Istanbul as a diplomatic favour.[1] While there, Gentile supposedly presented or sold to the Sultan a treasured possession, one of his father Jacopo's two great drawing books.[2] With their vivid renderings of animals, figures and architectural scenes, Jacopo Bellini's drawings opened a window on to Venetian culture. Such diplomatic channels offered a highly effective medium for cultural transmission. Not only were gifts and favours exchanged, but the process of negotiation itself demanded a degree of mutual understanding.

The very word 'negotiation' has its origins in the vocabulary of trade, the cornerstone of the Venetian economy. Lacking raw materials on the city's marshy lagoon site, the Venetian Republic depended for its prosperity on the exchange of commodities from the east with merchandise from northern Europe brought down over the Brenner Pass. For centuries Venetian ships sailed the trade routes through the Adriatic Sea to Constantinople (Istanbul) and the ports of the eastern Mediterranean.

From the early fourteenth century, the largest sea-going vessels were moored along the quayside right in front of the Doge's Palace.[3] Even the name of the shoreline signalled its eastern orientation, for it was known as the Riva degli Schiavoni (of the Slavs) because a large number of Dalmatians lived in the area. Here galley crews were recruited, pilgrims to the Holy Land selected their berths, and waterborne ceremonial processions embarked and disembarked. The waterfront formed a liminal zone through which artefacts and ideas permeated back and forth between Europe and the eastern Mediterranean. Two woodcut depictions of the Riva degli Schiavoni offer contrasting impressions of this cultural threshold. For Jacopo de' Barbari, whose great bird's-eye view map of Venice was published in 1500 (fig. 1), the Riva was an empty stage, its waterfront tidy and expectant, its basin filled with enormous ships. By contrast, an anonymous woodcut in the British Museum (fig. 2) portrays the same quayside as a chaotic flurry of activity. By the fifteenth century,

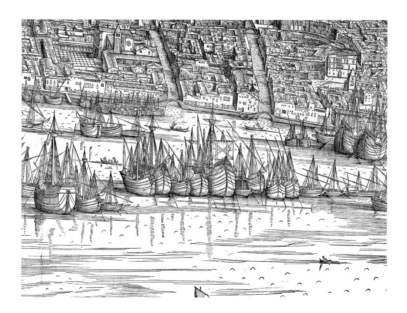

Venice dominated the European trade in eastern merchandise. Under state protection, Venetian galleys sailed in convoy to Alexandria, Beirut and the Black Sea, as well as to other ports in North Africa and to Flanders.

Venice and Constantinople

In the Venetian Republic's complex network of trading contacts, Constantinople (cat. 1) held a pivotal, but complex role. Established as the new capital of the Eastern Roman Empire by Emperor Constantine in 330, the old city of Byzantium became a Christian metropolis. Its dual identity as a classical and a Christian city made Constantinople an enduring role model for Venice. When the first Doge was appointed in 697, Venice was still an outlying colony of the Roman (Byzantine) Empire. Her bid for commercial, cultural and political independence culminated in 1204 in the dramatic events of the Fourth Crusade, when Venice diverted the fleet from the Holy Land to sack the great Christian city of Constantinople. Although the Byzantine Empire was reinstated in 1261, over succeeding centuries its territory became gradually smaller. Meanwhile, the Venetians acquired a series of genuine colonies (as opposed to trading bases in treaty ports) along the Adriatic coast and in the Greek world. By the mid fifteenth century they had achieved commercial supremacy over their former rivals, the Genoese, in the eastern Mediterranean.

In 1453, Constantinople was sacked a second time, this time by the forces of the young Ottoman Sultan Mehmed II, then just twenty-one years old. By this time the Byzantine Empire had become so small and weak that its obliteration could not be prevented. The Greek historian Kritovoulos commended the bravery of the Christian defenders, but the Venetian merchant Nicolò Barbaro's diary of the siege reveals that he and his compatriots were more concerned for the fate of their merchandise than for the survival of Byzantine rule.[4]

FIG. 1 (opposite)
Jacopo de' Barbari (1440–1516)
Bird's-eye view of Venice from the south, 1500
(detail)
Woodcut, 134 × 280.8 cm (full size)
The British Museum, London
(P&D 1895-1-22-1192-97)

FIG. 2 (below)
Venetian
The Doge of Venice embarking on the Bucintoro, the state barge, about 1500
Woodcut, 49.3 × 112 cm
The British Museum, London
(P&D 1866-7-14-48)

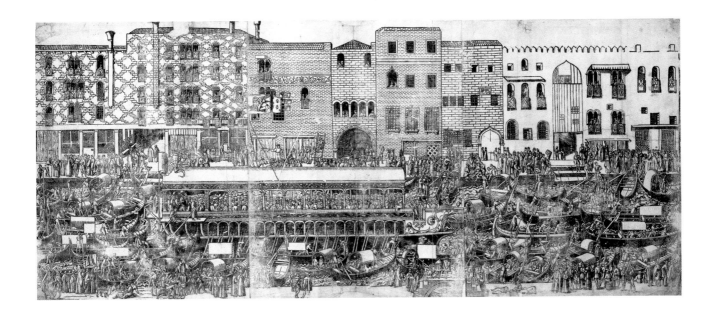

GIOVANNI ANDREA VAVASSORE
(active about 1510 – about 1572)

1 Map of Byzantium or Constantinople, 1530s

Titled: BYZANTIUM SI/VE CÖSTAN/TINEOPOLIS;
(signed lower right): OPERA DI GIOVANNI/ANDREA VAVASSORE/
DETTO VADAGNINO
Woodcut, 36.6 × 51.9 cm
Houghton Library, Harvard University, Cambridge (*51-2570 PF)

This bird's-eye panorama of Istanbul from the east shows the city essentially as Gentile Bellini knew it. Several structures built by Mehmed II are clearly visible, including the stepped terraces of the New Palace, later called the Tokapı Palace (*El seraglio novo dove habita El gran Turcho*). The building labelled *Seraglio vecchio* is the Sultan's first palace complex; in its courtyard can be seen the spiral column of Theodosios, which was destroyed by 1517. Also on the map is the Nea, or church of St Luke, which was destroyed by lightning in 1490, so the map's original design must have been drawn before then. The map seems to have been first made in the 1480s by an Italian employing an advanced perspectival system akin to that used in Jacopo de' Barbari's celebrated view of Venice of 1500 (fig. 1). Some scholars have suggested that Gentile Bellini was responsible for the design.

The map illustrates the principal Christian churches of Istanbul but omits many Islamic monuments. In contrast, another map of Istanbul made around 1480, a reworking of Christoforo Buondelmonti's map of about 1420, shows the principal mosques of the city (in the Landesbibliothek, Dusseldorf; see Manners). Kafescioğlu argues that the topographical specificity of Vavassore's map must have

required official sanction, and therefore may have been commissioned by Mehmed II.

While Gentile painted a number of detailed urban settings in his history pictures, he is not known to have produced a bird's-eye urban view like Vavassore's map. However, Angiolello and Sanudo both report that the artist made a view of Venice for Mehmed II, and in the 1490s he was asked for views of Venice, Cairo and Genoa, which were to be used for a cycle of city panoramas commissioned by the Marquis of Mantua for a villa. Now lost, this cycle also included a view of Istanbul, but somewhat surprisingly Gentile was not asked to depict the city. Since none of these views survive, it is almost impossible to associate Vavassore's map with Gentile Bellini's style.

Vavassore was a well-known woodcutter and book printer in Venice. His first dated map is of Rhodes, 1522. From the 1540s on, he concentrated on printing books. Probably made between 1520 and 1540, Vavassore's map of Istanbul inspired a number of later variants, including those published in Basel in 1550, Venice in 1567, and in Braun and Hogenberg's atlas of 1572. There is another impression of the original state in the Germanisches Nationalmuseum, Nuremberg. AC

PROVENANCE

Franz von Hauslab (1798–1883; mark: Lugt 1247), Vienna; Johann II, Prince of Liechtenstein, Vienna; purchased in 1951.

SELECTED BIBLIOGRAPHY

Mordtmann 1889, p. 3 (Gentile after Amiroutzes) Oberhummer 1902, pp. 21–2 (about 1520); Bagrow 1939, no. 16; Berger 1994; Kafescioğlu 1996, pp. 239–61; Manners 1997, pp. 91–4.

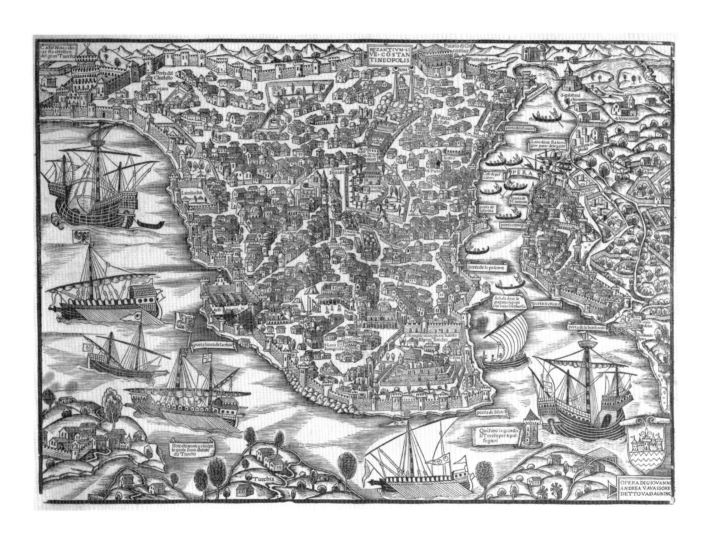

Throughout Europe, the fall of Constantinople in 1453 was recognised as a catastrophe for Christian civilisation. In a Latin elegy, the Venetian humanist Lauro Querini lamented: 'In these sad times, the ancient, noble and rich city, once capital of the Roman Empire and mistress of all the Orient, has been seized by cruel barbarians, sacked for three days and reduced to a state of miserable slavery.'[5] In accounts of the conquest, Italians called the Byzantines 'Greeks', whereas the Greeks, such as the historian Kritovoulos, referred to themselves as 'Romans' – highlighting the role of Constantinople as a cultural fulcrum.

After the Christian capitulation and two days of plunder by the invading Ottoman troops, Mehmed II himself entered the city, and, as Kritovoulos recounts, 'looked about to see its great size, its grandeur and beauty, its teeming population, its loveliness, and the costliness of its churches and public buildings and of the private houses'.[6] At once he halted the destruction and set about the transformation of Constantinople into his new capital. According to Kritovoulos, Mehmed encouraged Christians, Jews and Muslims alike to repopulate the city.[7] Nonetheless it is clear that the Sultan wanted to redefine the capital as Ottoman and unambiguously Muslim. On the prominent site of the historic Church of the Holy Apostles Mehmed founded a new mosque, named the Fatih Mosque after his own title, meaning 'conqueror'. Founded by Constantine and rebuilt under Emperor Justinian, Holy Apostles was recognised as the prototype for Venice's own apostolic church of St Mark's, giving added poignancy to its obliteration. The new Fatih Mosque was built between 1463 and 1470 by the architect Sinan-i Atik, probably a Greek.[8]

After the fall of Constantinople, with typical pragmatism, the Venetians lost no time in renegotiating their trading privileges with the new Ottoman regime. Meanwhile, their commercial links with the lands of the Mamluk Sultans, who ruled Egypt and Syria until their annexation by the Ottomans in 1517, continued unabated. The records of the chaplain-notary to the Venetian colony in Damascus in 1455–7 reveal intense trading activity, even in the immediate aftermath of the fall of Constantinople.[9] Around seventy named Venetians are recorded there in this single three-year period, some of them semi-permanent residents. Indeed, the threat of Ottoman expansion helped to unite Venetian and Mamluk interests, and Venice would later seek other alliances with Matthias Corvinus, King of Hungary, and Uzun Hasan, the Aqqoyunlu ruler of eastern Anatolia and Iran.

In the decades following the fall of Constantinople, intense diplomatic relations between Italy, Hungary and the Ottoman Empire opened up new lines of cultural exchange. As Corvinus patronised Italian artists, so, too, Mehmed II established contacts with various Italian states, and both rulers, apparently, employed the Bolognese architect and engineer Aristotele Fioravanti.[10] A letter written by the humanist Filelfo in 1465 records that the Florentine architect Filarete, then employed by the Sforza rulers of Milan, was about to sail for Istanbul.[11] Although there is no other evidence for this visit, its possible impact has been detected in the Ionic arcade of Mehmed's Treasury-Bath wing in the Topkapı Palace, and in the layout of the Fatih Mosque complex, which resembles aspects of Filarete's Ospedale Maggiore in Milan.[12] The richly illuminated Latin translation of Filarete's treatise on architecture, originally made for Corvinus in Venice since 1490, offers further evidence of this fertile period of exchange.[13]

Military expertise, then as now, was hungrily sought by rival powers. The star-shaped fortress of Yedikule, which Mehmed erected at the south-west corner of Istanbul soon after the conquest, has been associated with recent innovations in Italian military architecture.[14] The art of fortification was advancing rapidly in war-torn Italy, especially in the small principalities of Rimini and Urbino.[15] Sigismondo Malatesta, the despotic ruler of Rimini, dispatched his court artist Matteo de' Pasti to Istanbul in 1461, bearing maps of Italy and the Adriatic and a copy of Valturio's *De re militari* (On warfare), but he was arrested as a spy by the Venetians in Crete and never reached his destination.[16] Given the uncertain chronology of the early development of star-shaped fortifications, the fascinating possibility of influence from east to west cannot be ruled out.[17]

Venice and the Ottomans

The central focus of the exhibition that this book accompanies falls between two periods of direct conflict between Venice and the Ottoman Empire. Unashamedly, Mehmed dedicated his reign to territorial expansion, modelling himself on the similarly youthful Alexander the Great.[18] He recognised that the key to the conquest of mainland Greece lay in the modernisation and enlargement of the Ottoman navy, and in the technical improvement of weaponry. Kritovoulos attests to his interest in cannon design, evident from a splendid gun inscribed with his name (fig. 3).[19]

As a consequence, for the first time since their final triumph over the Genoese in the late fourteenth century, the Venetians were being seriously challenged at sea. Previous Islamic rulers had shown relatively little interest in naval conflict, leaving the Venetians to sail the Adriatic unchallenged. In 1463, however, the Ottomans seized the Venetian possession of Nafplion, forcing the Serenissima to declare war. During the ensuing conflict Venice engaged in intense diplomatic negotiations with Uzun Hasan, in an attempt to open a second front on the Ottoman advance.[20]

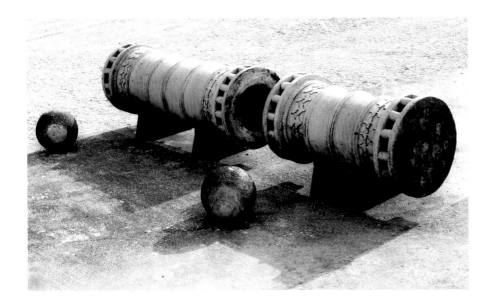

FIG. 3
Turkish (cast for Mehmed II)
Great gun, known as the Dardanelles Gun,
1464
Bronze, length 518.2 cm, calibre 63.5 cm
Royal Armouries, Leeds (XIX.164),
formerly at HM Tower of London

But Turkish raids into Friuli undermined Venetian confidence. Panic ensued in 1470 when a fleet six miles long, so that 'the whole sea looked like a forest' to a Venetian galley captain, enabled the Turks to seize Negroponte on the island of Euboea.[21] The Venetian possession of Scutari (now Shkodër) in Albania was besieged twice, in 1474 and 1478. After the failure of the first siege, Mehmed the Conqueror arrived in person to direct the second onslaught.[22] These sieges, successfully resisted by the Venetians in their hilltop garrison, are commemorated in an anonymous relief of about 1530 over the entrance to the Scuola degli Albanesi in Venice, in which Mehmed himself stands brandishing a scimitar below the citadel (fig. 4).[23]

In 1479, the Republic sent their envoy Giovanni Dario to Mehmed II's court in Istanbul to negotiate a peace settlement. Although it is often regarded as a Venetian humiliation, the peace treaty ceded only Scutari, Lemnos and the Morea (southern Peloponnese) to the Turks, allowing the Venetians to retain their other possessions in the Greek world. Even the tribute of 10,000 ducats for the right to trade in Ottoman territory was only paid for a few years.[24] With Dario's return, in the company of the Turkish envoy Lutfi Bey, came a request from Mehmed that artists should come to his court from Venice, leading to the departure of Gentile Bellini for Istanbul.

After Mehmed's death in 1481, equilibrium was restored. For nearly two decades, peace prevailed and trade resumed. The policies towards Europe of Mehmed's successor, Bayezid II, continued to be cautious while his rival for the succession, Sultan Cem, remained in western hands.[25] Cem, however, died in 1495, and in Venice the late 1490s were a difficult period, marred by plague in the overseas colonies, grain shortages and bank failures, not to mention the potential threat to

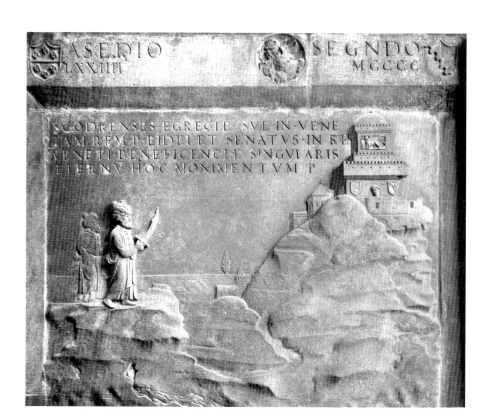

FIG. 4
Venetian
The Siege of Scutari, about 1530
Stone façade of the Scuola degli
Albanesi, Venice

trade posed by the Portuguese discovery of the Cape route to India. Once again – this time warily – the Serenissima found herself at war with the Turks. In 1499 the Turks seized Lepanto, and in the following year they captured the ports of Coron and Modon, strategically positioned at the mouth of the Corinthian Gulf and known as 'the eyes' of the Venetian maritime empire. Yet this was the quincentenary year in which Jacopo de' Barbari's woodcut view of Venice (fig. 1) optimistically depicted the city in the shape of a dolphin, regarded by mariners as an emblem of good fortune, and accompanied by Neptune, god of the sea, and Mercury, god of trade, whose inscription proclaimed his protection over 'this above all other emporia'.[26] Peace with the Turks in 1503, concluded during the dogate of Leonardo Loredan (fig. 20), closed the second period of conflict that frames the period of this exhibition.

Travel between Venice and the eastern Mediterranean

The rhetoric of official documentation – with its reports of extortion, conflict and irritation – is deceptive. Only deviations from the normal to and fro of east-west trade were addressed in political sources. Routine interactions, chronicled by travel diaries, pilgrim narratives, merchants' letters, account books, commercial manuals and shipping guides (portolans), must be considered in parallel. From this web of information we can construct a more harmonious, positive picture of east-west connections.

Because of the city's economic dependence on overseas trade, the number of Venetians who had direct experience of travel to the eastern Mediterranean was considerable. Many young Venetian nobles were sent abroad in their youth, to learn useful languages such as Arabic, Greek or Turkish, and to gain direct commercial experience. More experienced merchants might spend years at a time in one of the overseas trading posts, returning periodically for family visits. Others spent relatively brief periods abroad, staying in lodgings in a Venetian *fondaco* or trading headquarters. Through the system by which loans for trading voyages were raised from stay-at-home investors, a wide range of Venetians, including both clergy and women, invested in overseas commerce.[27] The less wealthy could join a galley crew, or serve in an overseas colony as a servant. Thus, to a greater or lesser extent, the whole community learned of the great emporia of the east and the goods that filled their bazaars.

The most popular destinations for Venetian merchants – Alexandria, Damascus and Istanbul – were so familiar that many travel narratives hardly troubled to describe them. Although scruffy and run-down, Alexandria retained its pre-eminence as a trading destination because of the profusion of commodities from India imported via the Red Sea. Emotionally, too, it held a special place in Venetian consciousness, both as the place of Saint Mark's martyrdom and as one of the greatest cities of antiquity. Indeed, even in classical sources its topography had been likened to that of the Venetian lagoon.[28] Life in the 'colony' centred on the two Venetian *fondaci*, but fifteenth-century Alexandria was not conducive to long-term residence by westerners. A letter of advice written between about 1473 and 1489 by Benedetto Sanudo to his brother Andrea warned him to sleep either in the consul's

house or on board ship, and not to wander around alone.²⁹ By this time, Cairo, the Mamluk capital, impressed western travellers to Egypt far more than Alexandria.

In Syria, by contrast, Damascus offered both prosperity and congenial surroundings. The trading privileges negotiated with the Mamluk authorities allowed Venetian merchants to live anywhere in the city, rather than within the confines of the *fondaco*, and to wear local clothes.³⁰ With its network of canals, luscious gardens and backdrop of hazy blue hills, Damascus was a favourite destination. The inventories of several Venetians who died in the city in the years 1455–7 reveal that their houses were filled with a kaleidoscopic profusion of domestic articles of both eastern and western origin.³¹ Alongside relics and small devotional images of Christian subjects were intricate Moorish objects in inlaid metalwork, such as lidded boxes, pomanders, candlesticks, bells, inkwells and rose-water sprinklers (see fig. 5 and cat. 3). As the destination of overland caravans from central Asia and the Silk Route, Damascus supplied merchandise from as far afield as China. Among the ceramics in these inventories were items of Chinese porcelain, Syrian blue-and-white ware and Italian or Spanish majolica. Visual evidence of the presence of Chinese porcelain in Venice is to be found in the three large blue-and-white bowls in Giovanni Bellini's painting *The Feast of the Gods*, sent to Alfonso d'Este of Ferrara in 1514 (fig. 6).

FIG. 5
Mamluk
Candlestick with a coat of arms (probably of the Venetian Boldù family), late 15th century
Brass inlaid with silver and gold,
diameter 8.3 cm, height 13 cm
The British Museum, London
(OA 1878.12-30.721)

FIG. 6 (right)
Giovanni Bellini (about 1431/6–1516)
and Titian (about 1490–1576)
The Feast of the Gods, about 1514–29
(detail)
Oil on canvas, 170.2 × 188 cm (full size)
National Gallery of Art, Washington, DC
Widener Collection (1942.9.1)

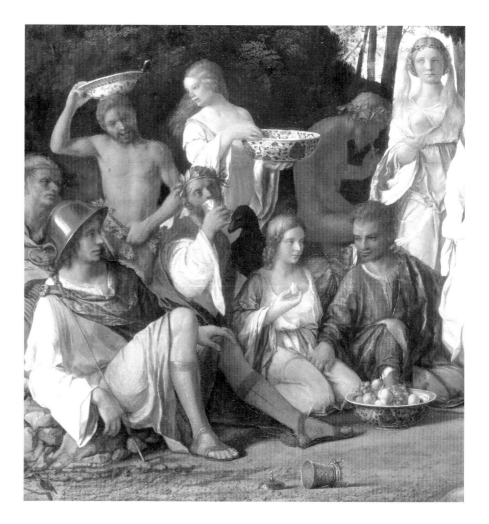

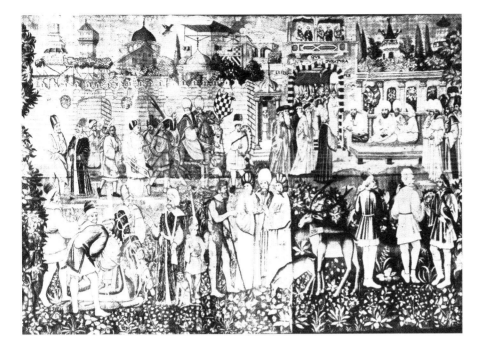

FIG. 7
French
Reception of the Venetian Ambassadors in Damascus, 1545
Tapestry, 360 × 540 cm
Powis Castle, Powys
The National Trust

No document records the Venetian fondness for Damascus more eloquently than the painting of *The Reception of the Venetian Ambassadors in Damascus* (cat. 2). Sadly, the identity of both artist and patron are unknown, but the picture itself has become an emblem of Venice's links with the east. Probably the client was the envoy himself, and the existence of early copies, even in tapestry (fig. 7), suggests that the work was well-known.[32] Indeed, this picture seems to have become a main conduit for visual information about Mamluk costume, in particular its spectacular ceremonial headdresses (quite distinct from the simpler, rounder turbans worn by the Ottomans). Although the picture shares the vivid 'eye-witness' realism of the canvases of Gentile Bellini and Carpaccio, it is not a strictly topographical view, but a composite of various separate elements, as if to display all the distinctive facets of life in Damascus in one image – the Great Mosque, the citadel, a laden camel on its way to the bazaar, the public baths, the walled gardens and the private houses.[33] Its vitality and colourful palette suggest that the artist may have experienced the Syrian capital in person, even if the work was executed in Venice from detailed sketches made on site.

Constantinople, too, was a favourite destination for Venetian merchants, whose trading networks had been established under Byzantine rule. The first colony in Constantinople, authorised by the Byzantine Emperor in 1082, had formed the model for future overseas bases.[34] The trading privileges favourably renegotiated in 1277 established a permanent residential and commercial quarter along the shores of the Golden Horn, facing the suburb of Pera (Galata).[35] Other trading posts along the shores of the Black Sea reinforced the Venetian presence. Marco Polo's uncle, also called Marco, had owned a house at Soldaia (now Sudak) on the south coast of the Crimea.[36] At the time of the Ottoman siege of 1453, as many as sixty-eight Venetian nobles were in Constantinople, according to the diary of Nicolò Barbaro.[37] The future Doge Andrea Gritti, born just two years later, established himself in

2 *The Reception of the Venetian Ambassadors in Damascus, probably 1513–6*

Oil on canvas, 118 × 203 cm
Inscribed left: M D X I
Musée du Louvre, Paris (100)

This remarkable painting celebrates the reception of a Venetian delegation by the Mamluk viceroy (*na'ib al-saltana*) of the province of Damascus. He is seated on a dais (*mastaba*), and wears a great horned turban, use of which was restricted to the Sultan and his highest officials. Damascus was a favoured destination for Venetian merchants, who enjoyed special trading privileges, including the right to wear local clothing. For this special occasion, however, the visitors are formally dressed in the customary black gowns and caps (*berete*) of Venetian patricians and citizens.[1] Their leader is presumably the consul (*bailo*), who was the highest Venetian official in Damascus, and even received a salary from the Mamluk authorities.

The third minaret of the Great Umayyad Mosque (to the left), built in 1488, and the Mamluk costumes of the Damascene officials, suggests that the painting was executed between 1488 and 1516. The date 1511, a year of great significance for the Venetian colony in Damascus, has been discovered recently on the wall between the horse's legs.[2] In May 1510 a Cypriot spy was intercepted on the Euphrates with messages from the Shah of Persia to the Venetian consuls of Alexandria and Damascus, Tommaso Contarini and Pietro Zen (1458–1539). Contarini and Zen – the Shah's second cousin – were subsequently accused of treason by the Mamluk Sultan. After much prevarication they were obliged to answer his summons to Cairo.[3] Meanwhile the Venetian merchants in Damascus were imprisoned, and their goods confiscated. To solve the diplomatic crisis, the Venetians resolved to send Domenico Trevisan as ambassador to Cairo.

A lost letter of 13 March 1512, dispatched from Damascus by the consul Nicolò Malipiero, records the Sultan's eagerness to see the Venetian ambassador.[4] Trevisan arrived in Cairo in May 1512, and relatively quickly arranged for Contarini, Zen and their compatriots to be released from prison. However, the Sultan's anger was still directly chiefly at Zen. He only narrowly avoided execution, and left the Mamluk court in disgrace – on foot, in chains and with a military guard.

Only four participants in the events of 1510–12 were entitled to wear as official dress the scarlet toga with open sleeves (*maniche dogali*) shown in the painting – Trevisan, Contarini, Malipiero and Zen. Of these, only Pietro Zen and Nicolò

Malipiero were in Damascus in these years. Malipiero appears to have arrived in Damascus in 1511 and could be the figure shown here. However, the distinct resemblance between a Titianesque portrait probably of Pietro Zen (State Hermitage Museum, St Petersburg) and the lead 'ambassador' suggests rather that it represents Zen. His treatment by the Mamluk Sultan did him no lasting harm: he returned to Venice in January 1513 to public acclaim.

It seems most likely that the Louvre painting was intended as a composite of different elements of Damascene life, to provide a retrospective souvenir or mnemonic of the city, and perhaps of Pietro Zen's life within it. No official reception of the Venetian community in 1511 is recorded in the numerous accounts of the 'Zen affair', but the meeting depicted here fits well with descriptions of Zen's formal audience on his arrival in Damascus in late 1508. The date on the painting, therefore, could be read not as the date of the meeting, but as a remembrance of the most important of Zen's Mamluk years. Nor do the buildings represented constitute a strict topographical view, although the depiction of the Great Umayyad Mosque was probably made from the Venetian *fondaco* in Damascus. The structures depicted range from public buildings such as the Great Mosque and the baths in the grain market to private houses with roof terraces and walled gardens. In the foreground on the left a generalised street scene conveys the bustle of the busy city (including a man on horseback with armed attendants in old-fashioned Syrian dress, laden camels and gossiping bystanders – all watched by women wearing Damascene headdresses). Such anecdotal details suggest considerable knowledge of Damascus, but not necessarily by the painter. They could easily have been supplied by a knowledgeable patron such as Malipiero or Zen. Indeed, Malilka Bouabolallah's observation that the artist has rendered the Arabic inscription 'There is no God but Allah' over the archway in reverse makes it more likely that the painting was executed in Venice rather than Damascus.

Who was responsible for this fascinating picture? Like every other Venetian painting of an oriental scene, it has enjoyed an historical attribution to Gentile Bellini. The accurate details of this Mamluk city scene could suggest a connection with

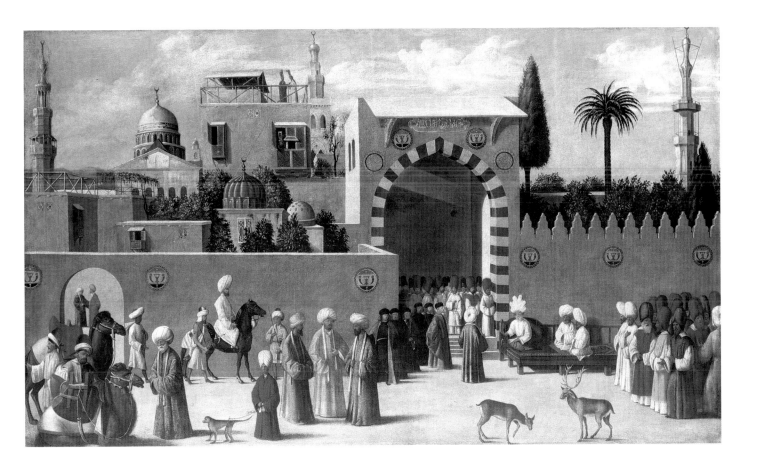

Gentile's pupil Giovanni Mansueti, who specialised in depicting this Muslim civilisation. Many of his paintings, from his earliest surviving work, the *Symbolic Crucifixion* of 1492 (National Gallery, NG 1485), include figures in Mamluk costume. A drawing at Windsor sometimes given to Mansueti (fig. 8), often said to represent three Mamluk officials from the right of the Louvre painting, is actually a conflation of individual figures from his *Arrest of Saint Mark* (1499) and *Scenes from the Life of Saint Mark* (fig. 9). Indeed the methodical, ordered structure of the Louvre picture seems a world away from Mansueti's preference for busy compositions. Rather, its internal organisation is akin to Gentile's characteristic integration of figures and architecture, exemplified by the *Procession in Piazza San Marco* (fig. 16). So, while the painting is clearly by a follower of Gentile (who died in 1507), working in his manner, the figural and architectural composition suggest that this was not Mansueti.

The Louvre *Reception* has long been considered the conduit by which accurate visual information concerning Mamluk dress and customs reached Venice. The discovery of the date 1511 precludes this. Nevertheless, the painting's significance remains as a unique pictorial record of a Venetian's experience of sixteenth-century Damascus. This canvas also played an important role in the transmission of authentic oriental motifs to France. The several close copies that survive share its French provenance – and one, a tapestry of 1545 now at Powis Castle (fig. 7), is of French manufacture. CC

NOTES

1 The cloak worn by the Venetian at the far left resembles Vecellio's woodcut of the old costume of Venetian merchants in Syria (Vecellio 1590, p. 71).
2 At this time the Venetian year commenced on 1 March. The dates in the text follow the modern calendar. On the relationship between cat. 2 and events of 1510–12 see Pagani 1875, pp. 21, 27, 31; Sanudo 1879, vol. 11, cols 825–30; vol. 12; col. 141; vol. 15, col. 457; Thenaud 1884, pp. lxxxv–lxxxvi; Lucchetta 1968, pp. 160–74; Lucchetta 1985, pp. 52–3.
3 Sanudo 1879, vol. 11, cols 825–30.
4 Sanudo 1879, vol. 14, cols 246–7.

PROVENANCE

Raphael du Fresne, who brought the painting to France before 1660 (Boschini 1660). Louis XIV, Versailles, before 1683 (attributed to Antonio Badile in the inventory of 1709–10).

SELECTED BIBLIOGRAPHY

Boschini 1660 (1966), pp. 49–50 (Gentile); Villot 1853, no. 68 (Gentile); Crowe and Cavalcaselle 1871, p. 127; Berenson 1894, p. 97 (Catena); Schefer 1895; Sauvaget 1945; Robertson 1954, p. 71, no. 1 (doubtful as Catena); Berenson 1957, p. 29 (follower of Gentile); Rouillard 1973; Conti 1977 (Benedetto Diana); Louvre 1981, p. 259 (Venetian); Raby 1982, pp. 55–65 (anon.); Meyer zur Capellen 1985, pp. 94–5, 143–4 (copy of Gentile); Brown 1988, pp. 197–200 (Venetian); Cuneo 1991; Raby in Washington 1991, no. 106 (circle of Gentile); Mack 2002, pp. 161–3.

Constantinople in his youth 'not only to attend to his private business, but also to learn as much as he could of that world and that way of life,' as his biographer Nicolò Barbarigo recounted.[38] Barbarigo claims that Gritti became intimate with Mehmed's heir, Sultan Bayezid, and his Grand Vizier, Ahmed Pasha. After about twenty years in the Ottoman capital, where he amassed a huge fortune, Gritti returned to Venice to marry, but following the death of his wife in childbirth he returned to Istanbul in about 1499. Entwined in the wartime negotiations at the turn of the century, he was imprisoned for spying, but later released. On his election as Doge in 1523, the diarist Marin Sanudo was to remark caustically that 'someone who has three bastards in Turkey ought not be elected Doge'.[39]

Orientals in Venice: myth and reality

During the last two decades of the fifteenth century Venetian painters in the circle of Gentile Bellini became fascinated by the depiction of oriental elements – whether figures, artefacts or buildings. Giovanni Mansueti was the artist who carried this to extremes, filling his narratives with a profusion of exotically clad oriental figures, although he is unlikely to have visited the eastern Mediterrean himself. In his *Scenes from the Life of Saint Mark* (fig. 9), for example, recognisably Mamluk costumes establish the setting as Alexandria. Every terrace, balcony, loggia and open space is filled with figures wearing an array of different versions of Mamluk headdresses. Mansueti probably used the same sources for his material as the artist responsible for *The Reception of the Venetian Ambassadors in Damascus* (cat. 2). Even the same Mamluk blazons on the walls are reproduced. The female figures in the background, with their high, veiled headdresses, are derived from the woodcut of Mamluk figures by Erhard Reuwich in Bernhard von Breydenbach's *Peregrinatio in terram sanctam* (Pilgrimage to the Holy Land, Mainz 1486). Any semblance of historical authenticity is compromised by the insertion of contemporary Venetians, likely to be portraits of members of the Scuola di San Marco, the guild that commissioned the canvas. In Mansueti's works the fantastic oriental costumes demand the spectator's attention at the expense of narrative clarity.

In the work of Gentile Bellini, oriental detail was both more controlled and more meaningful, thanks to his own visit to the court of Mehmed II. In his *Saint Mark preaching in Alexandria* (fig. 10), also for the Scuola di San Marco (finished after his death in 1507 by his brother Giovanni), we see a variety of Mamluk costume, probably inspired once again by Reuwich's woodcut, and perhaps also by sketches of envoys from Cairo visiting Venice.[40] As in Mansueti's canvas, Venetians are depicted alongside Mamluks. Bellini even included his own self-portrait in the left foreground, wearing a red robe (the colour normally worn by senators) and the gold chain presented to him by Mehmed II.[41] Here, however, the narrative is clearly constructed, with the sweeping buttress of the church pointing down towards the preaching saint, who stands on a marble bridge, his stature enhanced by the obelisk rising directly above his head. The architecture is a composite of Ottoman, Egyptian and Venetian monuments, but the obvious allusions to the architecture of St Mark's define at once the city's identification with Alexandria and the saint's inexorable destiny to be laid to rest in Venice.

FIG. 8
After Giovanni Mansueti (active 1484; died 1526/7)
Three Mamluk Dignitaries, after 1526
Pen and brush on paper, 26 × 19 cm
The Royal Collection (RL 062 P&WI)

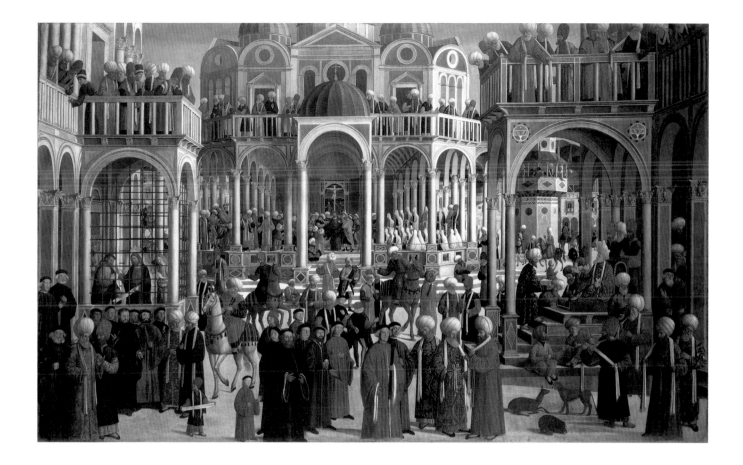

Muslim visitors to Venice

The two Turkish wars, acting as bookends to this remarkable pictorial development, establish the political context: a potentially dangerous 'other' arouses curiosity during any period of hostility. But how realistic is the image of Venice inhabited by turbanned figures as well as Europeans? The idea that colonies of Arabs, Turks and Persians resided in Venice at this time has passed into the city's mythology, but it does not stand up to serious scrutiny. Visitors to Venice at this period certainly noticed the cosmopolitan crowds: the Milanese priest Pietro Casola remarked in 1494 that 'it seems as if all the world flocks there', while the French diplomat Philippe de Commynes observed that 'most of their people are foreigners'.[42] In reality, however, trading legislation granted Venetians primacy in the sale of oriental merchandise, effectively excluding any other nationalities who might wish to compete in the marketplace. The putative Persian and Arab *fondaci* of this period seem to be nineteenth-century inventions.[43] The few traders from North Africa and Egypt who arrived on Venetian ships had to have all their transactions recorded by officials known as *sensali*.[44] The Fondaco dei Turchi was not established until 1621.[45]

What other groups of Muslims might have been visible in the streets of late fifteenth-century Venice? Slaves were brought back by merchants, who often provided for their liberation in their wills.[46] A black slave appears in the right

FIG. 9
Giovanni Mansueti (worked 1484; died 1526/7)
Scenes from the Life of Saint Mark, about 1518–26
Oil on canvas, 376 × 612 cm
Gallerie dell'Accademia, Venice

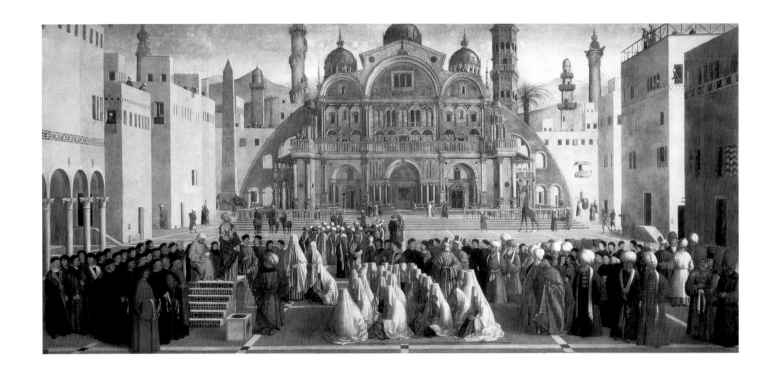

FIG. 10
Gentile Bellini, completed by
Giovanni Bellini
Saint Mark preaching in Alexandria, 1504–7
Oil on canvas, 347 × 770 cm
Pinacoteca di Brera, Milan

background of Gentile Bellini's *Miracle at the San Lorenzo Bridge* (fig. 17), where his mistress encourages him to dive into the canal to rescue the lost relic. In reality, however, most of the Ottoman or Mamluk visitors to Venice after the fall of Constantinople were envoys on diplomatic missions, their infrequent arrivals chronicled as events of special interest in Sanudo's diaries.[47] Perhaps it was the exceptional status of these visits that prompted their inclusion in the paintings of Gentile Bellini, to add an element of oriental exoticism. The fact of their improbability was overridden by the authenticity of the costumes, documented in drawings brought back by the artist from Istanbul. The group of oriental figures in the background of his *Procession in Piazza San Marco* (fig. 16), dated 1496, presumably based on his own sketches, was later copied by Dürer in a drawing now in the British Museum.[48]

Given the exclusion of non-Venetians from oriental trade in Venice and the rarity of Ottoman and Mamluk diplomatic missions, should we postulate the presence of Muslim craftsmen in Venice? This idea, too, entered the city's historiography in the nineteenth century: it was first proposed by Lavoix in 1862, and gained widespread acceptance, feeding the myth of Venice as an exotic eastern city floating on the edge of Europe.[49] The theory was not seriously challenged until 1970, and it still claims adherents, especially in the context of metalwork production (see below).[50] The presence of other eastern expatriates such as Greeks, Dalmatians and Armenians is securely documented, but these were all Christian communities. Even those Albanians who fled to Venice after the siege of Scutari are likely to have been Christians. Their guild, the Scuola di Santa Maria degli Albanesi, commissioned an important cycle of paintings of *The Life of the Virgin* from Carpaccio in about 1502.[51] To date, no archival evidence of colonies of Muslim artisans in Venice has come to light.

Emulation, imitation and counterfeit in craft production

Even today there is no consensus about the source of a group of fine pieces of metalwork probably datable to the late fifteenth century and known by the hybrid title of Veneto-Saracenic.[52] These are vessels of copper or brass, engraved with elaborate all-over geometrical and arabesque ornament and finished with inlays of silver, gold or tin, sometimes over a blackened background. A number of the pieces have shapes that are unusual in Islamic tradition, such as the semi-spherical bowls with flat lids or candlesticks with long necks, and were presumably intended for the European market (cat. 3, fig. 5). Some have blank armorial shields, while others bear the arms of Venetian and other European families, suggesting that they were made in the east for export and were to be inscribed on arrival in the west. The presence of numerous such pieces in several Venetian homes in Damascus in the 1450s adds weight to the idea that the Syrian capital might have been their place of manufacture.[53] Vasari includes a section on Damascene metalwork in the preface to his *Lives of the Artists*.[54] Another theory locates the origin of these pieces in Cairo, where crafts were reviving under the patronage of the Mamluk Sultan Qa'it Bay – indeed similarities have been found to relief ornament in Cairene architecture of the same period.[55] A third possibility is that the best-known of these metalworkers, Mahmud al-Kurdi, worked in Anatolia or Iran, for his name indicates that he was of Kurdish origin.[56] The lidded box in the Courtauld Institute (cat. 3) is inscribed with his name in both Arabic and Roman script; both the shape and the inclusion of the Roman inscription suggest that the piece was intended for export to Europe.[57]

Nevertheless, as in other crafts such as leatherworking, glass and ceramics, Venetian craftsmen later learned to produce passable imitations of Islamic models at home. One of the Venetians who died in Damascus in the 1450s, Stefano Ravagnino, had a number of goldsmith's tools in his possession; if he did indeed practise as a jeweller he would have been well-placed to notice the skills of local craftsmen. By the sixteenth century the production of imitation Veneto-Saracenic metalwork in Venice would become well-established (cat. 4). To the expert eye these works are easily distinguishable from the Islamic originals, betrayed by their meaningless Arabic inscriptions or by ornament influenced by European grotesque and knot-work. The circular tray in the Courtauld Institute (fig. 14), bearing the arms of the Giustiniani or Sagredo family, suggests its likely Venetian manufacture by its motifs drawn from *all'antica* ornament and its comparatively high-relief engraving. Such pieces would serve the home market, but could not have been exported back to the Ottoman Empire. Even when Islamic decoration was faithfully imitated, as, for instance, in Turkish-style book-bindings produced in Venice, the mixing of different patterns (contrasting with the greater unity of genuine Ottoman bindings) betrays the western authorship.[58]

Nevertheless, the quality of Venetian craftsmanship was apparently recognised by Sultan Mehmed, who not only sent for a painter from Venice but also requested a bronzeworker, a maker of chiming clocks and an expert in the manufacture of *cristallini*, or crystal-clear glasses.[59] Crystal-clear glass was one of the triumphs of fifteenth-century Murano glassworkers. As the Mamluk glass industry declined, the productivity of the furnaces of Murano increased. By the later sixteenth century

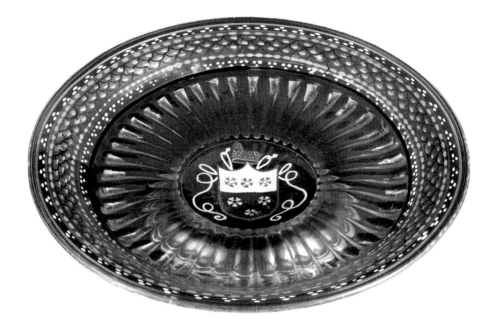

Venetian glass exports to the Ottoman Empire, ranging from window glass to
mosque lamps, would amount to twenty per cent of total production.[60] Abstract
decorative motifs, free of specific cultural meanings, passed freely between one
medium and another and between east and west – the fish-scale ornament popular on
enamelled Venetian glass (fig. 11) also appears on Ottoman Iznik ceramics. Because of
the fascination of the apparently alchemical process of transformation of sand into
crystal and the skill involved, Venetian glass held a strong position in the European
luxury export market.

Christianity and the east

A crucial aspect of this east-west cultural interface – the issue of the religious
divide – still needs investigation.[61] Despite centuries of interaction with Muslim
trading partners, dating back at least to the theft of the body of Saint Mark from
Alexandria in 829, Venice was proud of her role as a defender of the Christian faith.
Though ambivalent about the practicality of crusading, which interfered with her
trading initiatives, Venice was the major port of embarkation for pilgrims to the
Holy Land.[62] The acquisition of precious relics and the building of fine churches
underlined her identity as a pilgrim destination in her own right.

 Pilgrimage was one of the main channels for the acquisition of knowledge
about the Islamic world. Pilgrims brought back relics, souvenirs and information
in profusion; many merchants, too, visited holy sites in search of both spiritual
solace and sacred articles for sale. The belongings of Stefano di Bossina, one of the
Venetian merchants in Damascus in the 1450s, included 'six ropes from Jerusalem
for measuring the Holy Sepulchre', as well as relics, crosses, rosaries and images of
Christ in gilded lead.[63] With the development of printing, graphic images became

more easily transmitted. The pilgrim chronicle of Bernhard von Breydenbach, published in 1486, included woodcut views of Jerusalem and Venice, as well as those of other cities visited on the voyage. As already mentioned, the inclusion of a woodcut of three figures in Mamluk costume in this volume had its impact in Venice, being drawn upon by Mansueti. Soon afterwards, in 1493, a second illustrated pilgrim narrative, the celebrated Nuremberg Chronicle, included another series of topographical woodcuts. Anton Kolb, the publisher of Jacopo de' Barbari's bird's-eye view, seems to have imported the Nuremberg book to sell in Venice, for he acquired thirty-four copies in 1499.[64] While these woodcuts certainly gave coherence to the mosaic of individual memories of overseas cities, they also bred confusion, by reusing the same view for different cities and perpetuating the long tradition that the Dome of the Rock was the biblical Temple of Solomon. The German pilgrim chronicles were well-known to Venetian artists, not only Mansueti but also Carpaccio, who drew elements from Reuwich's woodcuts for architectural settings in his Saint Stephen and Saint Ursula cycles.[65]

In Carpaccio's paintings, a variety of objects of eastern origin have been identified, often inserted into Venetian-style interiors such as studies and bedrooms.[66] Just as articles of fine eastern craftsmanship added status to Venetian homes, so, too, their meticulous representation in the study of Saint Augustine or the bedroom of Saint Ursula could elevate the prestige of the subjects depicted.[67] The depiction of exotic eastern articles within recognisable Venetian settings further enhanced the Republic's image as a great eastern emporium and a Christian holy city. Here we also see a reflection of the long-standing Venetian tradition of including Islamic artefacts in the treasury of St Mark's because of their geographical associations with the biblical world.[68]

Since the Islamic world in the later fifteenth century encompassed most of the sites recorded in the Scriptures, it was difficult for the public to disentangle Muslim artistic tradition from biblical authenticity. It is not surprising, therefore, to find articles of Muslim provenance depicted in religious paintings. For example, the throne of the Virgin in Gentile Bellini's *Virgin and Child Enthroned* (cat. 11) stands on a carefully depicted Turkish carpet, apparently an Anatolian re-entrant prayer rug. It has been suggested that the inclusion of such objects of recognised monetary value celebrated the materialism of the Renaissance, at the expense of religious devotion, but this is unlikely to have been the response of the Venetian believer.[69] Of course, the inclusion of the carpet presumed an audience that would appreciate its value, just as the Virgin's splendid throne addressed a public familiar with the associations of rare coloured marbles, but such value only conferred honour and prestige on the subject. Because at this time fine carpets were usually laid on tables or chests, rather than on the floor, the placing of the Virgin's throne on a carpet implicitly lifted her above the level of everyday life. The fact that the carpet was recognisably of eastern provenance added biblical authenticity to the image. In Venice such rugs were known as 'mosque carpets' because of their use in prayer, but we cannot be certain whether spectators knew of the paradisical associations in Islam of the *mihrab* niche motif just visible in the centre of the carpet.[70]

The tradition of depicting precious oriental textiles as robes for sacred figures, had been established in Venice since the fourteenth century, giving a surface richness

that perfectly suited the Gothic intricacy of paintings by artists such as Paolo Veneziano and later Giambono. In works by the Bellini, for whom surface decoration was subservient to pictorial space and meaning, the use of oriental textiles was more controlled. In the *Circumcision* painted in the workshop of Gentile's brother Giovanni (fig. 12), the high priest wears a honey-coloured satin headdress embroidered in stripes and a rich cream damask robe lined with pink. The edge of the robe is decorated with a *tiraz* border bearing a pseudo-Arabic inscription in a stylised geometrical script. Since *tiraz* robes were originally worn exclusively by caliphs, they retained connotations of prestige and rulership.[71] They were still used in the Islamic world in elite ceremonial; thus Venetians accustomed to diplomatic ritual would have immediately recognised their status. The inscription underlined the biblical location and gave authority to the high priest, even if its ornate calligraphy held no specific meaning for the Venetian spectator. The picture originally decorated the chapel of Pietro Cappello in the Benedictine nunnery of San Zaccaria, the portal of the church of which has been suggested as the source for the architectural frame of Gentile's portrait of Mehmed II (see cat. 23).[72]

In the climate of mutual curiosity that often accompanies periods of hostility and rivalry, Mehmed II was just as eager to learn about Christian, and specifically Venetian, culture as the Venetians were curious about the Islamic world. Given the traditional recruitment of high court officials from Christian subject communities, and the continued existence of the Greek patriarchy in Istanbul, the Sultan is likely to have been familiar with the basic tenets of Christianity. One source even claims that he became devoted to the cult of Christian relics at the end of his life.[73] He seems to have owned western engravings, and supposedly commissioned a painting of the Madonna and Child from Gentile Bellini.[74] That he patronised Greek humanists is well known, although many of them took refuge in Venice after the fall of Constantinople, and his request to George Amiroutzes to update and translate Ptolemy's *Geography* may have been driven primarily by his need for accurate maps for his military campaigns.[75] As mentioned earlier, the gift of maps to him from Sigismondo Malatesta was intercepted by the Venetians. According to Giovanni Maria Angiolello, Mehmed wanted Gentile Bellini to provide him with drawings of Venice, and it is not unlikely that this desire was in part related to his ambitions of conquest – in particular, he needed to know more about the Arsenal and the topography of the harbour.[76] A late fifteenth-century Venetian shipping manual, now at Greenwich, includes Gentile's recipe for mixing colours for the illumination of maps, suggesting his possible involvement in cartography.[77]

The Sultan did not hesitate to make his authority clear to the Venetian authorities. When Giovanni Dario returned home from Istanbul in 1479, the Ottoman envoy who accompanied him, Lutfi Bey, presented the Republic with a girdle, formerly worn by Mehmed himself, intended to be worn by the Doge 'for love of his master'.[78] The Sultan's need of a bronzeworker might have been linked to his interest in weaponry, since Venetian cannon were cast in the workshops of bronze-founders.[79] Mehmed's enthusiasm for western skills of portraiture probably resulted from his own desire for self-aggrandisement, using representational conventions that would be internationally recognised. But not all his curiosity was military or political – the erotic decorations that he wanted for his harem were an entirely private concern.[80]

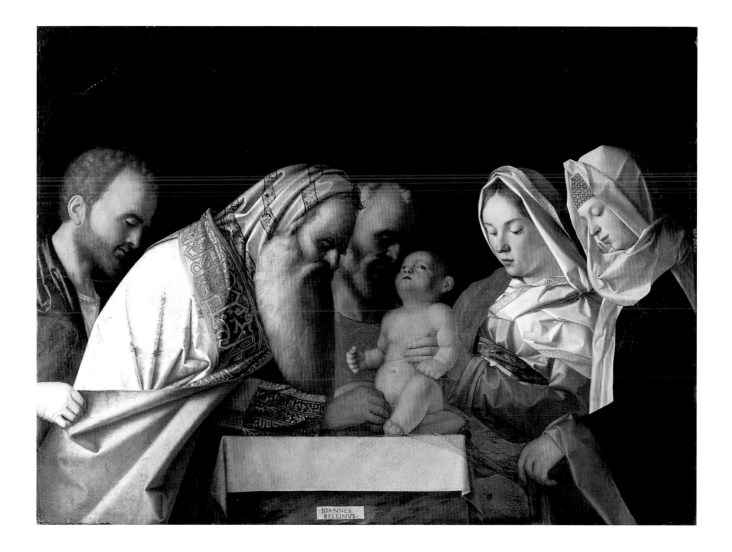

Giovanni Maria Angiolello recounts how the more austere Bayezid II sold many of his father's western pictures in the bazaar on his succession in 1481.[81] The less aggressive reign of Bayezid allowed Venetian art to flourish in relatively peaceful conditions, but the impact of the Conqueror's forceful personality and policies had left its mark. The deep fascination for oriental themes and motifs in Venetian pictorial culture of the late fifteenth century was greater than at any other time in the history of the Serenissima.

FIG. 12
Workshop of Giovanni Bellini
The Circumcision, about 1500
Oil on wood, 74.9 cm × 102.2 cm
The National Gallery, London (NG 1455)

MAHMUD AL-KURDI (active about 1460; died 1507)

3 Round-bottomed box and lid, second half of the 15th century

Signed twice on lip of bowl: AMELEIMALENMAMUD; and in Arabic:

عمل ابن مؤذن که از استادان مشهور فرنک است

amal al-mu'allim Mahmud yarju al-maghfira min maulahi
(Mahmud who hopes for forgiveness from his Lord)

Brass, engraved and inlaid with silver and a black compound,
diameter 15.6 cm (box) and 15.8 cm (lid)
Courtauld Institute of Art Gallery, London (O.1966.GP.204)

Although the signature does not include the *nisba* 'al-Kurdi', there is no doubt that this small box is a key object in the œuvre of Mahmud al-Kurdi, the best-known of a group of Muslim metalworkers once believed to have been working in Venice. This is now discounted and it is accepted that they were not a single group but were operating in Turkmen north-west Iran, north-east Anatolia and in Mamluk Egypt or Syria, and on stylistic grounds, probably in the later fifteenth-century. Wherever Mahmud al-Kurdi was working (probably north-west Iran) the skill with which he fashioned his metalwork is not in question. Against a background of minutely engraved arabesques are set silver-inlaid geometric and floriate designs of elegance and restraint. When first made, the gleam of silver and polished brass would have been accentuated by the use of a black organic compound to produce an object of considerable visual opulence.

No fewer than thirteen objects with Mahmud al-Kurdi's signature have survived, none dedicated to a specific patron or dated. Seven are round-bottomed boxes. Although not identical, all conform in shape and, to an extent, decoration. They were probably beaten into shape and then finished on a lathe. In all likelihood, the decorative pattern was worked out in advance. Probably the next step was for the background surface of the box and lid to be gouged out, leaving the design standing proud, before it was filled with the black background. Finally, soft, high-grade silver wire was rubbed into prepared, toothed, grooves. The covered boxes are a most unusual shape – their rounded base makes them unstable – but the tightly fitting lids would have preserved any contents.

What was their function? There was a close trading, and therefore diplomatic, link between Italian city states and the Levant. One idea is that the boxes held sweetmeats. In 1487, during trade negations with Florence, the gifts of a Mamluk diplomat to Lorenzo the Magnificent included spices and '*confetione*', both of which could have been transported in such a box. The diplomatic link may explain one of the puzzling features of this particular box – why did Mahmud sign it in two scripts? The Roman form is transliterated, not translated, and would therefore have been understood only by someone who spoke Arabic or Persian. One of the guests at an outdoor reception in Tabriz arranged by the Aqqoyunlu Turkmen ruler Uzun Hasan was the Venetian ambassador, Giosafo Barbaro. For ten years from 1463, Venice and Uzun Hasan had been allied against the advance of the Ottoman Turks. Barbaro, as guest of honour, was served first from a wooden or lacquer tray holding bowls filled with delicacies. Perhaps the little box was donated as a diplomatic gift after such a feast.

Another suggestion is that the boxes held precious 'minute' spices which the box would have kept dry and airtight in transportation to the west. These aromatic spices were served at western banquets, when the containers were first displayed on a side table and then brought forward by servants to be handed around the seated guests. The combination of display piece and functional serving vessel filled with exotic substances, both emphatically Levantine in flavour, would have identified the host as both wealthy and generous. The similarity in the boxes' size would have aided a pricing system based on capacity, a skill learnt by the Renaissance schoolboy and in use throughout the Mediterranean basin.

Another suggestion is raised by a little object made by Mahmud. It is a pierced brass sphere in two halves, and once held a gimbal (a series of concentric rings holding a small central cup; Museo Civico Medioevale, Bologna, 2110). These spheres, many now in western collections, were used as incense burners. On several, including the one signed by Mahmud al-Kurdi, the inlaid decoration is almost identical to the round-bottomed boxes, which were perhaps designed to hold the incense as part of a matching set. Whatever the original use, the combination of exquisite workmanship and precious contents clearly found favour in the west. SA

PROVENANCE

Purchased in 1858 in Zara (Zadar), Dalmatia, by Thomas Gambier Parry, Higham Court, Gloucestershire; by descent to Mark Gambier-Parry; bequest 1966.

SELECTED BIBLIOGRAPHY

Robinson 1967, pp. 170, 173; Auld 1989, pp. 46, 226; Ward et al. 1995; Mack 2002, p. 142; Auld 2004, pp. 18–19, 106, 146–7.

4 *Salver, about 1500*

Brass inlaid with silver, diameter 45.5 cm
Isabella Stewart Gardner Museum, Boston (M27N2)

Unlike the three surviving salvers signed by Mahmud al-Kurdi (see cat. 3), this example was almost certainly made in the west. But it is decorated in a Levantine mode, the silver-inlaid cusped roundels and cartouches set against a minutely engraved arabesque ground in a similar aesthetic to the authentic Islamic pieces. In Renaissance Italy, such work was much admired, to judge by the comments of men like the fourteenth-century traveller Simone Sigoli, who wrote that 'some of the most beautiful things in the world' were to be found in Damascus, which, 'if you had money in the bones of your leg, without fail you would break it to buy'. Even Cellini and Vasari praised the skill of the Levantine metalworkers, and rich merchant princes avidly collected their work.

The everted rim and raised central umbo of the salver are related to classical Greek and Achaemenid *phialae*, used to pour liquid libations. The form continued in the Byzantine period and was absorbed into the west. The salvers were used during the celebration of Mass as paten or collection plates, and to catch water poured over the hands of the officiating priest. They also functioned as a symbol of wealth.

The broad rim of this platter means that it would not have been possible to pour liquid with any degree of accuracy, and it is more likely that it was intended for secular use, on show as an object of conspicuous wealth, and to hold food. Many medieval paintings, particularly from Flanders and the Netherlands, show similar salvers displayed on a side table or shelf, or ranged on a table in front of guests. Frequently there was a biblical aspect to these paintings, for example a depiction of the Marriage at Cana or Last Supper. Seen as a symbol of purity, images of saints and the Virgin and Child also contain such salvers, with or without an accompanying water jug. Salvers continued to be used as collection plates in a religious context, and the association of the form would not have been missed in a secular setting. SA

PROVENANCE
Purchased in 1906 from the Galleria Sangiorgi, Rome.

SELECTED BIBLIOGRAPHY
Longstreet 1935, p. 233; Auld 1989, p. 260; Chong et al. 2003, p. 100; Auld 2004, pp. 7, 224.

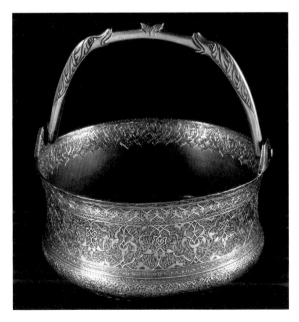

FIG. 13
Iranian, Turkish or Mamluk, *Bucket*, 15th or 16th century
Brass inlaid with silver, 11 × 23.1 cm
Courtauld Institute of Art Gallery, London (O.1966.GP.198)

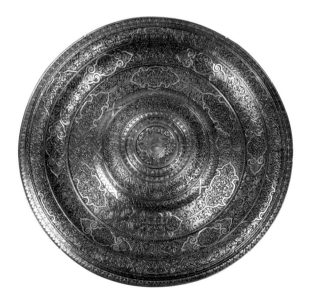

FIG. 14
Venetian?, *Dish with a coat of arms (possibly of the Giustiniani or Sagredo family)*, about 1530–50
High-tin bronze inlaid with silver, diameter 45.9 cm
Courtauld Institute of Art Gallery, London (O.1966.GP.202)

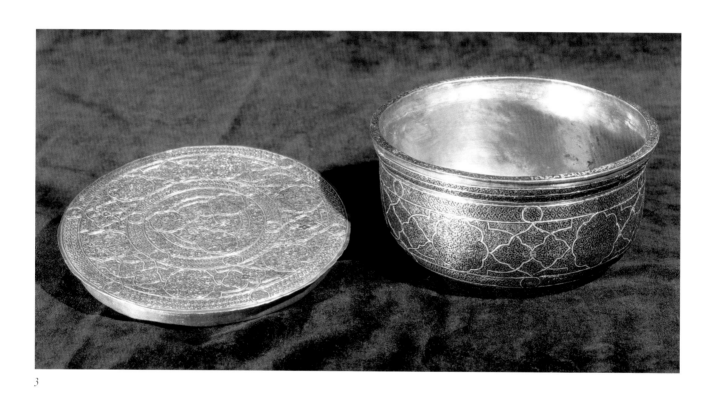

3

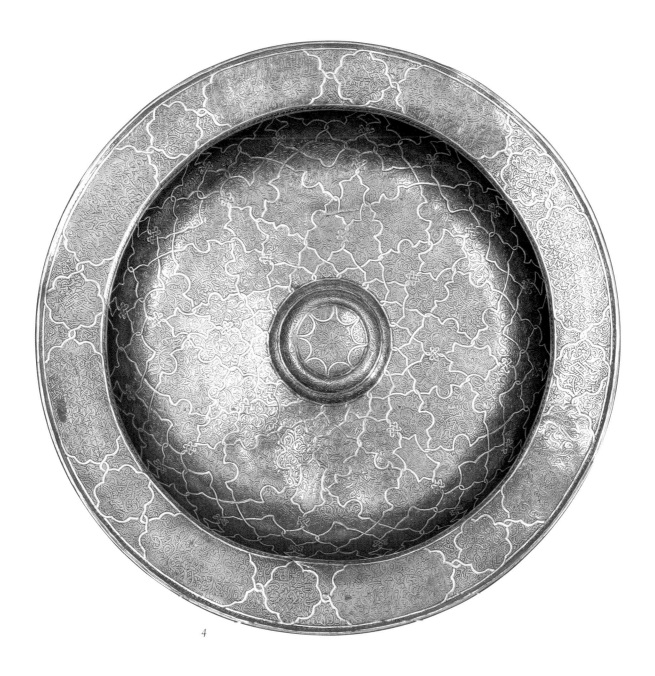

4

The Bellini, Bessarion and Byzantium

Though nations from almost all over the earth flock in vast numbers to your city, the Greeks are most numerous of all; as they sail in from their own regions they make their first landfall in Venice, and have such a tie with you that when they put into your city they feel that they are entering another Byzantium.[1]

With these memorable words the Greek exile Cardinal Johannes Bessarion gave his renowned collection of manuscripts to the Republic of Venice in 1468.[2] Most of Bessarion's library had been assembled after the fall of Constantinople fifteen years earlier 'for the sake of those Greeks who are left now, as well as for those who may have a better fortune in the future'.[3] Apart from inspiring living and future Greeks, the glories of pagan and Christian Greek literature contained in the library were also intended as ambassadors for the Greek cause. They would, Bessarion hoped, remind the Latins of their continuing debt to Greek culture and religion, and their related duty to save the Greek people.[4] This was also the function of Bessarion's other significant gift to Venice.[5]

Five years earlier, while negotiating with Doge Cristoforo Moro for Venetian support for a Crusade against the Turks, the Cardinal had given the city an object of an importance perhaps equal to that of his library.[6] This was a *staurotheke*, or container for the True Cross, which he promised to the Scuola Grande dei Battuiti della Carità,[7] maintaining a life interest for himself. Bessarion's gift (cat. 5) contained two fragments of the wood of Christ's Cross (which had been unearthed by the Byzantine empress Saint Helena in the fourth century) and two pieces of Christ's tunic, placed on either side of a silver-gilt crucifix. The earliest parts of the reliquary date to the mid fourteenth century. It had belonged subsequently to Princess Irene Palaiologina, niece of the Emperor (it is still unclear which of the four late Byzantine princesses who bore this name and title is meant),[8] and Bessarion inherited it from Patriarch Gregory, Confessor to the imperial court, in 1459.[9] The story of Venice's excited reception of the reliquary, and the artistic response it produced from Gentile Bellini (cat. 6) bear witness to the continuing importance of Greek examples for the city's life and art in the late fifteenth century.

Bessarion's reasons for favouring the Scuola della Carità with his imperial reliquary were probably a mixture of immediate gain and long-term strategy. The Carità was the oldest of the four Scuole Grandi or great confraternities that played a crucial role in Venetian public life,[10] and Bessarion's donation took place on the day of his formal election to its ranks.[11] He may have wished to thank its former Guardian Grande, or chief adminstrative officer, Ulisse Aliotti – also official notary, dogal secretary and a Count Palatine – for support in his Crusade negotiations. Aliotti was certainly involved in the donation: he wrote the deed of Bessarion's gift to the Carità.[12] However, the Cardinal was not primarily a politican, but a devout monk who had played an active role in the ecumenical Council of Ferrara and Florence in the late 1430s, and advocated passionately the reunion of the Eastern and Western Churches. Like Saint Jerome, translator of the Vulgate Bible, Bessarion saw himself as a mediator between Greek and Latin Christianity, and his coat of arms shows two hands (representing the two Churches) grasping a Greek cross.[13]

Appropriately, the icon of Jerome he probably owned (fig. 15) combines Greek and Latin iconography.[14] He was greatly impressed by the visible collective piety of the Scuole Grandi, whose devotional practices were incorporated into Venice's civic structure. They processed weekly through their quarter of the city, but the highlights of the confraternal year were major processions on religious feasts such as Saint Mark's Day, Corpus Christi and Good Friday, as well as civic celebrations (see fig. 16).[15] On these days brothers of the Scuole paraded through the city, bearing candles, banners and rarely seen relics of great sacral importance.[16] Another of the Scuole Grandi, San Giovanni Evangelista, was renowned for its possession of a miracle-working fragment of the True Cross, given to them in 1369 by Philippe de Mezières, Chancellor of Cyprus (fig. 17).[17] The Cardinal may have thought there could be no better way to perpetuate Greek Christianity within Latin Venice than to insert an even greater Byzantine relic into the public life of another of the city's religious institutions.[18]

At some point before 1472, probably at Bessarion's request, alterations were made to his reliquary to enable its more effective use by the Venetian confraternity.[19] Seven painted scenes of Christ's Passion, inscribed in Greek, were added to the box holding the reliquary. Although these look Byzantine, they include the western scene of the Flagellation, not part of the Orthodox Passion cycle. The paintings are in a pure late Palaiologan style, comparable to that of an important icon of *The Raising of Lazarus* in the Ashmolean Museum, Oxford (cat. 7). The date and place of their manufacture have been much debated.[20] However, on the basis of Polacco's convincing study of the various phases of the cross's manufacture, the paintings can now plausibly be assigned to an artist working in the last Constantinopolitan style on Venetian Crete and dated to the 1460s.[21] Certainly

FIG. 15
Veneto-Byzantine School
Saint Jerome, about 1400
Tempera on wood, 34.5 × 27 cm
The British Museum, London (P&E 1994. 5-1.1)

FIG. 16
Gentile Bellini
The Procession in Piazza San Marco, 1496
Oil on canvas, 367 × 745 cm
Gallerie dell'Accademia, Venice (567)

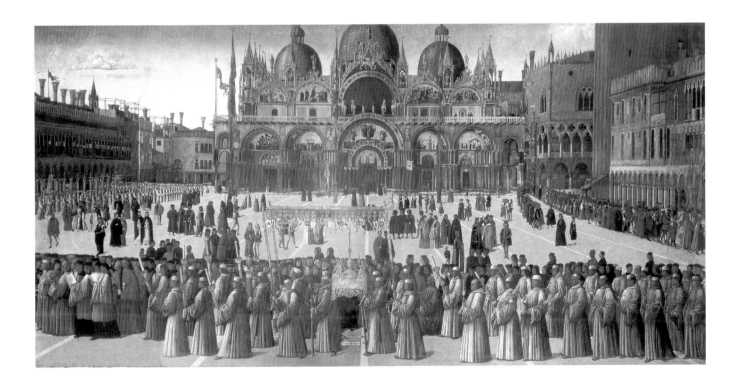

5 Reliquary of Cardinal Bessarion, late 14th century–1460s

Silver, silver-gilt, enamel, glass, jewels,
wood and tempera, 47 × 32 cm
Inscribed on the cover: H CTAYPΩCIC (The Crucifixion)
and IC XC (Jesus Christ)
Gallerie dell'Accademia, Venice (S19)

6 Cardinal Bessarion and two Members of the Scuola della Carità in Prayer with the Bessarion Reliquary, after 1472–3

Tempera with gold and silver on wood, 102.3 × 37.2 cm
The National Gallery, London (NG 6590)
Purchased, with a generous legacy, 2002

On 29 August 1463 Cardinal Bessarion was elected to the Venetian Scuola Grande dei Battuiti della Carità. He marked the occasion by promising a precious reliquary cross to the confraternity. The reliquary had originally belonged to a Byzantine princess, Irene Palaiologina, who had commissioned the figure of Christ writhing on a gilded filigree cross. This crucifix was later attached to a metal and wooden box, decorated with a blue-and-gold enamel background, which housed two relics of the True Cross and two pieces of Christ's robe. The box was further adorned with portraits on glass of the first Byzantine Emperor Constantine and his mother Helena (who rediscovered Christ's cross), to highlight the role of the imperial dynasty as protectors of the Orthodox faith. A removable cover, an icon of the Crucifixion (fig. 18), protected the relics themselves from unworthy eyes.

Before 1446 Irene's cross came into the possession of Gregory, Confessor to the imperial Byzantine court and Uniate Patriarch of Constantinople. In Rome, he bequeathed the reliquary to his fellow exile Bessarion, who commissioned further alterations to it, probably in Venice or her domains. Probably between 1463 and 1472 seven small paintings of Christ's Passion were attached to three sides of the reliquary; a silver revetment was added to the cover, and a jewelled frame and stand were made for the whole reliquary, so that it could be carried in procession (compare fig. 16). The metalwork is Venetian in style and, while the paintings surrounding the reliquary look Byzantine, certain iconographical features, notably *The Flagellation* (middle right) are western. This hybrid quality suggests that they are the work of a Byzantine-trained painter working for the western market. The elongated figures, sophisticated modelling of forms and highlighting are stylistically similar to the reliquary's cover (fig. 18) and, along with the somewhat later Passion Cycle, reflects the metropolitan style of Constantinople and Mistra in the late fourteenth and early fifteenth century, like the refined *Raising of Lazarus* (cat. 7).

Bessarion sent his reliquary to Venice in 1472, shortly before embarking on a diplomatic mission to France. On arrival in the city it was taken in solemn procession to the confraternity's *albergo* (meeting room). Gentile Bellini's painting was commissioned as the door of the tabernacle in which the reliquary was stored (two keyholes are still visible on the right). The reliquary was revealed only on special feast days, and Gentile's painting was intended to teach confraternity members how to behave before it, as well as celebrating its donation. Bessarion, on the left, kneels in prayer before his reliquary, while behind it are two brothers of the Scuola, probably Ulisse Aliotti and Andrea della Sega, who had played key roles in its acquisition. But the most important portrait here is that of the reliquary itself: rather than meticulously copying every detail, Gentile has sensitively captured the essence of this hybrid object. Strong dark lines evoke the movement of Christ's body, while the *alla greca* scenes of Christ's Passion are executed with a succession of swift – and stylistically very western – brushstrokes.

Gentile's painting performed its original function until 1744, when a new Baroque altar for the cross was commissioned. The tabernacle was dismantled, and the painting was presumed lost until the 1920s. This is the first time part of the reliquary and its protecting door have been seen together for several hundred years. Their reunification draws attention to Gentile Bellini's clear interest in Venice's Byzantine heritage, as well as the continuation of Byzantine artistry and culture in the Venetian empire following the fall of Constantinople. CC

PROVENANCE

CAT. 5: Gregory, Uniate Patriarch of Constantinople; bequeathed in 1459 to Cardinal Bessarion; presented to the Scuola della Carità, Venice, in 1463 (installed in the albergo 1472); Conte Luigi Savorgnan, 1797; Abbot Celotti; given to the Holy Roman Emperor Francis I, Vienna, 1821; returned to the Accademia, Venice, 1919.
CAT. 6: Scuola della Carità, Venice; Francis I, Vienna, by 1821; August Lederer, Vienna (by 1925); his wife Serena Lederer (whose collection was seized in 1940); Erich Lederer; Kunsthistorisches Museum, Vienna, by 1950; returned to Erich Lederer's heirs 1999; sold Christie's London 12 December 2001 (lot 61); purchased by the National Gallery 2002.

SELECTED BIBLIOGRAPHY

Sansovino 1581, pp. 282–3; Schioppalalba 1767, pp. 149–50; Michiel 1903, p. 132; Millet 1916, p. 453; Fogolari 1922; Planiscig 1928, p. 51; Berenson 1932, p. 68; Moschini Marconi 1955, no. 216; Frolow 1961, pp. 563–5; Kunsthistoriches Museum 1965, no. 450; Venice 1974, no. 112; Chatzidakis 1985, no. 6; Meyer zur Capellen 1985, p. 141; Lollini 1986, pp. 274–9; Polacco 1992; Labowsky 1994, pp. 287–94; Campbell 2002; Lillie 2003, p. 666; Polacco 1994; Venice 1994, no. 187; New York 2004, no. 325.

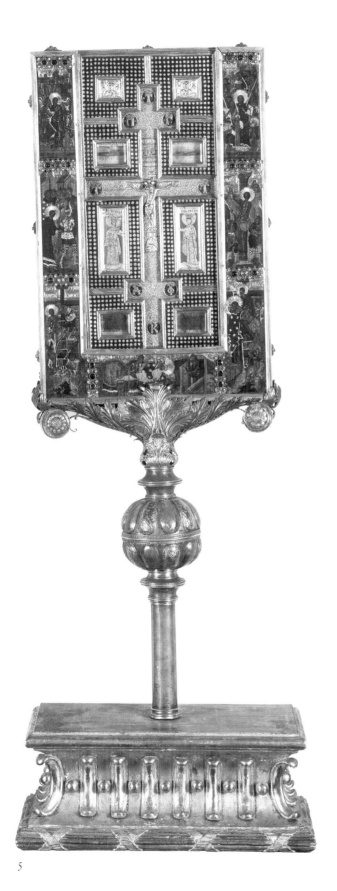

5

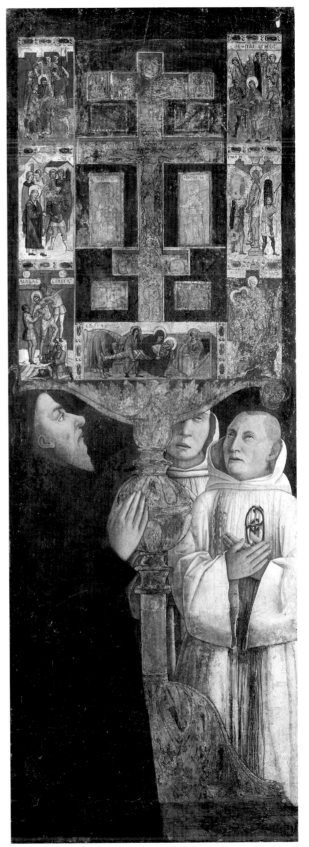

6

7 The Raising of Lazarus, 15th century

Tempera on wood, 45 × 31.6 cm
The Ashmolean Museum, Oxford (A 436; AN 1915.13)

By the early fifteenth century, even before the fall of Constantinople, the best icon painters were working in Crete, the most important centre for Greek painting in the eastern Mediterranean. The steep curvature displayed by this panel has been associated particularly with icons produced on Candia (as both Crete and its capital were known in Venice) and in the Morea (the modern Peloponnese). Like the painted scenes on the Bessarion Reliquary (cat. 5), *The Raising of Lazarus* seems to have been painted by a Byzantine-trained artist in the Venetian domains (presumably Crete), working in the imperial style which was fashionable in about 1400. The two works are close in style and may even have been painted in the same workshop.

The Raising of Lazarus is far more delicately worked than those Cretan icons associated with mass export to Venice at the end of the fifteenth century (see cat. 13), and seems to have been intended for careful perusal at close range. The subject is Christ's revival of Lazarus, at the request of the dead man's sisters (John 11: 17–43). Two figures carry the lid of the marble sarcophagus off to the right, while the watching Apostles and Jews are cleverly incorporated into gaps in the cragged landscape setting. The refinement of the elongated figures is heightened by the application of delicate red-brown paint with a fine brush for the details of their faces and hair. Strong lines of white highlights animating the drapery of Martha, Mary and the foremost Jew give these figures a heightened sense of movement. Similar stylistic qualities appear in the painted elements of Bessarion's Reliquary.

Both these objects relate to the Palaiologan style of fourteenth- and early fifteenth-century Constantinople, exemplified by the dynamic icon of *Doubting Thomas with Maria Palaiologina and her Husband* now at Meteora. However, they also bear a striking resemblance to the iconography, colours, modelling, distorted figures and rocky landscapes of the sophisticated frescoes in the Pantanassa church at Mistra (about 1430). From the late thirteenth century to the mid fifteenth century this city, capital of the Despotate of the Morea, was an important centre for learning and the arts, perhaps more important than declining Constantinople. Mistra was home to artists, scribes, clerics and philosophers, among them notably Plethon (about 1360–1452). Bessarion, who spent six years in Mistra (1430–6), was one of the many younger Greek scholars who flocked to this noted intellectual city. The Mistran stylistic affinities of his Reliquary and the delicate Ashmolean painting demonstrate that the widespread production of icons in Venice's Greek colonies in the second half of the fifteenth century was not restricted to objects of low artistic quality. CC

PROVENANCE

Conte Braseleoni, near Urbino; bought from Bwdowksi, Venice, in 1891 by Charlotte Bywater; Ingram Bywater Bequest 1915.

SELECTED BIBLIOGRAPHY

Rice 1963, no. 264; Lloyd 1977, pp. 197–8; Gendle 1980, no. 1; Harrison et al. 2004, p. 251.

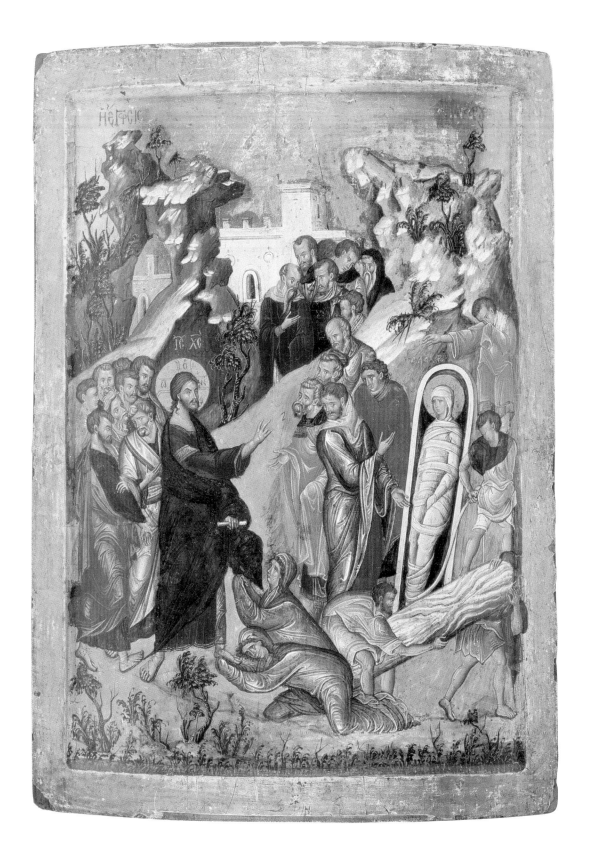

this is how these paintings appeared to the early sixteenth-century Venetian connoisseur Marcantonio Michiel, who described them as *'opera constantinopolitana'*.[22] The paintings were then framed by elaborate Venetian metalwork, and the cross was given a handle so that it could be carried by a confraternal devotee. The effect produced by this mix of Byzantine and western manufacture has been compared to that of the contemporary church of Santa Maria dei Miracoli. The building is covered with marble facing, a practice of Byzantine origin, but has a Renaissance form. The Miracoli, like Bessarion's refurbished reliquary, looks Greek *alla veneziana*.[23]

In May 1472 the aged and infirm Bessarion in Bologna sent three commissioners to accompany his reliquary to its new home.[24] They arrived over a month later on Trinity Sunday. The following month Andrea della Sega, Guardian Grande of the Carità, wrote to Bessarion recording the rapturous welcome Venice had given his cross.[25] The whole city, led by the Doge and Patriarch, celebrated its temporary installation on the High Altar of San Marco with a sung Mass.[26] Subsequently a procession led by

FIG. 17
Gentile Bellini
The Miracle at the San Lorenzo Bridge, 1500
Oil on canvas, 323 × 430 cm
Gallerie dell'Accademia, Venice (568)

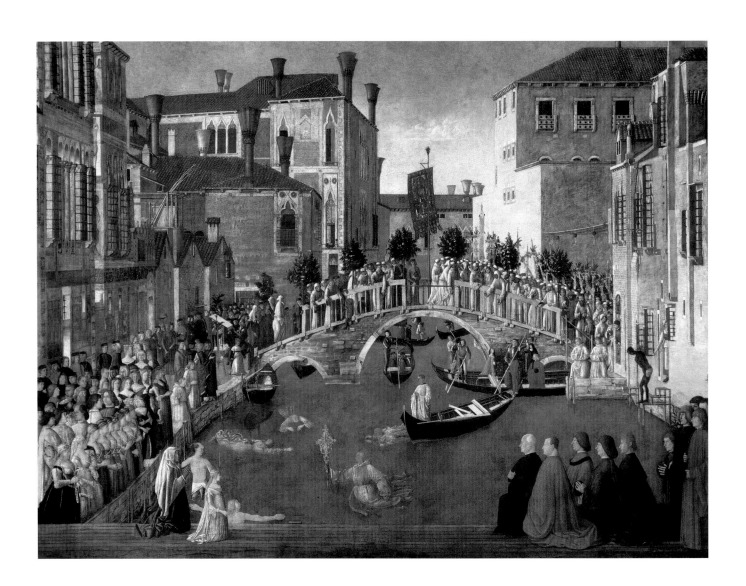

BELLINI AND THE EAST

the city's fathers, similar to that represented in Gentile Bellini's *Miracle at the San Lorenzo Bridge* (fig. 17), set off for the monastery of the Carità, crossing the Grand Canal on a specially constructed wooden bridge.[27] On arrival the cross was set on the main altar of the monastery church, and venerated until tears ran down the devotees' faces.[28] Following Mass the cross was carried into the confraternity's recently redecorated *albergo* or meeting room, which remains its home today.[29] Like other sacred objects, Bessarion's reliquary was revealed only on special festal occasions, when it travelled in solemn ceremony to Piazza San Marco.[30] During such appearances the reliquary was carried on a special portable platform, accompanied by four brothers in their customary white hooded robes and four priests, as well as two acolytes bearing incense.[31] Normally it was stored in the *albergo* under lock and key in a painted tabernacle next to a portrait of Bessarion and an inscription urging the brothers to remember him when they raised their eyes to his cross.[32]

During the summer of 1472 Gentile Bellini was commissioned to paint this portrait of Bessarion (now lost)[33] and the front of the tabernacle.[34] The choice of painter may have been influenced by Ulisse Aliotti, who had once dedicated a sonnet to the artist's father.[35] But the selection of Gentile would have been unsurprising: by 1472 he was already well established as a painter for the Scuole and for the State, and had already worked with his father and brother for the monastery church of the Carità in the 1460s.[36] The painted door, now in the National Gallery (cat. 6), is an intriguing amalgam of Gentile Bellini's two most renowned characteristics today – a curiosity about the civilisations of the eastern Mediterranean and an aptitude for communal portraiture.

Bellini's painting depicts the *staurotheke* without its cover (fig. 18) in its most sacred aspect, and shows Bessarion's probable additions. The four relics, and portraits in glass of Empress Helena and Emperor Constantine, are visible on either side of Christ on the Cross. Kneeling beside the cross in characteristic devotional attitudes are Cardinal Bessarion in the habit of a Basilian monk[37] and two brothers, dressed in white robes bearing the Carità's pink-and-black badge. The devotees are portrayed in Gentile Bellini's distinctive, convincingly truthful style, and their likenesses are conveyed by the accentuation of certain physical peculiarities, such as the carefully described bulbous nose of the Cardinal and the individual grey hairs of his Grecian beard (which had cost him the papacy),[38] or the gaunt, ascetic face of the elder brother (conceivably Aliotti). Such conscious simplification of forms was meant to impress the sitters' characteristics and identity on the viewer's memory.[39] This is clearest in the underdrawing (fig. 19), and it is likely that Gentile's portrayal of the Cardinal was based on earlier drawings or recollections of Bessarion's 1463–4 sojourn in Venice.[40] Certainly his physiognomy compares well with other surviving contemporary likenesses (fig. 21).[41] But the most important portrait is that of the cross, which dominates the composition and looms over the mortals. It was intended to evoke the reliquary rather than represent it with absolute accuracy. The techniques used to summarise the mens' features were also applied to the artefact. Thus Gentile abbreviated the jewelled borders dividing the episodes of the Passion cycle into an orderly geometric pattern, and rendered the Greek metallic inscriptions as if they were in paint. Perhaps of most interest is his interpretation of the painted Passion cycle: using the typically western technique of deft, seemingly swift strokes

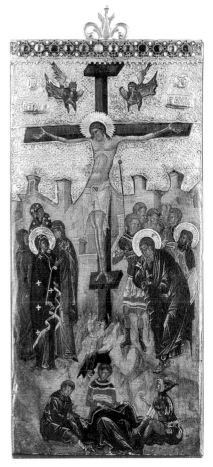

FIG. 18
Byzantine
Cover for the *Reliquary of Cardinal Bessarion* (cat. 5)
Paint, enamel, silver and precious stones on wood, 42 × 32 cm
Gallerie dell'Accademia, Venice (S19)

FIG. 19
Infrared detail of cat. 6

of paint and colour, Gentile captured the essential features and spirit, but not every detail, of the more measured Byzantine paintings. It is a memory or *ricordo* of a Greek object translated into Venetian pictorial dialect.

Bessarion's reliquary, as received in Venice according to Della Sega's account and as evoked by Gentile Bellini, exemplifies fifteenth-century Venetians' attitude to Byzantium and its relics. They illustrate a living legacy rather than homage to the dead. The document recording the donation of Bessarion's library characterised Venice as the place where the inheritance of Christian Greece could best be nurtured in exile. But the cross, his other major gift to Venice, was to play a more important role in the immediate afterlife of Byzantium within the city. Venice and her artists made use both of their Byzantine inheritance and of the work of living Greeks. Just as the fragment of the Cross played an active role in Venetian public life, so it and other Byzantine artefacts, old and new, provided creative inspiration for Gentile and his brother Giovanni, the most important Venetian painters of the late fifteenth century.

The Greeks in Venice

Bessarion's connections with Venice were long-standing, strengthened by shared diplomatic interests,[42] but most of his fellow exiles also acknowledged Venice as the capital of the Greek diaspora.[43] Venice and her empire housed Byzantium's life and culture, and the only hope of any recovery of the Byzantine Empire lay with the Venetians, who controlled both the finest navy in the eastern Mediterranean and what remained of Christian Greece outside Ottoman control. As a result of the Fourth Crusade of 1204 Venice had acquired territory along the Adriatic, Ionian and Aegean seaboard, including much of the Aegean archipelago.[44] Venetian expansion continued in the fifteenth century, despite setbacks such as the fall of Negroponte on the island of Euboea (1470) and territorial losses acknowledged in the 1479 peace treaty with Mehmed II. In 1489 she annexed Cyprus, long dominated by several Venetian families and latterly ruled by a widowed Venetian queen, Caterina Cornaro (cat. 8). Together with Candia (Crete), this island was probably the Republic's most important imperial possession.[45]

A considerable Greek community lived in Venice from the early thirteenth century onwards, concentrated in the *sestiere* (district) of Castello.[46] It has been estimated that perhaps 4,000 of the city's population of approximately 110,000 in 1478 were Greek.[47] The majority came from Candia and Cyprus, the Morea (the modern Peloponnese) and Negroponte. Their numbers included members of most ranks and professions,[48] including a sizeable but fluctuating community of scholars and intellectuals.[49] However, it was the Greek soldiers, or *stradiotes*, who made the greatest impact on the life of those of their exiled compatriots who had clung, unlike Bessarion, to the Orthodox faith, rejecting the decision of the Council of Florence and Ferrara that the Holy Ghost proceeded from God the Father and God the Son (the notorious *Filioque* clause of the Creed). The *stradiotes'* contribution to the Republic's Turkish campaign led to the formation of a Greek Scuola, the confraternity of San Nicolò, in 1498.[50] Sixteen years later Doge Leonardo Loredan (fig. 20)[51] allowed Venice's Greeks to build an Orthodox church in the city.[52] Loredan's interest in them

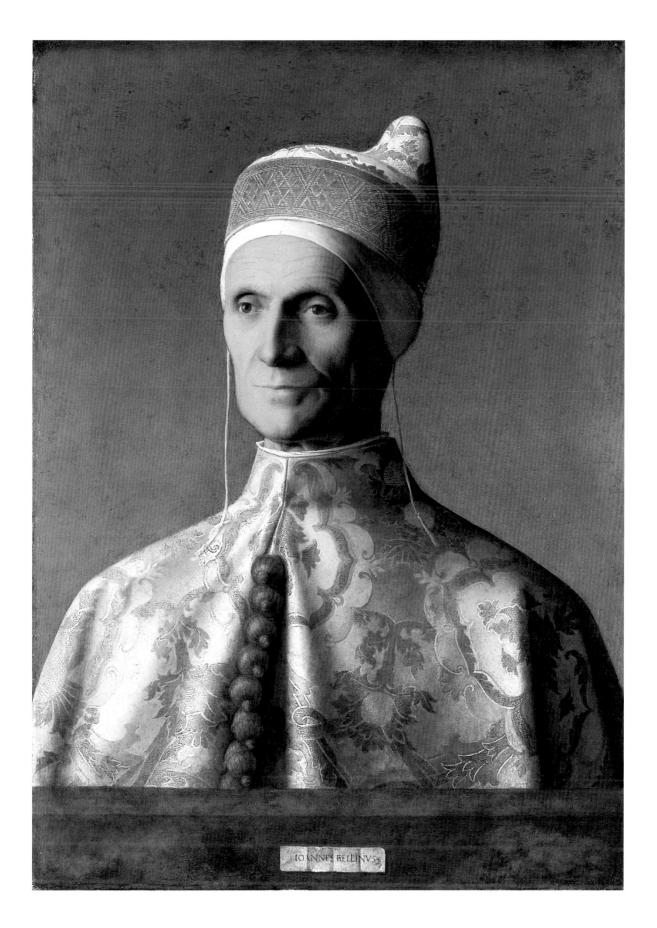

8 Portrait of Caterina Cornaro, Queen of Cyprus, about 1500–7

Inscribed: CORNELIAE GENUS NOMEN FERO/VIRGINIS QUAM SYNA SEPELIT/VENETUS FILIAM ME VOCAT SE/NATUS CYPRUSQUE SERVIT NOVEM/REGNOR SEDES QUANTA SIM/VIDES SED BELLINI MANUS/ GENTILIS MAIOR QUAE ME TAM/BREVI EXPRESSIT TABELLA

(Of the family of Cornelia. I bear the name of the Virgin whom Sinai buries [Saint Catherine of Alexandria]. The Venetian Senate calls me daughter and Cyprus serves me. I rule nine seas. You see how great I am but the hand of Gentile Bellini is greater which portrays me on such a small panel)

Oil on wood, 63 × 49 cm
Szépművészeti Múzeum, Budapest (101)

During his lifetime Gentile Bellini was Venice's most celebrated painter. This portrait represents one of his most renowned compatriots, and indisputably the most famous woman among them, Caterina Cornaro, Queen of Cyprus (1454–1510).

The contemporary inscription, perhaps in Gentile's hand (it somewhat resembles the fragmentary letters remaining on Mehmed II, cat. 23), narrates the main facts of Caterina Cornaro's life. It begins by celebrating her nobility and virtue, mentioning her claim to be descended from the ancient Roman Cornelii, who included the exemplary Cornelia among their number. By the fifteenth century Caterina's branch of the Venetian Corner or Cornaro family derived their wealth and prestige from their properties and interests on Cyprus.

Aged fourteen, Caterina was betrothed to the island's king, James II. She renounced her surname, and was solemnly adopted by the Venetian Senate as Caterina Veneta, the 'Daughter of Saint Mark'. In 1472 she was sent to her husband and his kingdom. James II's death, followed by that of the couple's infant son, soon left Caterina as Cyprus's monarch, although the real ruler of the island was Venice. In 1489 she was forced to abdicate and to return home while her kingdom was incorporated formally into the Venetian empire. In recompense, this Venetian celebrity was given the hill town of Asolo to rule, where she surrounded herself with a distinguished court, including among its figures Pietro Bembo.

Caterina's rank gave her considerable renown in Venice (she is portrayed using the conventions employed to depict male rulers, such as Doge Loredan, fig. 20). Vasari believed that she had sat for Jacopo Bellini (a mistaken reference to his son Gentile), and Giorgione and Titian were said to have portrayed her. Later historians somewhat exaggerated the significance of this romantic figure. By the nineteenth century many surviving portraits of Renaissance Venetian women were said to be of her. Titian's *Schiavona* (NG 5835), then owned by Herbert Cook, was believed by him to be a Giorgione and – just as earnestly – to represent the Queen of Cyprus.

The two surviving contemporary representations of Caterina Cornaro are both by Gentile Bellini – the present portrait, and the prominent depiction of the Queen and her ladies at the left of *The Miracle at the San Lorenzo Bridge* (see fig. 17). It is difficult to establish the order of their creation, or for whom the present painting was made. However, it is likely that the independent portrait is based on the larger canvas, just as Gentile's profile view of Cardinal Bessarion (in cat. 6) probably derives from earlier studies made for a narrative composition. In both paintings Caterina Cornaro wears the same distinctive costume, conveying her queenly status. Her ensemble of a black overdress and cloth-of-gold underdress does not differ radically from the Venetian norm, although it is regally adorned with gold, rubies and pearls. However, her head is covered with a most un-Venetian black-and-gold cap, embroidered with pseudo-Kufic symbols and an interlaced knot pattern (similar to that found on Veneto-Saracenic metalwork such as cat. 3), crowned with a bejewelled coronet.

An extraordinary aspect of the inscription is its assertion that the painter's hand is more powerful than his subject, because it conveys her greatness in such a small space. Gentile Bellini was renowned among his contemporaries for the high opinion he had of himself. As in his earlier portraits (cats 6 and 23), Gentile condenses characteristic details of Caterina's dress and features to produce a uniquely identifiable representation, like a ruler image on a coin. The transparent veils secured by pearls which protect her face are arranged so intriguingly that they become closely associated with the identity and image of their wearer. For this reason Caterina Cornaro's physical peculiarities – an ample bust, a beaky nose and pursed lips – are also accentuated. The boastful claim that Gentile's brush is mightier than her worldly greatness finds its justification in this, his ability to provide the defining likeness of the celebrated Venetian Cypriot Queen. CC

PROVENANCE
J.L. Pyrker (before 1830); gift of János László Pyrker, Patriarch of Venice, 1836.

SELECTED BIBLIOGRAPHY
Berenson 1894, p. 85; London 1930, no. 291; Gilbert 1961, p. 34; Vasari (1966) 1568, vol. 3, p. 428 (Jacopo Bellini); Pigler 1967, pp. 51–2; Meyer zur Capellen 1985, pp. 68–9, 78–9, 126–7; Brown 1988, pp. 150–1; Pächt 2003, p. 143.

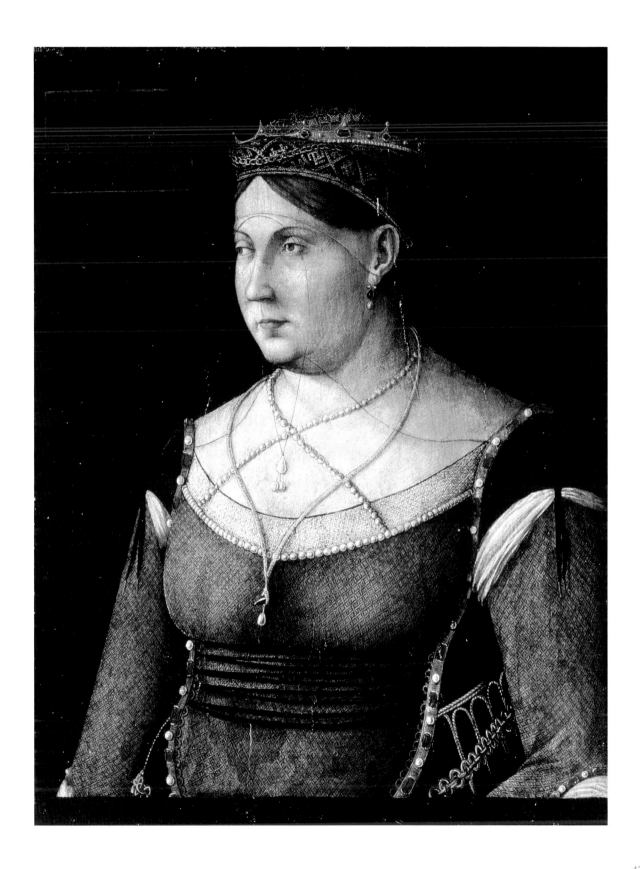

was strongly connected to the international circumstances of his reign. During the twenty years of his Dogate, Venice made substantial territorial concessions to the Turks and lost – temporarily – all her mainland Italian possessions. This is reflected in Giovanni Bellini's portrait, in which Loredan is attired in the mantle of 'white gold' he first wore for the annual procession to Santa Maria Formosa on the Feast of the Purification of the Virgin in February 1503. This robe, in the pure colours associated with Mary, may have been intended as a votive offering imploring her assistance in Venice's peace negotiations with the Ottomans. The continuing military support offered by Venice's Greeks in these trying years enabled them to gain tacit official approval for the performance of their Orthodox faith (technically regarded in Venice as heretical).[53]

Venice, the new Byzantium

Following the victorious Fourth Crusade, Venetians increasingly incorporated Byzantine influences within a western idiom. The great Byzantine Pala d'Oro on the high altar of San Marco was given a European aspect by adding a Gothic frame.[54] The returning conquerors also placed some of their more significant spoils in Venice's main public spaces. The four bronze horses from the Hippodrome in Constantinople were installed on the façade of San Marco (see fig. 16). More Byzantine *spolia*, the porphyry *Tetrarchs* and the Pillars of Acre on the south side of San Marco, were the first sight for important visitors to the city.[55] Within the chapel's treasury were Greek relics, liturgical vessels and icons, memorably described by the chronicler Marin Sanudo as the city's 'jewels'.[56] Among these venerated objects the *Virgin Nikopoios* (fig. 24) had particular resonance. This icon was believed to be the imperial *Virgin Hodegetria*, painted from life by Saint Luke.[57] She was venerated publically twice annually[58] and became the protectoress of Venice, as the Venetians believed she had been of Constantinople.[59] Other ancient icons were also the object of significant parish cults.[60]

By 1500 the loot of war had been joined by the spoils of imperialism. In the late fifteenth century Venice probably housed the greatest concentration of Greek relics in Europe.[61] Among the newest acquisitions, from former Greek territories now under Ottoman control, were Saint Luke's body, which arrived from Bosnia in 1463,[62] and Saint George's head.[63] The Bessarion Reliquary apart, the city contained at least six other reliquaries of the True Cross.[64] Sanudo's *Chronacetta* lists five of them, while singling out the miracle-working cross of the Scuola di San Giovanni Evangelista.[65] The influx of Greeks and sacred Greek objects into their city meant that late fifteenth-century Venetians had a heightened awareness of their historic ties to Byzantium.

Greeks were also drawn to Venice through a certain sense of shared culture. Venice's identity had been shaped by her ability to bridge the Christian civilisations of the eastern Mediterranean, and many of the most characteristic expressions of Venetian governance and culture were combinations of Byzantine and western practice.[66] In ecclesiastical matters she followed Rome, but her most important cleric bore the Orthodox title of Patriarch.[67] The title of Venice's prince, the Doge,

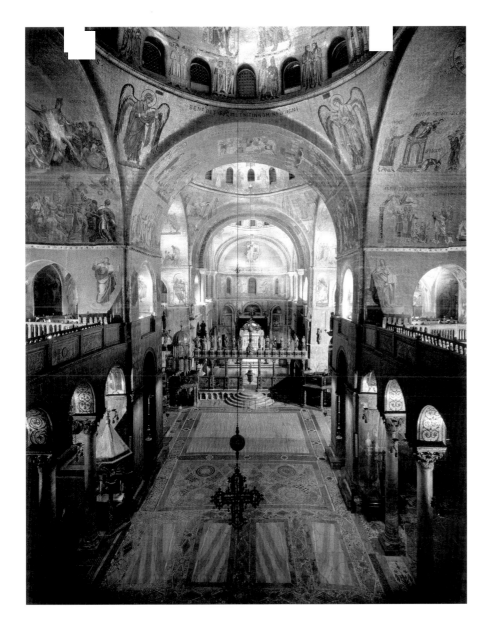

FIG. 22
The Basilica of
San Marco, Venice

was derived from that of the *megadux* of the Byzantine imperial hierarchy.[68] At
the centre of the city and its life was the Basilica of San Marco, the Doge's private
chapel. In the late eleventh century the third building on this site (fig. 22) was
re-built to a cruciform plan with five domes in emulation of the church of the
Holy Apostles in Constantinople, while the marble-clad internal walls were also
indebted to Byzantine precedents, notably Hagia Sophia.[69]

Perhaps the most significant Greek feature of San Marco was its decoration
with mosaics (from the 1070s onwards), which Latin Europeans considered the
archetypal Byzantine art form. The Basilica's floors were covered with complex
geometric pavements, composed of fine stone and marble. The most dazzling
effect was reserved for the church's dome, vaults and façade, which glittered with
mosaic narratives taken from the Bible and the life of Mark, Venice's patron saint.
Combined with the patterned floor, they still appear, at first glance, to give San Marco

9 A Procession before Santa Maria della Carità, probably 1481–96

Pen in brown ink over red chalk on paper, 14.5 × 20.9 cm
Annotated lower left: g 32
Duke of Devonshire Collection, Chatsworth (738)

This drawing is probably the sole surviving autograph work connected with Gentile Bellini's most important commission, the renovation of the narrative paintings in the Great Council Hall of the Doge's Palace. The painting cycle in the council hall had been inaugurated by Guariento da Verona in the late 1360s. It told the history of Doge Sebastiano Ziani's brokerage of peace between the Holy Roman Emperor Frederick Barbarossa and Pope Alexander III in 1177.

By 1474 these fresco paintings had been in poor condition for almost twenty years, and in this year Gentile Bellini's offer to restore and repair them was accepted by the Senate. All fifteenth- and sixteenth-century accounts assert that the cycle of canvases he produced contained Gentile's finest work. Unfortunately it was completely destroyed by a devastating fire in 1577. What remains of his achievement can be partially reconstructed from contractual documents, Francesco Sansovino's 1581 transcription of the accompanying inscriptions, and several drawings, including this sheet and a drawn copy after *The Consignment of the Sword to the Doge* (British Museum, London, P&D 1891-6-17-23).

The drawing at Chatsworth belongs to a campaign of work on the Great Council Hall after Gentile's return to Venice from Constantinople. According to Padre Sebastiano Resta's album notation, the composition represents Pope Alexander III's reception by Doge Ziani outside the Venetian monastery church of Santa Maria della Carità, where the pontiff had spent six months in hiding. In return for shelter,

he had consecrated the church and granted it an indulgence. Every year on 5 April Venetians flocked to the Carità to benefit from this privilege, and the episode had particular significance for both the monastery and the Scuola attached to it.

Like cat. 10, this drawing is concerned with the integration of a large procession within a particular architectural setting. It shares the same stylistic characteristics, notably its execution in pen over some markings in red chalk, and its use of simple geometric shapes to convey bodily forms. The artist has concentrated his attention on rendering the façade of the Carità and a temporary domed canopy under which pontiff and Doge met. Comparison with other views of the Scuola's exterior before its extensive alteration in the late eighteenth and early nineteenth century, such as Canaletto's *The Stonemason's Yard* (National Gallery, London, NG 127), confirms the essential accuracy of Gentile's depiction of this part of the Carità complex (although interestingly Bellini's view is incomplete: the church and its belltower are missing).

Plausibly it was the crucial role played by the Carità monastery in the events of 1177 that encouraged Cardinal Bessarion, the papal legate in Venice, to donate his reliquary cross to its associated confraternity in 1463. Gentile Bellini probably witnessed the procession which accompanied the reliquary's arrival there in 1472. It is tempting to believe that Gentile's depiction of the twelfth-century meeting of Doge and Pope before the Carità, recorded in this drawing, may have been influenced by this contemporary event. CC

PROVENANCE

Padre Sebastiano Resta (1690s, as Giovanni Bellini); sold to John, 1st Baron Somers, by 1710; auctioned in London, 6 May 1717 (lot G18, N13 or Q1); purchased by William, 2nd Duke of Devonshire [mark: Lugt 718].

SELECTED BIBLIOGRAPHY

Somers 1717; Hadeln 1925, pp. 44–5; Venturi 1926, pp. 1–3; London 1930, no. 694; Popham 1931, no. 169 (Carpaccio); Popham 1936, p. 18 (Carpaccio); Tietze and Tietze-Conrat 1944, p. 69; Nottingham and London 1983, no. 57; Meyer zur Capellen 1985, p. 163; Brown 1988, pp. 272–9; London 1993, no. 19; Jaffé 1994, p. 43.

10 The Procession in Piazza San Marco, 1496 or earlier

Pen in brown ink over red chalk on paper, 13 × 19.6 cm
Annotated lower left: g 34
The British Museum, London (P&D 1933-8-3-12)

This slight pen-and-ink sketch – a rapid rendering of the crowds in the Piazza San Marco – is clearly related to Gentile Bellini's finest surviving composition, *The Procession in Piazza San Marco* (fig. 16), part of the cycle made for the Scuola of San Giovanni Evangelista, paintings described by Otto Pächt as 'the most Venetian of all things Venetian'.

Although Popham and Pouncey considered this drawing a copy by Carpaccio after Gentile's monumental canvas, the considerable differences between the two works suggest that Gentile made the drawing in preparation for the painting. The complex painting depicts the annual procession in Piazza San Marco on the feast day of Saint Mark, specifically in 1444 when the Brescian merchant Jacopo de' Salis prostrated himself before the Scuola di San Giovanni's reliquary of the True Cross in the hope that his injured son would be cured.

The drawing is concerned with the broad organisation of space and dimensions within Piazza San Marco, and the integration of people and architecture. The Basilica's five portals are condensed into three. Figural forms are abbreviated into geometric patterns (a technique learnt from the artist's father,

Jacopo Bellini), in a manner comparable to Gentile's other surviving drawing for a narrative painting (cat. 9), as well as a set of architectural studies now in Munich. The ranks of the confraternity members are represented by a succession of thin rectangular shapes, topped by tiny circles, and the canopy covering the True Cross is drawn roughly over them, so that the spatial disposition of these figures relative to the reliquary they carry is correct.

The greatest change lies in the viewpoint of the two compositions. The Campanile looms into the sky in the drawing, while the top border of the painting cuts through the middle dome of Basilica of San Marco. The ink sketch gives a bird's-eye view of the Piazza, centred on the church (indeed Gentile has manipulated the church's position to face down the middle of the square).[1] In contrast, the viewer of the painting seems to see straight into another world that is wholly convincing because not so regularly ordered. This compositional drawing is a reminder of the artifice required to produce such seemingly effortless realistic results. CC

NOTE

1 I am grateful to Deborah Howard for this observation.

PROVENANCE

Padre Sebastiano Resta (1690s as Giovanni Bellini); sold to John, 1st Baron Somers, by 1710; auctioned in London, 6 May 1717 (lot G18, N13 or Q1); anonymous collection; Sotheby's, London, 2 August 1933, lot 58, sold to Colnaghi for the British Museum.

SELECTED BIBLIOGRAPHY

Somers 1717; Popham 1936, p. 18; Tietze and Tietze-Conrat 1944, p. 70; Popham and Pouncey 1950, no. 34 (Carpaccio); Meyer zur Capellen 1985, pp. 164–5; Brown 1988, pp. 149–50; Pächt 2003, pp. 133–5.

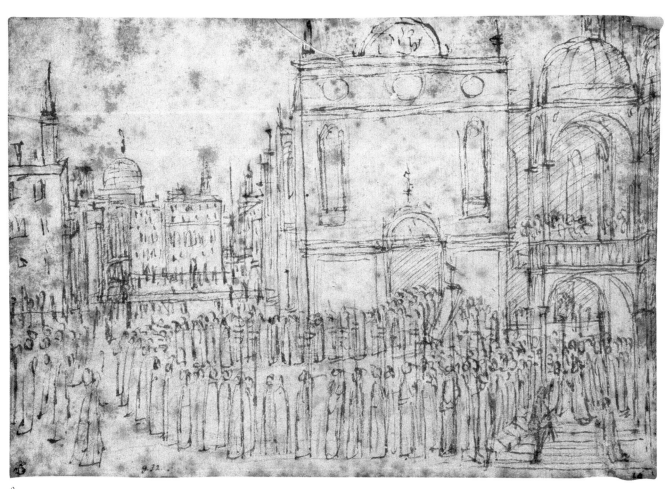

9

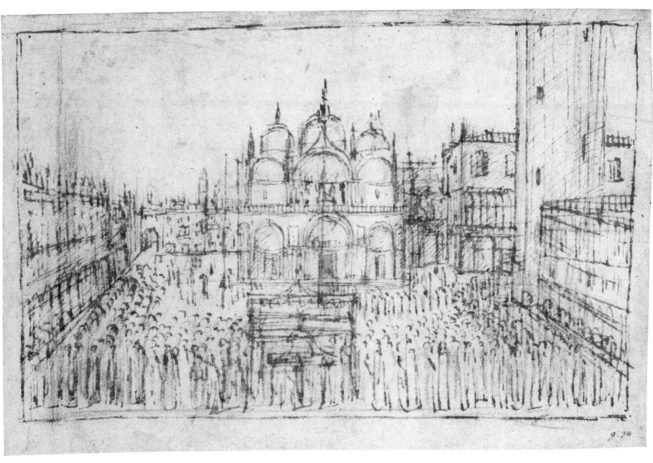

10

a notably uniform Byzantine appearance. But no matter how Greek San Marco might look, it celebrated the Roman Catholic liturgy,[70] and gradually the Byzantine mosaics begun by Greek artisans were Venetianised.[71] A local workshop of Venetians trained in the Byzantine manner took over production in the early twelfth century,[72] and by the mid fifteenth century San Marco's mosaicists worked on the basis of cartoons provided by the city's own painters.[73] The result was that the most Greek of art forms came to look Venetian. In the sixteenth century Titian's civic pride and respect for the Basilica's mosaics led him to propose their wholescale renovation in order to honour the church, and Venice itself.[74]

Painting *alla greca* in fifteenth-century Venice: mosaics and antiquity

The mosaic arts of Byzantium, mediated through San Marco, had a profound impact upon painting in Renaissance Venice. The changing appearance of these refracted glass-and-gold surfaces created one of Venetian painting's defining characteristics, a curiosity concerning the interchange of light and shade on colour.[75] The San Marco mosaics also provided the models for monumental narrative painting in the city.[76] In the late fifteenth century their example would have been most apparent in the redecoration of the Hall of the Great Council in the Doge's Palace, undertaken from 1474 by Gentile and, from 1479, Giovanni Bellini. Although their work was obliterated by a fire in 1577, it is known from verbal descriptions and several related drawings (among them cat. 9).[77] Following the mosaic representations of Saint Mark's relics in the Basilica, the Bellini brothers populated their canvases with living *uomini illustri* (great men) to give their historical subjects greater immediacy.

The paintings of Gentile and Giovanni Bellini suggest that they, unlike Titian, were more interested in San Marco's early fabric than its newer mosaics (despite the fact that their father had been among the first modern painters to supply designs for them).[78] They used the Basilica's medieval structure and decor to give their narrative paintings and altarpieces a sense of sanctity, and of Venice's Byzantine ancestry (cat. 11). Indeed, their interest in Christian antiquity can be connected to their parallel quasi-archaeological investigation (encouraged by their father and their brother-in-law Andrea Mantegna) of the Greek classical world. Just as the Bellini brothers collected Greek sculpture, and used its pure forms in their secular paintings, so they prized Byzantine religious art, including icons and mosaics, because of its historical associations with early Christianity and the Christian Roman Empire founded by Constantine.[79] Three of Giovanni's most important Venetian altarpieces, for the churches of San Giobbe (about 1478–80), the Frari (1488) and San Zaccaria (1505) are set within mosaic-clad apses that consciously recall the internal domes of San Marco.[80] The colours are deep and slightly opaque, evoking the interior of the church, and the mosaics, somewhat blackened by candlesmoke, are illuminated sparingly. In each case the central enthroned figures of the Virgin and her infant Son, themselves echoing the form of the Byzantine *Virgin Hodegetria*, are placed within a curved arched structure glittering with coloured mosaics. The light reflected

from the sacred figural groups on to these fictive glass surfaces surrounds them in a golden aura, reminiscent of the surface of a Byzantine icon.[81]

A fourth altarpiece by Giovanni Bellini (for the church of San Giovanni Crisostomo, dated 1513)[82] responds both to the San Marco mosaics and its own architectural setting within Mauro Codussi's neo-Byzantine church, built on a Greek-cross plan.[83] The sacred participants mirror the shape of the mosaic arch, itself inscribed in Greek.[84] Worshippers in front of Bellini's altarpiece would see in the sacred space before them an imagined continuation of their immediate environment in San Giovanni Crisostomo.[85] The sanctity of both church and altarpiece were increased by their complementary Greekness and antiquity.

Such invocations of Venetian Byzantine locations to convey holiness were adopted by some of the city's younger generation of painters around 1500, including Sebastiano del Piombo and Marco Marziale.[86] Marziale's *Circumcision* in the National Gallery (NG 803), painted in Venice for a Cremonese patron, evokes the mosaics, inscribed arches and small arched windows of San Marco to give his representation of the Temple in Jerusalem an appropriate sacred setting.[87]

Gentile Bellini, San Marco and the Scuole

Perhaps the most consistent use of Saint Mark's Basilica to represent the ancient Christian world can be seen in Gentile Bellini's surviving paintings for the Scuole Grandi. The enormous canvas of *Saint Mark preaching in Alexandria* (fig. 10) for the *albergo* (meeting room) of his own Scuola of San Marco was unfinished at his death, and completed by Giovanni and his workshop following his brother's design.[88] Gentile would have known little of Alexandria's real appearance, and he plundered figuratively Saint Mark's Basilica and its interior for a suitably early Christian locale. The painting's rather two-dimensional narrative structure is based on the San Marco mosaics – antiquated, and therefore ancient. The vast structure looming behind Saint Mark, soon to become a centre for Christian worship, is the temple of the ancient Egyptian goddess Serapis, here modelled on his Venetian church. This appropriation emphasised Mark's prediction that Venice would be his final resting-place, and the hope that Mark's Venetians would re-convert the Alexandrians to Christianity.[89] The figure of Saint Mark, largely the work of Giovanni Bellini, has been criticised for its discordant scale and allegedly clumsy style, but Mark is differentiated from his followers because he is derived from mosaic representations of the saint in the San Pietro and Zen chapels at San Marco.[90]

The contract for *Saint Mark preaching* obliged Gentile to surpass his earlier painting of *The Procession in Piazza San Marco* (fig. 16). This is one of three canvases he produced for the meeting room of the Scuola di San Giovanni Evangelista, narrating the miracles performed by their reliquary of the True Cross.[91] Ostensibly this painting depicts the recovery of a Brescian merchant's son following his father's prayers before the reliquary in the Piazza San Marco.[92] However, the real subject is the crowded square on Saint Mark's Day, one of the key moments of the Venetian calendar, thus demonstrating the importance of the Scuole to their city's life. A surviving compositional drawing (cat. 10) shows that Gentile first intended to give

a bird's-eye view of the Piazza. In contrast the painting, like the thirteenth-century mosaics it portrays, arranges the figures in regular planes before the buildings, so that architecture and people are interrelated rather than integrated. The painting is particularly indebted to the mosaic of *Saint Mark's Body carried into the Basilica* from the Porta Sant'Alipo, the extreme left portal of the church – the one surviving medieval mosaic on the church's façade. Gentile's *Procession* can be interpreted as an expanded reprise of this, which he records in miniature as he does the mosaics over the other portals. The members of the confraternity of San Giovanni Evangelista, seeing themselves represented in Gentile's painting, would be heartened by this connection of their activities to the return of Saint Mark's relics from Alexandria to Venice, the sacred legend at the heart of Venice's life. Gentile's picture would also have given them the impression that their Greek reliquary cross was almost as worthy of veneration as Saint Mark's miraculous body in the Basilica.

Gentile's interpretation of San Marco in this painting is related to his earlier evocation of Bessarion's Reliquary (cat. 6). At first glance Gentile's representation of both looks almost photographic: the viewer is convinced that the reliquary, down to even the smallest details of its metalwork and inscriptions, has been reproduced accurately. Similarly, the impression of the Basilica's façade is so convincing that it has been used as evidence for its unrestored appearance. However, Otto Demus's detailed comparison of the one surviving mosaic with Gentile's painting has demonstrated that it conveys the broad outlines of the composition and narrative, but misses out details and transcribes all the inscriptions incorrectly.[93] As in his 'portrait' of the Bessarion Reliquary, Gentile used a sketchy brush, strong outlines

FIG. 23
Attributed to Nicolò Zafuris (dead by 1501)
in part after Giovanni Bellini
The Lamentation Triptych, about 1490
Tempera on wood, 24.6 × 47 cm (open)
The State Hermitage Museum,
St Petersburg (1-364)

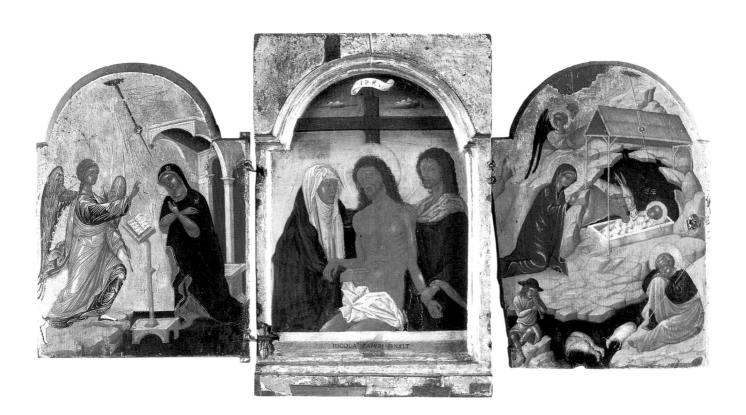

and abbreviated forms to condense the essential elements of the mosaic façade through a Venetian lens. His depictions of the reliquary and Saint Mark's Basilica meld what he would have seen as ancient Greek form with modern Venetian technique to create a true Veneto-Byzantine hybrid.

The living Veneto-Byzantine style

The traditional narrative of Italian art tells how painters from Cimabue onwards shook off the repressive shackles of Greek pictorial formulae and developed expressive, individualised styles.[94] However, numerous works of art continued to be produced in the traditional Byzantine manner in Venetian territory during the fifteenth and sixteenth centuries. The term 'Veneto-Byzantine' was invented to describe the largest category of these, the mass-produced icons of the so-called *madonneri* (Madonna painters), which combine Venetian and Byzantine styles and iconography.[95] Such paintings were a familiar part of life in Venice and her domains, recorded in contemporary inventories, and represented in late fifteenth- and early sixteenth-century portrayals of domestic interiors.[96] Their iconographic descent from ancient icons often attributed to Saint Luke himself gave them a sacred value far beyond their variable pictorial quality and monetary worth. But 'Veneto-Byzantine', like the parallel term 'Veneto-Saracenic' used for metalwork (see above, p. 27), has fallen out of favour, as a consequence of recent research which to date has unearthed only three Greek painters active in Venice between 1300 and 1509.[97] Furthermore these investigations have indicated the true scale of the icon trade between the Venetian colonies, especially Crete, and the mother city.[98] Now most, if not all, modern scholars would agree that the vast majority of Veneto-Byzantine paintings were made in Crete.[99]

However, this fact should not discredit what remains a useful term. A famous group of contracts from 1499 between two merchants (one from Venice, the other from the Morea) and several Cretan painters refer to the shipment of 700 icons in terms familiar from contemporary inventories and critical literature – five hundred 'in forma alla latina', or the western style, the remainder 'in forma alla greca', or Byzantine in appearance.[100] There was a steady demand in late-fifteenth-century Venice for such devotional paintings by artists able to work in both the Venetian and Greek manners. The Cretan painter who was probably responsible for the passion scenes surrounding the Bessarion Reliquary (see cats 5–6) executed them in the metropolitan style associated with the fourteenth-century 'Palaiologan Renaissance', but followed a western iconographic tradition. In the 1490s another Cretan painter, Nicolò Zafuris (or Nikolaos Tzafouris) synthesised Venetian and Byzantine styles in a small portable triptych now in St Petersburg (fig. 23), signed in Latin.[101] The *Pietà* of the central panel is derived from a painting by Giovanni Bellini now in Berlin.[102] One wing depicts *The Annunciation*, after a fourteenth-century western model, but the other represents *The Nativity* in the western fashion with a landscape background in the *maniera greca*.[103] Zafuris united his different sources using an identifiable two-dimensional style and a muted brownish colour range very typical of the late fifteenth-century Cretan school.

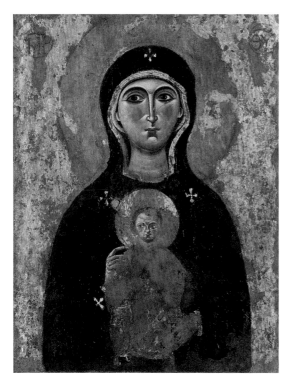

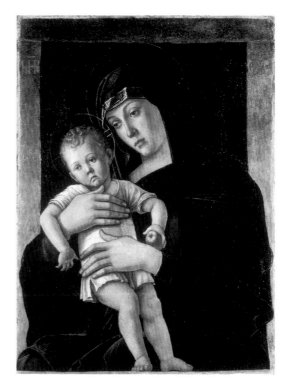

FIG. 24
Byzantine
Virgin Nikopoios, 11th century
Tempera and gold on wood, 48 × 36 cm
The Basilica of San Marco, Venice

FIG. 25
Giovanni Bellini (about 1431/6–1516)
Madonna Greca, about 1460
Oil on wood, 82 × 62 cm
Pinacoteca di Brera, Milan

Although Zafuris's 'hybrid' manner is most often associated with Cretan painting, this word, derived from post-colonial studies, can also be applied to some of Gentile and Giovanni Bellini's œuvre. Both were capable of working in a Byzantine manner, and it is notable that during Gentile's sojourn in Constantinople the Sultan is said to have asked him to make a '*parvam ymaginem*' (small image) of the Virgin and Child more beautiful than one he already owned, presumably a Byzantine icon.[104] However while Zafuris and his peers in Crete incorporated Latin elements into their work to increase its potential market, Greek examples influenced the Bellini brothers because of the close associations they made between Byzantine art and sanctity. This could be manifested in pictorial style and iconography. The deeper yellow and reduced colour contrasts found in Giovanni Bellini's later religious paintings such as the San Zaccaria Altarpiece are indebted to the tonality of works like Zafuris's St Petersburg triptych or the *Madre della Consolazione* (cat. 13) by one of Zafuris's followers.[105]

But Greek inspiration is most apparent in the small devotional paintings, mainly half-length images of the Virgin and Child, which were such a speciality of Giovanni Bellini and his school.[106] Like all western representations of the Madonna and the infant Jesus, these works were indebted ultimately to Byzantine icons such as the *Virgin Nikopoios* in San Marco (fig. 24), which, as paintings attributed to the Evangelist Luke, were venerated for their proximity to the historical figure of Christ. The typology of Giovanni Bellini's small Virgins reveals the strong impact of

Byzantine forms. Even representations of the Madonna by Giovanni and his shop that do not obviously follow a Greek model reveal Byzantine influence. Their facial characteristics – high cheeks almost level with the eyes, an elongated nose, large eyes and narrow lips – recall icons like the *Virgin Nikopoios*. As significant as the direct quotation of specific motifs is their contemplative mood. Like Byzantine representations of the Virgin, many of Giovanni Bellini's Madonnas are either set in a plain background, or, like the *Madonna of the Meadow* in the National Gallery (NG 599), separated from it. Their isolation on the painted surface reflects their sense of psychological separation from the world.

Several of these paintings are so closely connected to Byzantine icons that it is hard to separate them from the conflations of Eastern and Western Christian religious art produced by contemporary Byzantine trained painters such as Nicolò Zafuris. The term Veneto-Byzantine seems appropriate to characterise these works, which are in a Venetian style but derive most of their spiritual power from their association with Greek religious art. One of these, the so-called *Madonna Greca* (fig. 25), which represents the Eleousa, or Compassionate Virgin, or compassionate, with her face tenderly inclined towards that of her son, is inscribed with the Greek letters for 'Mother of God'.[107] Giovanni Bellini's *Virgin and Child* (cat. 12) in Oxford is a derivation of the same iconographic type, which was extremely popular in late Byzantine and post-Byzantine art. This tiny panel painting is approximately the same size as many Cretan icons of the same date, and it is not clear what devotional distinction – if any – would have existed between it and Cretan works like the Latin-inspired but Byzantine-looking *Madre della Consolazione* (cat. 13).

> After all this, how could I better dispose of this gift than amongst those to whom I was myself most tightly bound by their many gifts to me: than in the city which I had chosen as my new home when Greece was enslaved and where I had been welcomed and acclaimed by you with such honour.[108]

Bessarion's description of the bonds of friendship and affinity which led him to donate his library to the Procurators of Saint Mark can also be applied to his gift to the Scuola della Carità. These ties were reciprocal: Bessarion and the reliquary were 'welcomed and acclaimed' by the city with honour. Just as Bessarion's Reliquary became part of Venice, so Gentile's rendering of it became part of the long creative interaction between the Byzantine Empire and Venice, which made an enduring contribution to Venetian painterly production, not simply to the work of Paolo Veneziano, El Greco and their contemporaries. In the late fifteenth century the intersection of respect for Byzantium's sacred legacy with international power politics made Venetian painters particularly conscious of their past and present ties to Greece. Artists of every quality responded to this, from anonymous Cretan and Venetian producers of Madonnas to the Republic's leading painters, Gentile and Giovanni Bellini. In art as in politics, Bessarion's Venice was 'almost another Byzantium'.[109]

11 The Virgin and Child Enthroned, about 1480

Oil on wood, 121.9 × 82.5 cm
Inscribed: OPVS.GENTILIS.BELLINI.VENETI.EQVITIS
(The work of Gentile Bellini the Venetian, Knight)
The National Gallery, London (NG 3911)

This imposing Virgin and Child, the most commonly represented theme in Renaissance art, is one of only two paintings of the subject among Gentile Bellini's surviving work. The relatively large dimensions of this full-length depiction suggest that it may have been the central panel of a polyptych, and it has been connected with a lost altarpiece for the Scuola dei Merciai in Venice. The presence of the artist's signature at the foot of the steps before Mary's throne, where it could be best seen in a church or chapel, adds credence to this hypothesis. The painting must postdate Gentile Bellini's first knighthood (1469); stylistically it most closely resembles works of around 1480 such as cats 23 and 32.

The Virgin and Child Enthroned is remarkable chiefly not for its iconography, but for the convincing representation of its architectural and decorative elements, one of Gentile Bellini's most striking characteristics as a painter. This can be seen in the application of textured strokes of paint to show the surface effects of the cut and polished insets of precious stone adorning the Virgin's throne and is most evident in the Virgin's mantle of rich red voided velvet, woven on a cloth-of-gold ground. The raised velvet pile seems to have been painted with thicker and repeatedly applied brushstrokes, so that it appears to stand slightly proud of the surface, like the material it depicts.

These details reflect Christianity's eastern Mediterranean origins, as well as Venice's historical ties with Byzantium, and the extensive trade in luxury goods between the city and the eastern Mediterranean during the fifteenth century. The ornamentation of the niched throne with decorative panels of coloured marble and porphyry recalls the adornment of Roman and Byzantine ecclesiastic and imperial buildings, which was adopted in several Venetian churches, particularly San Marco and Santa Maria dei Miracoli (begun 1481). The façade of the Ca' Dario, the palace of the Venetian secretary Giovanni Dario who concluded the 1479 peace treaty with Mehmed II, provides a secular parallel. A more specific source for Gentile's throne could be the celebrated stone chair, long believed to be Saint Peter's (actually a reworking of an Islamic funeral stele), which had been brought from Antioch to the Venetian cathedral church of San Pietro di Castello by the late twelfth century. (Its earlier state is recorded in a fine coloured drawing by the architect John Talman (1677–1726) belonging to the Society of Antiquaries, London.)

The Virgin's mantle is covered with a pattern resembling a pinecone, derived from the pomegranate design regularly found on Renaissance Italian decorative cloth (itself descended from oriental textiles). By the late fifteenth century fabrics like that worn by Gentile's *Virgin*, and Giovanni Bellini's *Doge Loredan* (fig. 20) were being exported, and were copied in Turkey (compare the decoration of the robe of the *Seated Scribe*, cat. 32). The Western Anatolian prayer-mat, the top of which can just be glimpsed under Mary's feet, travelled this route in reverse. These 'mosque carpets' appear to have been first produced in the mid fifteenth century for the ritual of praying five times a day in the direction of Mecca. They are recorded soon after in Italian inventories, such as that drawn up of the estate of Francesco Gonzaga in 1483. The carpet represented here is decorated with a niche, symbolising both the *mihrab*, or niche, in mosques that shows the direction of Mecca, and the doorway to paradise. The unusual patterning of the decorative border is found in several surviving carpets (sometimes called 'Bellini' carpets, after a representation of a whole such carpet in a group portrait of Doge Loredan with four magistrates by Giovanni Bellini and workshop in the Staatliche Museen, Berlin). Carpets, which were highly valued, were normally displayed on tables or walls, and the careful placing of the prayer-mat underneath Mary's feet draws further attention to the spiritual rank of the Mother of God. CC

PROVENANCE

Probably with Paolo Fabris, Venice, in 1857; purchased by Sir Charles Eastlake between 1855–65; to Lady Eastlake; auctioned 2 June 1894 (lot 59); bought by J. P. Richter for Ludwig Mond; Mond Bequest, 1924.

SELECTED BIBLIOGRAPHY

Richter 1910, pp. 97–101; Berenson 1957, p. 28; Davies 1961, pp. 49–50; Meyer zur Capellen 1985, p. 128; Mills 1991, p. 90; Dunkerton et al. 1990, pp. 44–5; Baker and Henry 2001, p. 27; Mack 2002, pp. 82–4; Pächt 2003, pp. 145–6.

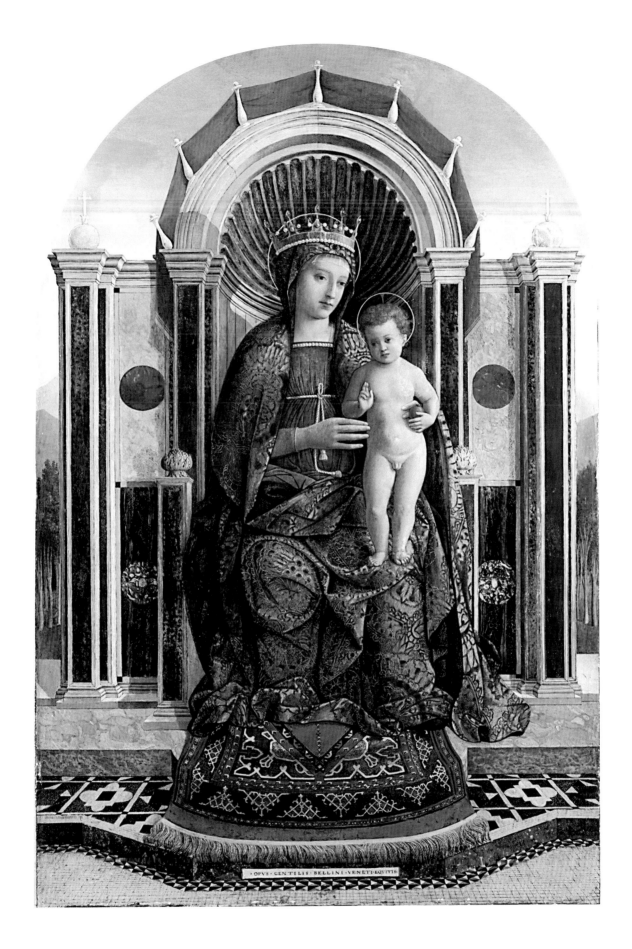

GIOVANNI BELLINI (about 1431/6 – about 1516)

12 *The Virgin and Child, about 1470*

Oil and gold on wood, 33.5 × 27.2 cm
The Ashmolean Museum, Oxford (A1145; WA 1987.26)

The attribution of this little-known panel to Giovanni Bellini has been questioned, principally because of its condition. However, its powerful infusion of a Byzantine iconic model with naturalism is very reminiscent of several of Giovanni Bellini's securely attributed 'Grecian' Madonnas, such as the *Madonna Greca* in the Brera (fig. 25) and the *Virgin and Child* (National Gallery of Art, Washington). As in these paintings, the Byzantine feel of the Ashmolean Madonna is derived as much from the contemplative mood it evokes as from its quotation of specific motifs. The figural grouping of the Virgin and Child derives from one of the most common variants of the Byzantine icon, the Eleousa, or Compassionate Virgin. Following this typology, the Virgin's oval eyes are lowered, as if meditating on her infant Son's fate. She tenderly inclines her cheek towards the Christ Child, both to restrain him and clasp him more deeply towards her.

This painting's ancestry is not generically Byzantine, but is specifically indebted to late Byzantine icons, in particular those produced on contemporary Crete. The picture's modest scale and muted colours, especially the Virgin's purple-cinnamon

mantle, are reminiscent of the Cretan paintings that were exported to Venice in large quantities in the fifteenth and sixteenth centuries. In addition, they shared broadly equivalent private devotional functions.

Like many of these Cretan icons, Giovanni Bellini's *Virgin and Child* conflates the Virgin Eleousa with the iconographic type of the *Madre della Consolazione* (see cat. 13), in which Christ's Passion is presaged. The addition of an active and unruly Christ Child, surely related to studies from life (such as a drawing from Giovanni Bellini's workshop also in the Ashmolean Museum, PII.2), to the painting makes this Venetian icon as much a hybrid object as its Cretan counterparts.

The Ashmolean Madonna suffered from an insensitive restoration in the early twentieth century. The monochrome background was gilded to enhance its Byzantine appearance, while Christ's damaged right hand was replaced with a strange three-fingered claw. It remains a moving document of Giovanni's ability to meld Greek and Latin forms and iconography into a convincing image. CC

PROVENANCE

Portalupi, Verona; J. P. Richter; Ludwig Mond, London (1930); Lord Melchett, Melchet Court, Hampshire (1932); Kenneth Clark, later Lord Clark of Saltwood, Saltwood Castle (1957); accepted by H. M. Government in lieu of inheritance tax and allocated to the Ashmolean Museum, 1987.

SELECTED BIBLIOGRAPHY

Berenson 1932, p. 73 (Giovanni, before 1480); Berenson 1957, p. 34 (Giovanni, before 1480); Heinemann 1962, vol. I, p. 1 (with seventeenth-century restoration; influenced by Mantegna); Ghiotto and Pignatti 1969, no. 29 (Giovanni); Tempestini 1992, no. 28 (Giovanni); Harrison et al. 2004, p. 12 (Giovanni, but insensitively restored).

13 *Madre della Consolazione,*
first half of the 16th century

Tempera on wood, 35 × 27 cm
The British Museum, London,
Department of Prehistory and Europe (MLA 1994, 1-2,6)

Inscribed on the Virgin's left hand side: [...] ΘΥ [for ΜΗΤΗΡ ΘΕΟΥ (Mother of God)].
Above Christ's head: ΙϹ ΧϹ
On Christ's open scroll: ΠΝΕΥΜΑ ΚΥΡΙΟΥ ΕΠ ΕΜΕ, ΟΥ ΕΙΝΕΚΕΝ ΕΧΡΙΣΕ ΜΕ (The spirit of the Lord is upon me, because he hath anointed me.) Luke 4: 18, repeated from Isaiah 61: 1

This type of Virgin and Child icon is known as the *Madre della Consolazione,* after – but only loosely based on – a fifteenth-century Italian frescoed icon in the church of Santa Maria della Consolazione in Rome. The acclaimed post-Byzantine Cretan painter Nicolò Zafuris (dead by 1501) is credited with the introduction of the type to Crete in the late fifteenth century. The island, which had been under Venetian rule since 1211, was by that time experiencing a very fertile cross-cultural interaction between its ethnically and religiously different inhabitants, the native Greek Orthodox and the Roman Catholic Venetians. This interaction resulted in a hybrid society highly receptive to elements of both cultures. A substantial number of Cretan works produced during the post-Byzantine period, such as representations of the *Madre della Consolazione,* clearly reflect this fusion.

The gentle touch of the Child's knee by the Virgin, her seemingly downcast yet aloof expression, his diaphanous undergarment and the open scroll in his hand are iconographic elements rooted in Byzantine art. At the same time the decorative patterns on the Christ Child's *chiton* (or tunic) are inspired by fabrics and paintings of the Italian Trecento. Similarly, the brooch fastening the Virgin's *maphorion* (head-scarf) in front of her chest is a common element of western attire, and her kerchief, visible beneath it, while never forming part of the Virgin's head cover in Byzantine art, is often used in Italian representations of the Virgin. The combination of Byzantine and western elements made this type of icon equally appealing to its two clienteles: it was frequently reproduced and exported from Crete to Italy and Flanders, and remained popular until the seventeenth century. AL

PROVENANCE
Temple Gallery, London; Guy Holford Dixon JP; given to The National Gallery, London; transferred to the British Museum.

SELECTED BIBLIOGRAPHY
Lymberopoulou 2003.

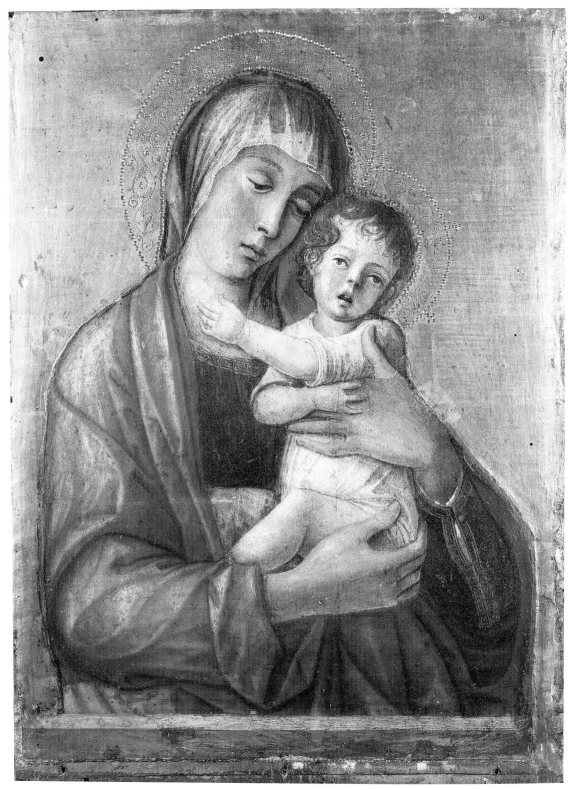

12

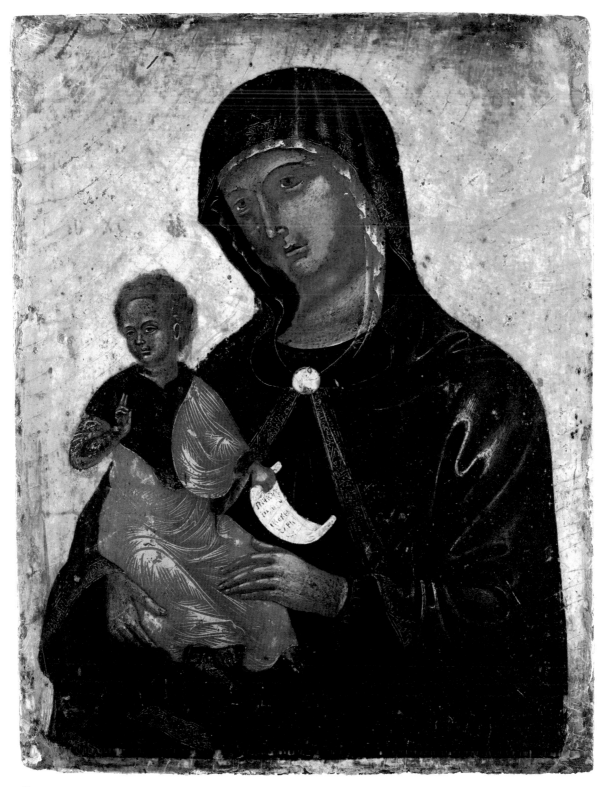

13

Italian Images of Mehmed the Conqueror

14 *El Gran Turco*, about 1470

Engraving, 24.5 × 19.7 cm (plate), 27.8 × 19.9 cm (sheet)
Inscribed lower right: EL GRAN TURCO
Staatliche Museen zu Berlin, Kupferstichkabinett (140-1879)

FIG. 26
Pisanello (about 1395–1455)
Medal of Emperor John VIII Palaiologos, 1438–9
Bronze, diameter 10.3 cm
The British Museum, London (GIII, Naples 9)

This engraving, which survives in only two impressions, is an allegorical portrait of Mehmed II. Captioned 'the Great Turk', the common epithet for the Sultan, the image is not an accurate record of the Sultan's face or attire, but a *capriccio* partly based on the features of the Byzantine Emperor John VIII Palaiologos, who in 1438 or 1439 was portrayed in a medal by Pisanello (fig. 26) and in a bronze bust attributed to Filarete or Donatello (Vatican Museums).[1] However, this print is not a slavish copy of these images, for Mehmed II has been given a richly patterned garment edged in pearls and an even more elaborate tooled helmet topped by a fanciful shell from which a dragon springs. The face and beard are subtly distinct from the visage of John VIII, perhaps in response to the verbal descriptions of the young Sultan. Although Hind and Weiss have claimed that the engraver could not read the Greek inscription on Pisanello's medal and therefore simply mistook the portrait for Mehmed, the print is more complex. In the absence of the Sultan's portrait from the life, *El Gran Turco* was based on the features of a famous predecessor. The print in turn inspired several later images, including a maiolica jar (fig. 27).

Helmets decorated with dragons similar to that seen here appeared frequently in Florentine art during the 1470s and 1480s, not only in other engravings of profile heads (Hind A.I.55-57), but also, for example, in a marble relief depicting Alexander produced by Andrea del Verrocchio's workshop (National Gallery of Art, Washington).[2] Because of these various contexts, the dragon helmet probably did not refer intrinsically to Alexander, nor does it seem likely that it symbolised the Turkish menace, although such imagery was sometimes employed in contemporary literature.[3] Nothing in this impressive engraving suggests that it was intended to condemn or ridicule its subject. Moreover, real parade armour featured almost identical dragon crests, as demonstrated in a fifteenth-century Tuscan example with a winged dragon (Museo Medioevale, Arezzo).[4] The dragon appears to have been a more general evocation of chivalric triumph over evil. Embellishing the helmet in the print, it symbolises Mehmed II's role as warrior.

Hind thought that the engraving was made about 1460 by the anonymous Florentine engraver known as the Master of

FIG. 27
Florentine
Storage jar with *El Gran Turco*, about 1470–80
Maiolica, height 26.2 cm, lip diameter 11.3 cm
The British Museum, London (P&E 1906.4-18.1)

given or sold to Mehmed II himself, since the engravings were pasted into an album now in the Topkapı Palace along with two portraits of the Sultan (see figs 34–5). An Italian merchant in Istanbul may have been the source of the prints.

What could possibly have motivated a visiting Italian to present Mehmed II with *El Gran Turco*, and what would the Sultan have made of such a fantasy? Mehmed's fascination with European culture generally and portraiture in particular must have been well enough known that the gift would not have risked offence. Indeed at this very moment Mehmed was seeking Italian portraits of himself. In 1461 he asked the medallist and painter Matteo de' Pasti to come to Istanbul, an invitation later repeated to Naples, Venice and Florence.

AC

the Vienna Passion, perhaps after a design by Antonio del Pollaiuolo. The print is clearly by the Master of the Vienna Passion, as more recently confirmed by Oberhuber, Zucker and others, but the design has little connection with Antonio del Pollaiuolo's known work, except perhaps for general similarities to the decorative helmet and costume found in the painting *Archangel Michael* (Museo Bardini, Florence). A similar helmet can also be seen in a drawing associated with the Pollaiuolo workshop (Uffizi, Florence, 2299F) and, in addition, in 1472 the Florentine government ordered from Pollaiuolo a presentation helmet of gilded silver and enamel surmounted by a figure of Hercules with a griffin.[5]

The one other surviving impression of the print (fig. 28), though less well-preserved, was coloured soon after it was made. Along with fourteen other Italian engravings of the period (some coloured by the same hand), it was apparently

NOTES

1 New York 2004, no. 320.
2 Butterfield 1997, pp. 156–7, no. 25. The commission dates from the mid-1480s. A soldier in Verrocchio's *Beheading of John the Baptist* of 1478 on the Silver Altar (Museo dell'Opera del Duomo, Florence) also wears a dragon helmet.
3 Raby 2000, p. 64, notes that Felice Feliciano in the 1460s used the dragon or basilisk to symbolise Turkish iniquity.
4 Syson and Gordon 2001, p. 65.
5 Ettlinger 1978, p. 168. For the drawing, see Ortolani 1948, p. 222, fig. 59.

SELECTED BIBLIOGRAPHY

Lippmann 1881; Hind 1910, pp. 18–19; Hind 1938, no. D.I.5; Ortolani 1948, p. 222; Weiss 1966, p. 27; Oberhuber in Washington 1973, pp. 20, 65; Meyer zur Capellen 1983, p. 209; Berlin 1989, no. 5/16; Zucker 1993, pp. 68–70; Landau and Parshall 1994, p. 94; Dresden 1995, no. 2; Kafescioğlu 1996, p. 250; Raby 2000, p. 64; Spinale 2003, pp. 99–110; Wright 2005, pp. 129, 513 (after Antonio del Pollaiuolo).

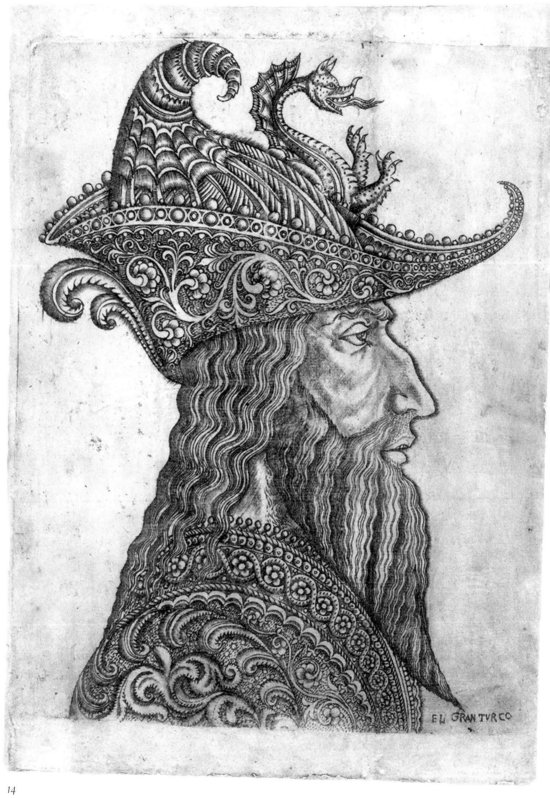

14

FIG. 28
Master of the Vienna Passion
El Gran Turco, about 1470
Engraving with watercolour, 24.9 × 18.7 cm (sheet)
Topkapı Palace Museum, Istanbul (H2153, fol.144r)

15 *Medal of Mehmed II as a Young Man,
1460s or 1470s?*

Inscribed (obverse): MAGNUS & ADMIRATUS SOLDANUS
MACOMET BEI (Great and Admired Sultan Mehmed Bey)
Bronze, diameter 6.1 cm
The Ashmolean Museum, Oxford (HCR 177)

This unsigned medal is one of the earliest known portrait medals of Mehmed II. The encomiastic Latin inscription, even while addressing the Sultan with titles then used for diplomatic correspondence, would seem to feature, in the word '*admiratus*', a naive misinterpretation of the indigenous Ottoman title *amir*. In addition, formal details of the portrait suggest that the medal was designed with limited knowledge of Mehmed's actual appearance. The fleshy, blandly rendered facial features bear little resemblance to the one contemporary medal or to the several later portraits of the Sultan, both medallic and painted, that seem to be based on life studies. The raised cap and turban are unrecognisable as an authentic form of Muslim (let alone specifically Ottoman) headgear of the period, and the authenticity of the epaulet is also doubtful. It more closely resembles those on robes worn by contemporary Venetian doges than Ottoman ceremonial caftans.

Despite the inaccuracies of the portrait, the iconography of the reverse parallels the rhetoric of universal rule cultivated at Mehmed's court from the onset of his sultanate. The motif of a nude male figure holding a victory torch and reclining in a rocky landscape was first employed by Pisanello for the elegant reverse of a medal he designed in about 1441 for Leonello d'Este, Duke of Ferrara. Pisanello's figure is believed to reinterpret a Roman statue then thought to represent Bacchus, and associated with Alexander the Great by virtue of their (mythological and actual) conquests of India. In emulating this prestigious model, the present medal promotes the association of Alexander with Mehmed II, whose careful self-identification with the ancient empire-builder was widely known in Italy. The emblematic reverse refers not only to the Sultan's military victories, but also to his literary studies of Alexander and documented appreciation of the visual idioms of western antiquity. The medallist was probably a follower of Pisanello, perhaps Marco Guidizani, who was active in the 1460s and 1470s in Venice. It is unlikely that the medal was commissioned by Mehmed himself. SS

SELECTED BIBLIOGRAPHY

Karabacek 1918, pp. 13–16; Hill 1930, no. 1201 (Venice or Ferrara); Raby 1987, pp. 173–5; Raby in Istanbul 2000, no. 3; Spinale 2003, no. 2 (attr. Marco Guidizani); Spinale 2003a (Venice or Ferrara).

16 *Medal of Mehmed II, probably 1478*

Inscribed (obverse): *SUITANUS MOHAMETH OTHOMANUS TURCORUM IMPERATOR* (Ottoman Sultan Mehmed, Emperor of the Turks)
Inscribed (reverse): *HIC BELLI FULMEN POPULOS PROSTRAVIT ET URBES / CONST/ANTIUS F*
(This man, the thunderbolt of war, has laid low peoples and cities. Constantius made it)
Bronze, diameter 12.3 cm
National Gallery of Art, Washington, DC
Samuel H. Kress Collection (1957.14.695)

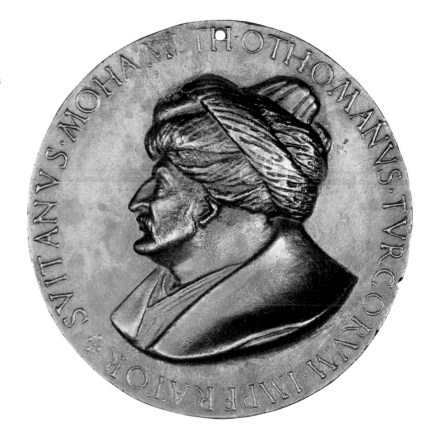

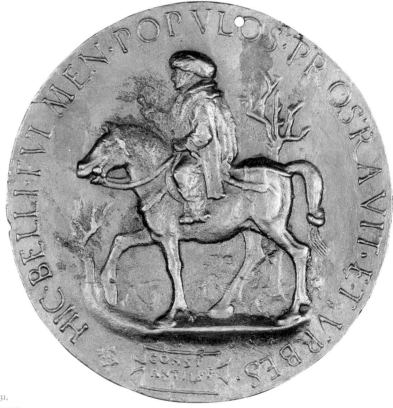

PROVENANCE

Gustave Dreyfus, Paris (probably by 1879, died 1914); sold in 1930 by his heirs to Joseph Duveen, London; the Samuel H. Kress Foundation, New York, 1945; presented to the museum in 1957.

SELECTED BIBLIOGRAPHY

Armand 1879, p. 53; Armand 1883, p. 79; Heiss 1885, pp. 81–2; Karabacek 1918, pp. 22–5; Hill 1926, pp. 288–9; Hill 1930, no. 321; Hill 1931, no. 102; Hill and Pollard 1967, no. 102; Raby 1987, pp. 176–8; Washington 1991, no. 107; New York 1994, no. 21; Spinale 2003, no. 3; New York 2004, no. 322A.

17, 18 *Medal of Mehmed II, 1481*

Inscribed (obverse): *SULTANI MOHAMMETH OCTHOMANI UGULI BIZANTII INPERATORIS 1481* (Of Sultan Mehmed, descendant of Osman, Emperor of Byzantium, 1481)
Inscribed (reverse): *MOHAMETH ASIE ET GRETIE INPERATORIS YMAGO EQUESTRIS IN EXERCITUS / OPUS / CONSTANTII* (Equestrian image of Mehmed, Emperor of Asia and Greece, on campaign. Work of Costanzo)

CAT. 17: Bronze, diameter 12 cm
Victoria and Albert Museum, London (A.208-1910)

CAT. 18: Bronze, diameter 11.9 cm
The Ashmolean Museum, Oxford (HCR)

Costanzo di Moysis (or Costanzo de Ferrara) produced one of the most compelling medallic portraits of the fifteenth century, yet he remains an elusive figure. King Ferrante I of Naples is reported to have sent him to Istanbul in response to Mehmed II's request for a painter. The exact date of his sojourn, whether around 1467 or in 1478, remains unclear (see further p. 127). A signed medal by Costanzo of Mehmed II survives in a unique cast in Washington (cat. 16); a second version, dated 1481, is known in several versions (cats 17 and 18). Like Gentile's cast (cats 19 and 20), these represent the artist's only known foray into making medals.

The Washington medal is best understood as a direct product of Ottoman patronage. Casting flaws on both sides suggest the Sultan pressed into service an artist inexperienced in the technique, Costanzo's ability to translate two-dimensional studies into a sculpted portrait notwithstanding. Rigorously classical in style and syntax, the Latin inscriptions describe in

unequivocal terms Mehmed's sovereign status and his prowess in war. To the medal's European viewers the combination of a naturalistic profile, Latin legends, imperial titles and canonical equestrian image, each firmly grounded in the visual idioms of western antiquity, would have acted as painful reminders of the Sultan's quest to add Italy to his empire.

The year of Mehmed's death, 1481, appears directly above his regal profile suggesting that the medal was intended to be posthumously commemorative. The reverse inscription has been made comparatively less menacing, although it is no less accurate. The title 'Emperor of Asia and Greece' reflects the rhetoric of power at Mehmed's court, and the epithet 'descendant of Osman' on the obverse, knowledge of Ottoman dynastic titulature. It remains a matter of conjecture whether Costanzo produced this medal after his return to Italy on commission or independently with an eye towards the Italian market for images of the 'Great Turk'. ss

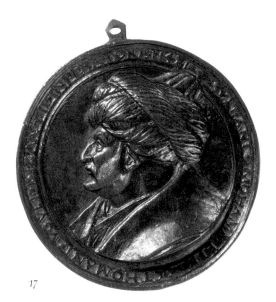

17

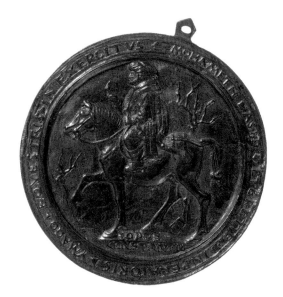

SELECTED BIBLIOGRAPHY

Trésor de numismatique 1834, p. 16; Armand 1883, p. 78; Karabacek 1918, pp. 21–5; Hill 1926, p. 288; Hill 1930, no. 322; Raby 1987, pp. 176–8; Raby in Istanbul 2000, no. 6; Spinale 2003, no. 4; London 2005, no. 225.

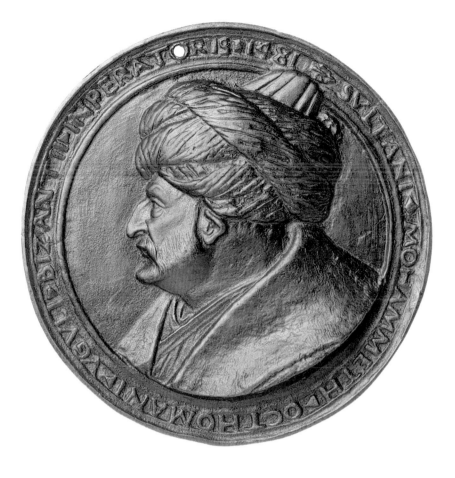

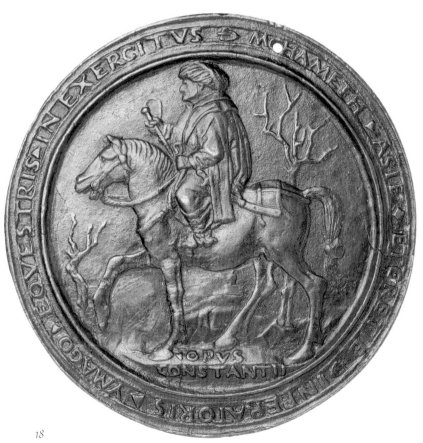

19, 20 *Medal of Mehmed II, about 1480*

Inscribed (obverse): *MAGNI SOULTANI MOHAMETI IMPERATORIS*
(Of great Sultan Mehmed, Emperor)
Inscribed (reverse): *GENTILIS BELLINUS VENETUS EQUES*
AURATUS COMES.Q. PALATINUS F (Gentile Bellini, Venetian,
Golden Knight and palace companion [or 'Count Palatine'], made it.)

CAT. 19: Bronze, diameter 9.4 cm (second state)
The Ashmolean Museum, Oxford (HCR)

CAT. 20: Bronze, diameter 9.4 cm (first state)
Victoria and Albert Museum, London (A207-1910)

Gentile's medal of the sultan is distinctive for the comparatively spare detail of the obverse and the artist's prolonged signature on the reverse. The latter inscription frames the emblem Bellini incorporated into his painted portrait of Mehmed (cat. 23), namely three stacked crowns symbolising the rival powers vanquished during Mehmed's rule. The artist's expansive signature may represent his competitive response to the medals of the Sultan signed by Costanzo di Moysis and Bertoldo di Giovanni, respectively (cats 17, 18; 21, 22). Although the chronology of the artists' medals remains uncertain, it seems likely that Gentile designed his medal after returning from Istanbul in early 1481 as a response to

the demand for images of the Sultan after his death the same year. Western interest in Mehmed and the Ottoman dynasty remained high, fed by the vicissitudes of war and fostered by texts published in several languages which described Ottoman customs and rule. Numerous contemporary casts of the three artists' medals of Mehmed survive.

Despite the economy of detail, the expressive bristle of Mehmed's beard is still visible in the best surviving casts and the portrait retains a persuasive corpulence. Every cast thought to be contemporary (there are at least seven) is pierced at the first *M* in *MOHAMETI*, indicating that Gentile's medals of the sultan may originally have been hung for display. SS

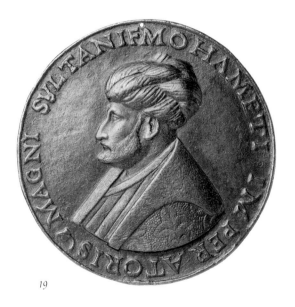

19

SELECTED BIBLIOGRAPHY

Trésor de numismatique 1834, p. 16; Armand 1883, p. 78; Thuasne 1888, pp. 49, 57–8; Karabacek 1918, pp. 47–9; Jacobs 1927, pp. 7–10; Hill 1930, no. 432; Meyer zur Capellen 1985, p. 130; Raby 1987, pp. 180–3; Draper 1992, pp. 97, 99; Raby in Istanbul 2000, no. 4; Spinale 2003, no. 5; Syson 2004, p. 127 n. 28; New York 2004, no. 322B; London 2005, no. 224.

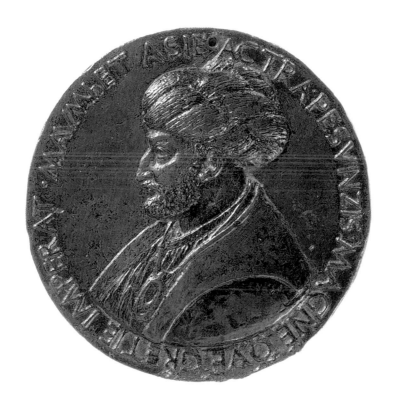

20

21, 22 *Medal of Mehmed II, 1480s*

Inscribed (obverse): MAVMET ASIE AC TRAPESUNZIS MAGNE QUE GRETIE IMPERAT. (Mehmed, emperor of Asia and Trebizond and Great Greece)
Inscribed (reverse): GRETIE / TRAPESUNTY / ASIE (Greece, Trebizond, Asia). OPUS / BERTOLDI / FLORENTIN / SCULTOR / IS (The work of Bertoldo, Florentine, sculptor)

CAT. 21: Bronze with remains of original fire gilding, diameter 9.4 cm
Victoria and Albert Museum, London (A.202-1910)

CAT. 22: Bronze, diameter 9.3 cm
The British Museum, London (CM 1919-10-1-1)

Compared to the medals designed by Costanzo and Gentile (cats 17, 18; 19, 20), Bertoldo di Giovanni's medal of Mehmed II, produced in Florence under the auspices of Lorenzo de' Medici, presents a more complicated, but still overtly imperial, iconographic programme.

On the obverse the sultan appears in bust-length profile in full regalia and is identified ambitiously as 'emperor of Asia and Trebizond and Great Greece'. The allegory of victory pictured on the reverse, in a similar *all'antica* style, develops the theme of territorial dominion. A turbanned, bearded figure stands on a triumphal cart and extends a victory figure in his left hand, while with his right he tethers three female nudes crowned and labelled 'Greece, Trebizond, Asia'. Captor and captives are pulled right by two rearing horses guided by Mars, the Roman god of war, recognisable by his helmet and the trophy hoisted over his shoulder.

Bertoldo undoubtedly drew on ancient Roman coins – of which there were many examples in the Medici collections –

for this classicising image of Mehmed II as a pseudo-Roman emperor and general. Beyond celebrating the geographic reach of the Ottoman empire, the reverse includes a second specific reference to Mehmed's rule. The personifications in the exergue of the medal pay conscientious tribute to the ruler who adopted the title 'Sultan of the two Continents and Emperor of the two Seas', as seen boldly inscribed in Arabic at the entrance of Mehmed's sumptuous new residence in Istanbul, the Topkapı Palace.

The portrait bears clear similarities to Gentile's medal (cats 19, 20), from which it may have derived. However, it is also possible that Bertoldo may instead have based his representation on a portrait drawing carried by one of the Ottoman embassies to Lorenzo de' Medici in the late 1470s. The medal, which he signed 'work of Bertoldo, the Florentine, sculptor', survives in at least seven contemporary casts. It was one of the most prized medals of the Sultan to circulate in the early modern period. SS

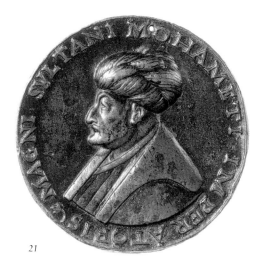

21

SELECTED BIBLIOGRAPHY

Cicognara 1823, vol. 4, pp. 136–8; Armand 1883, pp. 76–7; Karabacek 1918, pp. 49–52; Jacobs 1927, pp. 14–17; Hill 1930, no. 911; Andaloro 1980, p. 193; Raby 1987, pp. 180–3; Vermeule 1987, pp. 265–7; Draper 1992, pp. 95–101; New York 1994, pp. 126–8; Woods-Marsden 2000, p. 49; Raby in Istanbul 2000, no. 5; Spinale 2003, no. 7.

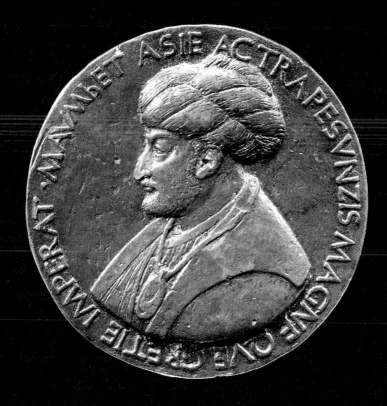

22

23 *Portrait of Mehmed II, 1480*

Oil on canvas, 65 × 48 cm (the original paint surface is irregular),
70 × 52 cm (present canvas size)
The National Gallery, London (NG 3099)
Inscribed (right-hand corner): .MCCCCLXXX./ DIE XXV.ME/NSIS
NOVEM/BRIS. ; (left-hand corner). . . .IL[?]ISQV. . .R/. . .OR ORBIS . . .
CVNCTARE (The left-hand inscription is very damaged:
another, more recent, has been inserted into the gaps in it.)

Gentile Bellini's contemporary and posthumous fame, as
well as his self-image, was based on the portraits he made of
Mehmed II. This is the only surviving painting of the Sultan
produced during Gentile's visit to the Ottoman court. Although
it has been damaged and much repainted (in particular by
the restorer Molteni), much more of the portrait painted on
25 November 1480 survives than has been sometimes supposed.
How it returned to Venice is unclear, but it may have been
among the paintings that Mehmed's son Bayezid reportedly
sold in Istanbul's market.

Mehmed is shown in a three-quarter view, partially turned
to the front, comparable to Gentile's portrait of Doge Agostino
Barbarigo formerly in the Harcourt Collection. As in Venetian
dogal portraits, the Sultan's princely dignity is maintained by
the distance the parapet places between him and the viewer.
An arch, made convincingly three-dimensional by shading and
perspectival recession, further surrounds the sitter. This illusion-
istic architectural framing, which has been connected with the
portal of the Venetian church of San Zaccaria, is unparalleled
in Gentile's surviving portraiture (but see cat. 11).

However, similar effects are found in the production of
the artist and his circle. A manuscript illumination in the
Boijmans Van Beuningen Museum, Rotterdam, shows Doge
Andrea Vendramin, his secretary and the papal legate, as if
framed by a window. A cloth of honour is thrown over the
window frame, like the cloth placed on the projecting ledge
of the parapet before Mehmed. One may also compare the
women watchers in fig. 17. The use of diagonal hatching to
convey the texture of Mehmed's bejewelled cloth recalls
the *Seated Scribe* (cat. 32), while the gems are reminiscent of
Gentile's painting of Bessarion's reliquary (cat. 6). Although
these stylistic qualities have affinities with Gentile's other work,
the textile shown does not. Its decoration with tulips suggests
an Ottoman origin: but no surviving Turkish or Italian fabrics
resemble it closely.

Beneath the parapet, two panels (originally purple) contain
inscriptions. The much-damaged text at the left may once
have praised the Sultan as 'Conqueror of the World' (VICTOR
ORBIS). The crowns flanking each side of the arch also appear
on the reverse of Bellini's medal of Mehmed (cats 19, 20) and

FIG. 29
Venetian (based on
Gentile Bellini)
Portrait of Mehmed II,
about 1510–20
Oil on canvas,
21 × 16 cm
Private collection,
Singapore

on the medallion Gentile himself wears in fig. 10 (detail on
p. 116). This may be an official device of the Sultan, referring
to the three realms of Greece, Trebizond and Asia which he
had captured. Their bound personifications are also portrayed
on Bertoldo di Giovanni's portrait of the Sultan (cats 21, 22).
It has been suggested, perhaps too ingeniously, that the crown
on the embroidered cloth below Mehmed refers to his position
as the seventh Sultan of the House of Osman.

Several later eastern and western portraits of Mehmed
derive from the prototype represented by the National Gallery
painting. They include the miniature of *Mehmed II smelling
a Rose* (fig. 35), which expands Gentile's bust portrait into a
traditional Turkish full-length depiction of the Sultan seated.
Artists updated Gentile's famous image to suit changing taste.
A reduced version of this painting, now in Singapore (fig. 29),
shows Mehmed turning towards the viewer in the manner
promoted by Giorgione and Titian. CC

PROVENANCE

Bought by Sir Austen Henry Layard in Venice about 1865; at the Ca' Capello,
Venice, until 1916; Layard Bequest.

SELECTED BIBLIOGRAPHY

Thuasne 1888, pp. 50–3; Crowe and Cavalcaselle 1871, pp. 126–7; Layard 1887,
pp. 304–5; Berenson 1894, p. 85; Babinger 1961; Davies 1961, pp. 51–2 (attr.);
Meyer zur Capellen 1985, pp. 128–9; Longo 1995; Pedani Fabris 1996; Glover
1999, pp. 14–24; Pedani Fabris 1999; Istanbul 1999; Istanbul 2000, no. 1; Baker
and Henry 2001, p. 28; London 2005, no. 226.

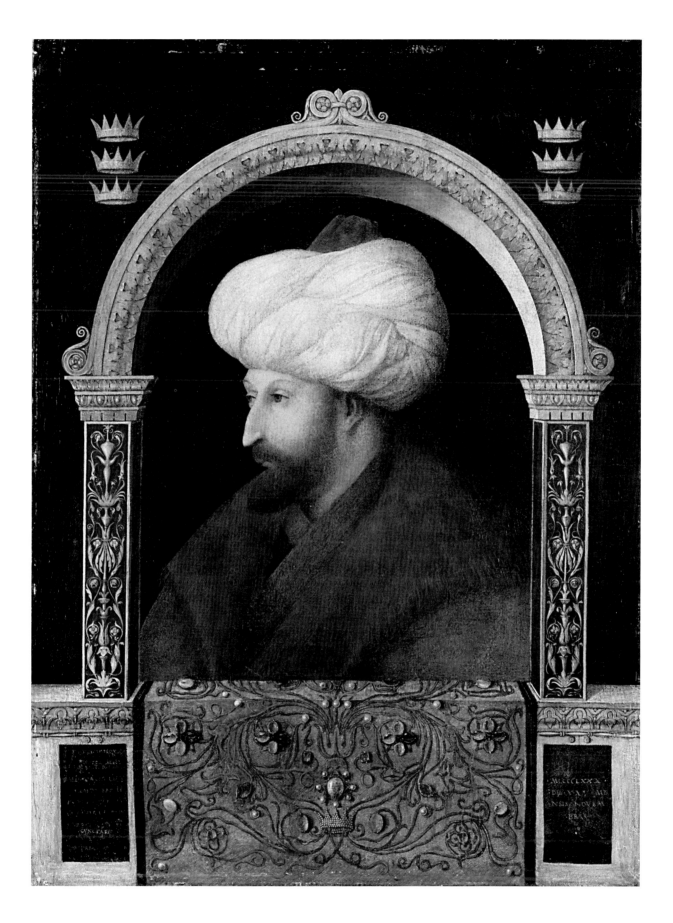

J. M. ROGERS

Mehmed the Conqueror: Between East and West

Mehmed II (1430 1481) was the first of the Ottoman sultans of whom we can form a rounded impression, not so much from his court historians and contemporary chroniclers (who were relatively uninterested in his character and personality)[1] as from the European historians and travellers who visited his court after his conquest of Constantinople in 1453 and from the books and works of art we know, or may deduce, that he owned. Born in the Ottoman capital of Edirne (Adrianople), he spent his youth in the Anatolian provinces, first at Amasya in Pontus and then at Manisa, east of Izmir (Smyrna). On his second accession in 1451, he aggressively expanded the Empire he had inherited, not only by capturing Constantinople at the age of twenty-one and taking over the remnants of the Byzantine Empire, but also by successive campaigns against former Byzantine possessions in Greece, Albania and Bosnia – and even Otranto in the heel of Italy – and also in Moldavia and Wallachia north of the Danube. He built up the Ottoman navy, fortifying the Dardanelles and the Bosphorus against the possibility of a European counter-attack and largely excluding foreign shipping from the Black Sea. In Asia he pushed his frontier eastwards to the Upper Euphrates and in the south to the Mediterranean coast. His imperial ambitions were consciously modelled both on the Byzantine Empire he had overthrown and on that of Alexander the Great.

In his vision of society and the economy as complementary to the state Mehmed was not perhaps alone among his contemporaries, but his creation of a highly centralised regime, of which he was the all-powerful ruler, was an astonishing success. His codification of land-tenure, commercial practice, penal law, the judiciary and the relations between the 'feudal' military elite and the tax-paying classes was to last for more than two centuries and excited the admiration of his successors and the fear of his European enemies.

Mehmed's education, as was customary, was in the Arabic and Persian religious, historical and literary classics, but Manisa, where he spent the greater part of his adolescence, had close links with the Genoese at Yeni Foça (Byzantine Phocaea) and the island of Chios. He was thus well prepared for his meeting with the Italian antiquarian Cyriaco of Ancona beneath the walls of Constantinople in 1452: at his request, one of Cyriaco's associates, according to the *Cronaca* of Zorzi Dolfin, gave him tuition in the historians of classical antiquity and the chronicles of the popes and the Lombard kings. Since Mehmed was only twenty-one when he captured Constantinople, Cyriaco's comparison of him to Alexander the Great cannot have seemed to him to be totally extravagant.[2] According to Kritovoulos of Imbros, Mehmed's Greek biographer and encomiast, his classical interests were further stimulated by a Greek counsellor, George Amiroutzes, the Grand Chamberlain of David Comnenos, the last Byzantine emperor, based in Trebizond: Amiroutzes gave him tuition in geography and Aristotelian philosophy and compiled a wall-map of the world for him from the separate maps in Ptolemy's *Geography*. Amiroutzes also encouraged him to carry on with the rebuilding and embellishment of Constantinople (Istanbul).[3]

As her European adversaries loudly complained, Venice had traditionally favoured accommodation with 'the foes of Christendom', in order to protect her trade with her Muslim neighbours in the Mediterranean. Though on the fall of Constantinople in 1453 the Venetians were excluded from the general amnesty

accorded to the non-Muslim population, they received permission to settle and engage in commerce there a year later.[4] The commercial and military policy of Mehmed II brought about the eclipse of the Genoese in Istanbul and the eastern Mediterranean, and his capture of Trebizond in 1461 and Caffa and other Genoese colonies in the Crimea in 1475 excluded them from the Black Sea. This was vastly to the benefit of Venice, which, notably, took over the lucrative Genoese concession for the alum mines of Yeni Foça. Within little more than a decade of Mehmed's conquest of Constantinople the volume of Venetian commerce far surpassed that under Byzantine rule and continued to expand, despite the sixteen-year-long war forced on the Republic by Mehmed II's occupation of Bosnia and Greece in 1463,[5] and despite the failure of the Venetian riposte, an anti-Ottoman alliance with the White Sheep (Aqqoyunlu) Turkmen ruler, Uzun Hasan, in Tabriz.

With the trading capitulations of 1454 Mehmed enabled the resumption of movement by Venetian and other Italian Turkey merchants and craftsmen who had thronged Constantinople in the last decades of the Byzantine empire, now serving the Ottoman court, the Venetian resident community and doubtless a wider public. These men are difficult to trace, but their activity continued despite the outbreak of hostilities between Mehmed and the Venetian Republic: some idea of their importance is given by the substantial accounts for large quantities of Murano glass imported by the merchant Giacomo Badoer between 1436 and 1440.[6] Without their activity the artistic interchanges of the 1460s and 1470s, which owed as much to the Venetian pursuit of commerce as to Mehmed II's initiatives, would, in practical terms at least, scarcely have been realisable.

In 1460 the Sultan also granted trading capitulations to Florence, and Benedetto Dei, who was in Istanbul from 1460 to 1466, boasts that Florentine influence, doubtless profiting from the hostilities with Venice, rapidly became paramount. In the middle of the decade four of the senior members of the Florentine community in Pera, he says, even advised Mehmed on the construction and artillery emplacements of the fortress of 'Vitupero' on the Dardanelles, though it has not proved possible to identify any such place with this bizarre name. Dei also records a request by Mehmed a number of years later, early in 1480, for Florentine bronze-casters (perhaps cannon-founders rather than sculptors, given his constant need for artillery), skilled carvers and carpenters.[7] A group of craftsmen was organised and despatched to Istanbul, but how long they stayed and what they were commissioned to do is not known, and Florentine influence on the arts under Mehmed II, including the possible contribution of Florentine siege-engineers to his fortifications, remains imponderable.[8]

East and west in Mehmed II's library

Although it is difficult to give more than an impressionistic picture of Mehmed II's private library, enough evidence remains to give an idea of the range of his personal tastes.[9] For centuries after his death it was the source of intense European speculation, for it was erroneously believed to contain the fabled library of the Byzantine emperors with its legendary collection of classical authors, though most of the

desired texts had actually reached Italy long before. Of the non-Islamic manuscripts in Mehmed's library a small number, including a Byzantine Octateuch with 352 miniatures, must have been loot. The rest are a wide-ranging collection of classical literature, geography, cosmography, history and natural history, mostly in mid-fifteenth-century copies and most probably newly made to order. These manuscripts constituted the standard Byzantine school curriculum – excluding the classical tragedians – and Julian Raby has suggested that one of their purposes was to train the staff of his chancery who handled his Greek correspondence with European states.[10] More characteristic of Mehmed's own taste, seemingly, are works on magic and a collection of sensationalist legends on the foundation and antiquities of Constantinople, the *Diegesis*, a Byzantine equivalent to the medieval Latin *Marvels of Rome*; this was to spawn a series of Persian and Turkish versions in the last decade of his reign. Other works which Mehmed himself must have ordered included (still in the Topkapı Palace library in Istanbul) Arrian's *Anabasis* and *Indica*, the principal sources for the life of Alexander the Great, which were copied by Kritovoulos. Also reflecting his interests was a copy of Homer's *Iliad*, now in Paris, datable about 1463. Its commission was evidently prompted by his visit to the supposed site of Troy in 1462 in the course of his campaign against the island of Lesbos. According to Kritovoulos, he enquired what had become of the tombs of heroes such as Ajax and Achilles and, standing on the plain of Ilium, claimed that he had avenged the injustices inflicted on the Trojans and the Orient by the West. Kritovoulos doubt-less reported to him the current belief in Europe that the Turks were descended from Troy and the Trojans, one of the names for whom in Virgil's *Aeneid* is Teucria and Teucri – though Mehmed, who was thoroughly familiar with Persian historical sources on the origin of the Turks, was not necessarily taken in by this bogus etymology. He had Hebrew manuscripts, as well, including a copy now in the Vatican of Maimonides's *Guide to the Perplexed*, the most famous work of medieval Hebrew literature, which may have been ordered for his Jewish physician, Jacopo of Gaeta.[11]

Mehmed II's reputation as a connoisseur of artillery and siege engines was well known to his European contemporaries. Accordingly Sigismondo Malatesta, tyrant of Rimini, sent him Roberto Valturio's *De re militari*, a compendium of battle machines written in 1455.[12] Malatesta distributed several lavishly illustrated copies to contemporary princes; for Mehmed a copy (now in the Bibliothèque nationale de France, Paris) ordered in 1463 was to be delivered by the celebrated medallist, Matteo de' Pasti, whose services Mehmed had requested.[13] Since Matteo was arrested on the way by the Venetian authorities in Crete as a spy this never reached Istanbul, but a copy of the printed *editio princeps* is still in Istanbul in the Topkapı Palace library.[14]

Matteo de' Pasti was also carrying sea-charts, strategic material that would have been very useful to Mehmed in his war of attrition against the Venetians and their colonies in the eastern Mediterranean and, later, in the naval campaigns he under-took in 1480 against the Knights Hospitallers of Rhodes and against the Kingdom of Naples, beseiging and taking Otranto. He acquired a copy of Paolo Santini da Duccio's *Tractatus de re militari et machinis bellicis*, a work on seige engines, which had been made for Wladislas Jagiello, King of Hungary, and contained a map of the Balkans from the Adriatic to the Bosphorus bound in at the end.[15]

Western manuscripts and printed books were, however, only a small part of Mehmed's collection. His Arabic and Persian library, identifiable from the fine book-plates the volumes contain, was remarkable for the exquisite quality of the volumes he commissioned, mostly rather small in format, but with fine bindings, non-figural illumination and calligraphy, on paper which was generally imported from Italy. Only one Qu'ran bearing his book-plate is known, nor does he seem to have commissioned works on Qu'ranic subjects; the great majority of these works are heroic fiction, including tales of chivalry like the romance of the legendary Arab hero, 'Antar, though there are also treatises on mysticism, music, philosophy, law and medicine.[16] Many of the authors were wandering scholars and poets, who travelled the eastern Islamic world in search of patronage or experience and who often arrived in Ottoman Turkey on their return from the hajj. Mehmed II was reputedly so fond of Persians, some of them eccentric and even disreputable, that the Turkish poet Le'âlî claimed that this was an essential qualification for preferment at court and falsely claimed to be Persian himself.

These manuscripts owed much to the courtly culture of the Timurids, the descendants of Tamerlane (to whose authority the Ottomans pretended) in Persia and Central Asia, and to the Turkmen, the Ottomans' eastern neighbours and rivals. Many notable figures from both the 'Black Sheep' (Qaraqoyunlu) and 'White Sheep' (Aqqoyunlu) Turkmen courts, particularly in the wake of his victory over Uzun Hasan at Otluk Beli in 1473, came to work in Mehmed's scriptorium and staff his Persian chancery, including the head of the Aqqoyunlu chancery, and celebrated calligrapher, anatomist and book-binder, Giyâs el-Dîn of Isfahan, who introduced a radical new style of luxury binding to Mehmed's court. Mehmed 's cultivation of the Timurid epigone rulers of Central Asia against the Aqqoyunlu also caused him to recruit officials conversant with their chancery language, Eastern Turki (Çağatay). He was himself deeply interested in Çağatay literature and culture, notably in the works of 'Ali Shir Neva'i, the vizier of the Timurid Sultan Husayn Bayqara at Herat and the virtual creator of Çağatay as a literary language. In addition Mehmed made more than one effort to attract the famous Persian poet and mystic Jami (1414–1492) from Herat to Istanbul.

Perhaps the most notable of these wise men from the east was the distinguished astronomer 'Ali Kuşcı. He had been the head of the observatory which Tamerlane's grandson, the celebrated scholar-prince Ulugh Beg, had created in Samarkand, sponsoring the compilation of a revised and updated set of star-tables. After his patron's murder in 1449 and after having spent some years at Uzun Hasan's court at Tabriz, 'Ali Kuşcı found his way to Istanbul in 1482 and was appointed at the colossal stipend of 200 akçe (more than four ducats) per diem to be professor and keeper of the observatory attached to the mosque of Aya Sofya (the former church of Hagia Sophia). At his death in 1474 the bequest to the mosque of his large library, which included many works and instruments from the observatory at Samarkand, revolutionised Ottoman astronomy and indirectly brought the star-tables compiled in the Samarkand observatory to the knowledge of European astronomers such as Copernicus and Tycho Brahe.

Palace albums

Not only did Mehmed patronise this throng of scholars and craftsmen from the east; his demand that the ransom of the Turkmen prince Yusufça Mirza, captured in 1472, be paid in manuscripts and pictorial albums demonstrates his aim to usurp the artistic pre-eminence his eastern neighbours had acquired.

There are three albums in the Topkapı Palace library which contain specimens of Persian and Arabic calligraphy, drawings and all sorts of paintings, from designs and sketches up to large-scale finished compositions, whether book illustrations, parts of hand-scrolls or larger-format paintings probably for display on walls in special galleries or pavilions.[19] A small number of the paintings are of Chinese origin, while others are western European, but the vast majority of them are fifteenth-century Persian work, from Herat, Tabriz or Shiraz. The contents are in no particular order, the pages very often have no single axis, and the volumes could properly be described as scrapbooks (see fig. 30). From the original contents of one or more of these albums were probably also compiled the well-known Diez albums, which were presented in the 1780s to Heinrich Friedrich von Diez (1751–1817), the Prussian ambassador at the Sublime Porte, and are now in the Staatsbibliothek in Berlin.

Might any of these albums have been part of Yusufça Mirza's ransom? The questions raises three others. When were the Topkapı and Berlin albums put

FIG. 30
Aqqoyunlu (Tabriz)
Execution scene (top right on album page)
about 1470
Watercolour on paper, 18 × 27 cm
Topkapı Palace Museum, Istanbul
(H2153, fol.29v)

together into their definitive form? When did the material they contain reach Istanbul? And in what form did it reach Istanbul? One convenient, though unprovable, assumption is that, in whatever form, they reached Istanbul as booty from Tabriz, which was sacked after the Ottoman victory at Çaldıran in 1514. Julian Raby, who favours the view that, of the three, the album H2153 at least was mounted in its definitive form about this time,[20] does, however, also admit the likelihood that the contents of the three albums may have been acquired at various earlier dates. He argues, too, that the numbers on some of the paintings relate to the posthumous inventory of Mehmed's library made under his successor, Bayezid II.[21] That the mass of material is Timurid or Aqqoyunlu in date, not one of these paintings being later than the reign of Sultan Ya'qub (1478–90), is certainly significant. For, had the material reached Istanbul only in 1514, one might have expected that the painting and calligraphy of the early Safavids, who overthrew the Aqqoyunlu dynasty and seized power in 1501, should be as well represented in the booty as were the Safavid precious metalwork and hardstones which are still one of the glories of the treasury of the Topkapı Palace.

Whatever the date of their compilation as albums, however, much of the material the volumes H2152, H2153 and H2160 contain is representative of what would have been in circulation in the later fifteenth century and familiar to Mehmed. The larger-scale paintings include real or imaginary portraits of heavily armed warriors, horsemen, prisoners, musicians and other figures, often shown in an exaggeratedly *contrapposto* stance, and some possibly after Chinese originals. Figures of this kind, sometimes verging on the grotesque, are a typical genre of Aqqoyunlu painting: a heavily armed warrior in the Freer Gallery (fig. 31) has two swords, one of them drawn and one in its sheath, a battle-axe, a dagger, a shield, and a bow round his neck, and has simply no room for a quiver or a bow-case on his person. A seated figure (fig. 32) is almost a parody of an enthronement scene. His costume is extravagant enough, with a frilly skirt, a stole with flying ends, and a bell-shaped helmet with fur trimmings and no fewer than three plumes. To this he adds a sword, a purse slung from his belt, a quiver and a bow-case, a stringed instrument, a large bottle with a wine-cup attached to it and a lance or battle-standard. These studies are characteristic of the Aqqoyunlu culture of Tabriz in the 1470s, and especially of the work of the painter Shaykhi, which is well represented in these three albums.

Palace albums as portable compilations of fine calligraphy and paintings by famous practitioners became an established form in mid-sixteenth-century Safavid Persia, following the acceptance of an artistic canon of Persian painting, which in the late fifteenth century had probably not yet come into being. But there is some evidence that as a result of Mehmed II's patronage albums were coming to be less haphazardly compiled – notably a volume in Istanbul University Library (F1423) known as the Baba Nakkâş album,[22] which was most probably put together under Bayezid II (ruled 1481–1512). The opening page (fig. 33) bears an impressive study of roses in a maiolica jug, Northern Italian and mid-fifteenth-century in style, but most of the remaining contents are specimens of calligraphy – pages from Qur'ans by eminent scribes, exercises in both the canonical Qur'anic hands and the Persian scripts used in Mehmed II's chancery, lyrics and couplets by highly esteemed Persian and Ottoman poets of his court, specimens in archaic Kufic and the Uyghur script,

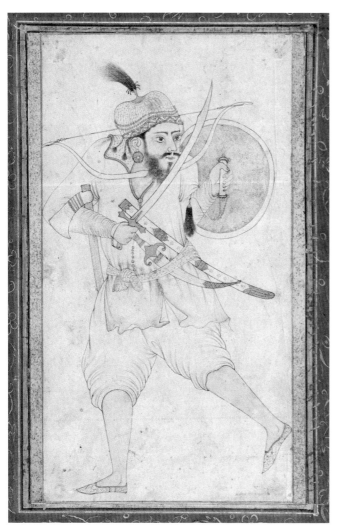

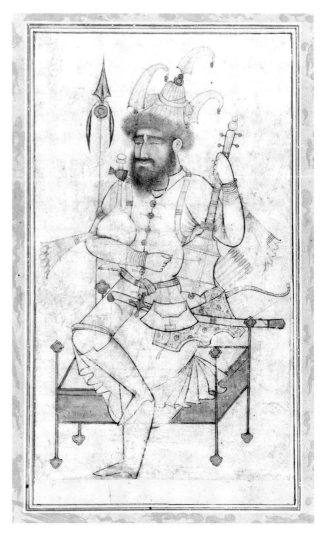

FIG. 31
Aqqoyunlu (Tabriz)
A Heavily Armed Warrior, 1470s
Black ink and gold on paper,
tinted with red and pink, 24.3 × 13.5 cm
Freer Gallery of Art, Smithsonian
Institution, Washington, DC (F1919.79)

FIG. 32
Aqqoyunlu (Tabriz)
A Seated Figure (Ubaydallah Khan), 1470s
Opaque watercolour, ink and
gold on paper, 33 × 22.4 cm
Formerly Art and History Trust Collection
(LTS2005.2.50)

and scroll-fragments from chancery documents in coloured inks on tinted papers, some of them gold-sprinkled. Further pages are filled with patterns and designs in black ink and wash, some of them for bindings and at least one of them for the early Iznik blue-and-white pottery which was currently being made for the Sultan's table, and with specimens of manuscript illumination in gold and polychrome. Though not all the contents relate to Mehmed II, it is clear that his association with the contents was the organising principle and the album may have been conceived posthumously as a sort of souvenir.

Medals and painted portraits

By the time of Mehmed's accession in 1451 a tradition of portraiture at the Muslim courts of Persia was well established. Tamerlane, according to his biographer, Giyâs el-Dîn 'Alî Yazdî, who accompanied him on his Indian campaign of 1398–9, took with him on his campaigns skilled draughtsmen who should depict the fortresses and cities that he conquered and the likenesses of his defeated enemies for the decoration of his palaces on his return to Samarkand. Tamerlane's example was enthusiastically followed by his successors and their rivals and was perhaps one of the precedents prompting Mehmed to commission Gentile Bellini to decorate apartments in the Topkapı Palace. Meanwhile Mehmed's awareness of Italian Renaissance portraiture evidently dates back to his youth, for in the Topkapı Saray library there is an album datable to the 1440s which has been identified as one of his school exercise books, and contains sketches in a childish hand of horses, herons, owls and human heads.[23]

As a ruler Mehmed appears to have been primarily interested in medals as a medium of portraiture, and in representations of himself in them. But what connection he had with the earliest known of these is obscure – with a medal of him in the Ashmolean Museum (cat. 15) and with the Tricaudet medal in the Bibliothèque nationale in Paris, in which he appears as a youngish man (but the authenticity of the latter medal is not certain). The design for the Ashmolean Museum medal is not likely to have been made in Istanbul, or commissioned by Mehmed. Julian Raby has suggested that Mehmed's interest in Italian medal-making may have been stimulated by Pisanello's medal of John VIII Palaiologos, a specimen of which was very probably in the Byzantine treasury on the fall of Constantinople;[24] and, curiously enough, an early Florentine engraving based on this medal, inscribed however *El Gran Turco* (the Great Turk, that is, the Sultan), is represented in the album H2153 in the Topkapı library (fig. 28).[26] Sigismondo Malatesta's letter in response to Mehmed's request for the services of the medallist Matteo de' Pasti gives various reasons why Mehmed may have been interested in this kind of portraiture, but it reflects contemporary Italian ideas and may well be putting words into Mehmed's mouth. Sigismondo notes that portraits of illustrious men may serve as moral examples to their successors and have given their subjects immortality, as Mehmed's portrait would, too – provided, of course that, like Alexander the Great, who ordered his portrait from Apelles, the most celebrated painter of his time, Mehmed were depicted by the finest artists, such as Matteo de' Pasti.

Since Matteo de' Pasti never reached his destination, the first known commission by Mehmed for a medal of himself that was executed seems to be that given to Costanzo di Moysis, otherwise known as Costanzo da Ferrara, who worked in Naples. Costanzo may have gone to Istanbul around 1467 or in 1478, when Naples was at peace with Mehmed and travel there would have been easier (see also p. 126). Costanzo's is easily the most impressive of the medals of Mehmed. Only one example of the first state is known, in the National Gallery of Art in Washington (cat. 16). It shows the profile of a stout man with a very thick neck. It was reissued in 1481, evidently to commemorate Mehmed's death (cats 17, 18). The other medals of Mehmed, Gentile Bellini's in particular (cats 19, 20), are less remarkable. None of them is dated. It may be that the medal of Mehmed by Lorenzo de' Medici's household sculptor, Bertoldo di Giovanni (cats 21, 22), was derived from an example of the Gentile Bellini medal, either as a gift for the Sultan or on the occasion of his death. Its reverse is the most elaborate in its iconography, showing a heroic figure standing on a triumphal chariot, leading captive the personifications of Asia, Trebizond and Greece. The obverse, portraying the Sultan wearing a medal round his neck, is inscribed 'Asie ac Trapesunzis Magneque Gretie Imperator' (Emperor of Asia, Trebizond and Great Greece), which has been interpreted as an allusion to his naval campaign in 1480 against Otranto in Apulia in the south of Italy.[25]

The marked differences between the Costanzo medal and Gentile Bellini's canvas (cat. 23), or indeed between Gentile's canvas and Gentile's own medal, are not easy to interpret, partly because they are not securely dated, and give rise to differing estimates of Mehmet's age and health (he died, possibly by poison, at the age of fifty-eight). Julian Raby describes the figure on Costanzo's medal as 'young and robust' and that in Gentile's canvas as 'weak and emaciated', but to this writer the reverse is more the case. Rather, the Costanzo bust and a drawing after it in the Topkapı album H2153 (fig. 34), like the equestrian portrait on the reverse of the Costanzo medal, show a man in advanced middle age; while Gentile's canvas and the so-called 'Sinan' portrait in the same album (fig. 35) show a sensitive, refined figure, pale, slimmer and markedly younger. In his later years Mehmed suffered greatly from gout, the dynastic malady of the Ottoman Sultans, which was aggravated by his corpulence. This was common knowledge in Italy and the Balkans, and his physician, Jacopo of Gaeta, more than once had recourse to Ragusa (Dubrovnik) for medical texts giving new ways of treating it. What effect this had on Mehmed's appearance is difficult to judge, for, notoriously, those who suffer from gout tend to look very healthy.

The 'Sinan' portrait

The relation between the 'Sinan' portrait and Gentile Bellini's are worth pursuing at greater length, since they highlight many of the difficulties – and interest – in tracking diffusion and transmission between east and west. In the *Menâkıb el-Hünerverân*, a late sixteenth-century account by Mustafa 'Âli of famous calligraphers and painters, it is stated that Sinan Beg, who was a Frankish (most probably an Italian) renegade (*mesfûr*), had studied with a certain Mastori Pavli, himself the pupil of a certain Dâmyânî (otherwise unknown) and that Sinan had a pupil

called Şiblizâde Ahmed.[27] Mastori Pavli has been tentatively identified with Paolo of Ragusa, who worked at the Neapolitan court and in 1474 executed two medals, of Federigo da Montefeltro and of Alfonso I of Aragon. There is no direct evidence that Sinan, rather than another Ottoman painter, made the Topkapı portrait of Mehmed II (fig. 35), but he is the only artist of Mehmed's time whom the Ottoman sources indicate to have been associated with him, for part of his career at least.

Sinan Beg's gravestone, now in the Ethnographical Museum in Bursa, is more informative, though it is undated. Here he is given the patronymic Ibn Sâ'atî, meaning 'son of the clockmaker'. Such was the demand in the Ottoman empire for craftsmen capable of repairing clocks that his father, who at this time would almost certainly have been a European, could have expected a prominent post at court. The epitaph describes Sinan first and foremost as 'the Sultan's painter' (*el-nakkâş el-Sultânî*). In the Ottoman hierarchy of the time there was a social gulf between the artisan class and the military feudal nobility and it would have been anomalous for a practising painter to hold a military feudal title such as Beg: he evidently earned this from a court appointment, as Keeper of the Royal Parasol (*sâhib el-kubbe el-sultâniye*), a post derived from the Timurid courts of Iran and Central Asia, which gave him close access to the Sultan. That he was a personage of standing is confirmed by a description of him in Venetian documents of 1480 as '*depentor del Sultan*' and as the Sultan's dragoman.[28] He may also have been sent on an official mission to Venice the following year to negotiate an Ottoman-Venetian alliance against Ferrante I, King of Naples, although Sinan ('Spear-head [of the Faith]') was such a common Muslim name in Ottoman Turkey at this period that this 'Sinan' may have been a quite different person.

Following medallic conventions, Costanzo di Moysis, Gentile Bellini and other artists showed their subject in profile, but in his painting Gentile and the author of the 'Sinan' drawing (fig. 35) show him in three-quarter view, in a pose which was subsequently adopted as standard for later sixteenth-century Ottoman ruler-portraits. However, the 'Sinan' portrait is clearly indebted to non-Ottoman conventions, notably in the densely hatched stippling of Mehmed's robes, which recall the techniques of Pisanello's workshop.[29] Pisanello's influence was more persistent away from the major centres of northern Italian painting, and Mastori Pavli, Sinan's master, whether or not he was Paolo of Ragusa, may have been a follower of Pisanello, ensconced in a comparative backwater, who transmitted to his pupil Italian techniques of an earlier generation.

Istanbul in Italian town views

Gentile Bellini is reported by Angiolello to have made a view of Venice for Mehmed II. Could he not also have made a view of Istanbul for Venice? There is a tradition of views of Constantinople that goes back at least to Cyriaco of Ancona, and is little altered by the events of 1453 and after. Their interest remains the classical Christian monuments. The view by Hartmann Schedel in his *Universal History* of 1493 shows the Augustaion, the famous equestrian statue erected by Justinian, still on top of its column, while the Turkish chroniclers of Mehmed II's reign record that, under the

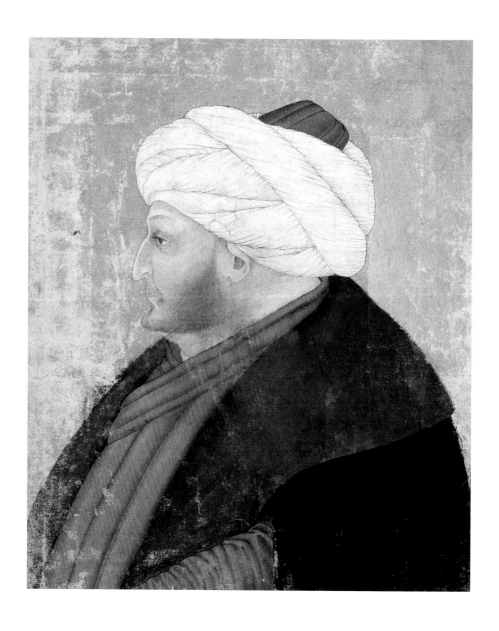

FIG. 34
Turkish (after Costanzo di Moysis)
Bust portrait of Mehmed II, about 1478
Watercolour and gold on paper, 26 × 21 cm
Topkapı Palace Museum, Istanbul
(H2153, fol.145v)

FIG. 35 (opposite)
Turkish
Mehmed II smelling a Rose (the so-called
'Sinan' portrait), about 1480 (?)
Watercolour on paper, 39 × 27 cm
Topkapı Palace Museum, Istanbul
(H2153, fol.10r)

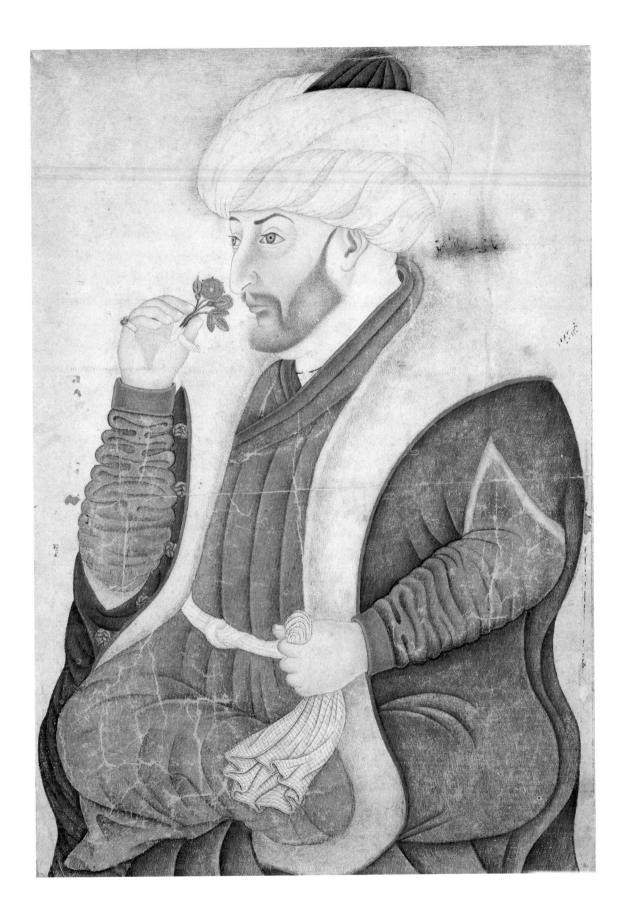

impression that it was a maleficent talisman, he ordered it to be taken down in 1456.[30] The record was, however, corrected in Onofrio Panvinio's view of the Hippodrome, published in 1600 after a drawing of about 1500.[31]

In the light of Angiolello's assertion it has been claimed that Erhard Reuwich, the illustrator of Bernhard von Breydenbach's *Itinerarium*, a handbook for pilgrims to the Holy Land published in 1486, used drawings by other hands, including Gentile Bellini's.[32] Reuwich's view of Venice from the lagoon certainly displays a grasp of detail, notably of the Doge's Palace and San Marco, such as a Venetian painter might have provided, for example Gentile, although there is nothing comparable in his surviving œuvre. However, in 1493 the Mantuan ambassador reported that Gentile Bellini had agreed to paint views of Cairo (where he had never been and of which there are no accurate views before the sixteenth century) and of Venice for Francesco Gonzaga.

Giovanni Andrea Vavassore's map of Istanbul (cat. 1), published in Venice in the sixteenth century, is likely to have used earlier sources, among them possibly drawings by Gentile Bellini made during his stay in Istanbul.[33] The map, oriented west, is a bird's-eye view taken from an angle of about 60° above the sea off the Saray Point, where foreign ships were often required to anchor for some time. The Tersane, the naval dockyard, is here depicted on the Marmara, where Mehmed built his dockyard in 1462; it fell into disrepair early in the sixteenth century and was re-established on the Golden Horn. Near the Old Palace the map bears an indication of a '*Colona istoriata*', Theodosius's column, which was pulled down by 1517 (see further p. 113) And the cannon foundry, the Tophane, which, according to the seventeenth-century traveller Evliya Çelebi, was built by Mehmed II, marked '*Bombarda*' on the map, seems to be in the process of construction. All this, and the absence of the mosque complex, of Bayezid II, inaugurated in 1505, indicates that at least the earliest drawings on which the Vavassore map was based could have been made late in Mehmed's reign.

Eastern interest in Western art

Unlikely as it may seem in the light of Mehmed's capture of Constantinople and his re-creation of the Byzantine empire in a Muslim mould, rumours circulated widely in Europe that he was about to convert to Christianity. These were, of course, unfounded, but on many occasions Mehmed showed reverence for Christian works of art. The preservation of some of the Byzantine mosaics in the church of Hagia Sofia was, as his chroniclers record, the result of his direct intervention, and he systematically collected Christian relics, many of which remained in the churches and monasteries of Constantinople at its fall. According to a list dated 4 July 1483,[35] drawn up at a time when his son, Bayezid II, was considering their disposal as a means of confining his fugitive brother, Sultan Cem, to residence at the French court, these included the stone on which Christ was born; various of Christ's garments; instruments of the Passion; the body of the Prophet Isaiah, complete with hair, beard and ears; one of the Holy Innocents murdered by Herod; the bodies of Saint John Chrysostom and Saint John Damascene; the Gospel of Saint John written out by Saint John Damascene; and a fine icon of the Virgin with 300

saints. Many of these must have been a testimony to Mehmed's credulity, or that of his informants, but the collection well illustrates his pietistic turn of mind.

Further evidence of his pietism may be a group of early Florentine and Ferrarese engravings usually dated to the 1460s that appear in the Topkapı album H2153. This 'modish if heterogeneous collection' Julian Raby sees as a reflection of Mehmed's interest in contemporary Italian art, supposing that it had been put together for him, though as a group its contents are too variable in subject-matter and quality to have been an official gift. Heterogeneous is certainly the word, since, in addition to Christian subjects, like the Mass of Saint Gregory and Saint Sebastian, they include illustrations for Petrarch's *Trionfi* and a card depicting Urania from a set of Italian *tarocchi* (playing cards). How they reached Istanbul, and when, indeed, they were pasted into the album H2153, is disputed (this is discussed further on p. 129). They could have belonged to an Italian jeweller or silversmith working in Istanbul.[36] However, the overwhelmingly Aqqoyunlu contents of this Topkapı album may suggest that the collection of prints was brought to Istanbul via Tabriz, which was a major entrepot in the trade of raw silk from Northern Iran to Bursa in Ottoman Turkey and thence to Florence and Venice. The presence of craftsmen from a variety of Italian cities in Tabriz is documented in Venetian reports. It was, moreover, precisely in the early 1460s that Venetian diplomatic efforts to bring Tabriz into an anti-Ottoman alliance were at their height.

There is also indirect evidence that Uzun Hasan, the ruler of Tabriz, possessed the famous classical sardonyx cameo made for Ptolemy Philometor of Egypt, later known as the Tazza Farnese, now in the Museo Archeologico Nazionale in Naples, since there is a depiction, attributable to Tabriz and datable to the 1450s, bearing the signature of a painter, Muhammad b. Mahmudshah al-Khayyam, in one of the Diez albums in Berlin (fig. 36). In Europe, the cameo is first recorded in the collection of Pope Paul II, who died in 1464. How it came into his possession is unknown, but its presence in Tabriz shortly beforehand would be easy to explain: it might have been an heirloom acquired from the Comnene rulers of Trebizond, to whom he was related, by Uzun Hasan, the ruler of the Aqqoyunlu confederation. If it was not a gift to him he could have salvaged it from the Comnene treasury on the fall of Trebizond to Mehmed II in 1461. However, it could have reached Italy slightly earlier as a gift brought with a (fruitless) diplomatic mission led by a Franciscan, Lodovico da Bologna, which was sent by the alliance in 1460–1 to persuade the Christian courts of Europe to embark on a crusade against the Turks.[37]

Gentile Bellini and Mehmed II

Italian travellers to the Turkey of Mehmed II, for purposes of self-advertisement, must often have been tempted to exaggerate their familiarity with the Sultan. Gentile Bellini's reception in Istanbul, however, sets him quite apart from the artists who journeyed to the east in search of commissions, and not merely because he was an honoured guest rather than an adventurer seeking his fortune. His intimacy with Mehmed II which Angiolello reports is unique in the relations between the Islamic rulers of the time and the artists and craftsmen working for them, and is all the

more surprising given that the *Kânûnnâme,* or code of state ceremonial, promulgated towards the end of Mehmed's reign laid down that any intimacy between the Sultan and his subjects derogated from his majesty.[38]

The most important document for Bellini's activity in Istanbul is a letter in Latin, dated 15 January 1481, addressed by Mehmed to the Doge in Venice (fig. 43).[39] Major Ottoman documents of state were mostly drafted in Turkish, but Mehmed used his Latin chancery (which was also responsible for documents in Italian) for the issue of safe-conducts and for minor correspondence with European powers. Its language was more informal and apparently not entirely standardised.[40] However, this document is aberrant in being issued in 'Byzantium', not Constantinople (Konstantiniye, the official name for the Ottoman capital) and in not preceding the Christian date with the Muslim year. The small number of published documents makes these inconsistencies difficult to evaluate. They are probably insufficient in themselves to cast doubt on the authenticity of the letter. Other anomalies are, however, more disturbing, notably, as Babinger observed, the fact that the Sultan's monogram is shakily written in a hand unfamiliar with the ductus of the *tuğra,* which was the standard guarantee that a document had been properly issued and registered in the chancery. Indeed, the document, if genuine, is clearly in an Italian hand, perhaps copying an original letter of commendation.

The letter conveys Mehmed's satisfaction with Gentile's work and his appreciation of the Serenissima's generosity in lending his services. In recognition of these he has appointed him a *miles auratus* (in other sources *eques auratus* is used) and a *comes palatinus*, the two titles awarded him by the Emperor Frederick III, and bestowed upon him a solid gold chain or collar inscribed in Ottoman Turkish with Mehmed's name and titles. This raises two problems, however: first, the two titles have no obvious Ottoman equivalent; and, secondly, the reward was highly unusual, since even the most distinguished palace craftsmen and artists received no more than a robe of honour and a sum (often substantial) in cash.[41]

The problem raised by the titles is perhaps superficial, for these may be explanatory calques or translations for the benefit of Gentile's European public. If Sinan was appointed a Beg (though, I have argued, that would have been by virtue not of his painting or his interpreting but of his court office),[42] and perhaps Costanzo da Ferrara too, this might have seemed appropriate for Gentile also, and *miles* or *eques* could at a pinch have been seen as a rough equivalent. As for *comes*, that might have been a calque on the group of distinguished clerics, scholars, soldiers, government officials and litterateurs in the Sultan's suite, known as the *müteferrika*,[43] to whom the *Kânûnnâme* of Mehmed grants substantial daily allowances – the equivalent, perhaps, of paid companions of honour. The fact that these appointments carried a salary, which Gentile could hardly expect to receive without remaining in the Sultan's service, could then explain the gold chain or collar, as compounding for the salary he could not receive abroad.

This explanation is at least consistent with the claim that Gentile Bellini was 'ennobled' by the Sultan, and that he was given a lavish piece of goldsmith's work, as his contemporaries and successors unanimously believed. But the tone of the letter is oddly apologetic, almost as if it is explaining the Sultan's behaviour for the benefit of the Doge. Could the draft have been concocted by Bellini himself?

Conclusion

According to Angiolello, during his stay in Istanbul Bellini executed, besides his portrait of the Sultan, portraits of various courtiers, a self-portrait, and a study of a dervish, and presented Mehmed with a *Madonna and Child*. Except for the portrait of Mehmed (cat. 23), these are lost, though reflections of his sojourn in the east do appear to survive in a number of drawings (see cats 24–9, 32). Mehmed II's patronage of European artists was less influential than perhaps he might have wished. The Ottoman Sultans were widely believed not to tolerate figural painting, although they tended to avoid expressing a rigid prohibition. Ottoman society as a whole took a rather different view: Ottoman coinage was aniconic, and the Muslim clerisy, like much of the Ottoman public, was far from sharing the Sultans' tolerance.[44] In the reign of Mehmed's son and successor, Bayezid II, no figural painting seems to have been commissioned at all. The Bellini portrait and Mehmed's other paintings, so Angiolello reports, met with his disapproval and were sold in the Bazaar, where they were acquired by Venetians.[45]

If Angiolello's report is true, it may be connected with an Ottoman palace inventory of the reign of Bayezid II drawn up early in 1505,[46] which lists a miscellaneous collection of objects and materials, including silver and gold vessels, splendid silks and fine woollens, a large wardrobe of luxurious garments, furnishings, fine arms and armour, gaming pieces and their boards, table utensils and cutlery, astronomical instruments, carpets, musical instruments, furs, Chinese porcelains, table vessels and kitchen implements. As an inventory proper it is, however, markedly incomplete: apart from Qur'ans there are no books and no albums, and the very miscellaneous contents, including such trivial items as 'six chests of bits', suggests that the list was partly of things to be endowed upon the mosque of Bayezid II in Istanbul, which was inaugurated later in 1505, and partly of things to be disposed of in aid of its endowment.[46] Many of the objects are designated as European – Hungarian or Frankish – but most significant is a separate group of 'heathen' (*gebr*) objects, including a crossbow, and things bearing figural decoration – a silver flask and cups, a bag of playing cards (Italian figural *tarocchi*), a European book with illustrations ('*bir gebr musavver kitâbi*') – though not necessarily with improper illustrations – and six pictures. Angiolello rather implies that Bayezid disposed of the portraits on his accession in 1481, but this need not have been the case.

FIG. 37
Nakkaş Osman
Queen Qaydafe showing Alexander the Great his own Portrait, about 1560–70
Illumination, album 38 × 25 cm
Topkapı Palace Museum, Istanbul
(H1522, fol. 410a)

Gentile Bellini's portrait of Mehmed II lived on in Europe in Vasari's *Lives of the Artists* and in the *Elogia virorum bellica virtute illustrium* of Paolo Giovio who owned a drawing attributed to Gentile Bellini, as well as the Costanzo medal, which he misattributed, despite the signature, to Pisanello. The likeness Paolo Giovio reproduces in his history is in some respects closer to the 'Sinan' portrait (fig. 35),[48] though the quilted front of the caftan which crosses over the chest is replaced by a garment buttoning straight down. It was not only the Italians who conserved the tradition of Mehmed's patronage, however.[49] In a Turkish translation of Firdawsi's *Shâhnâme* probably illustrated by Nakkaş Osman, about 1560–70 (fig. 37), Alexander the Great is pictured in disguise before Qaydafe, Queen of the Maghrib, who is contemplating his portrait. It is not, however, a likeness of Alexander but a portrait of Mehmed II in a European frame. Although Gentile Bellini's portrait had been disposed of immediately after the Sultan's death, this illustration confirms Mehmed's enduring reputation among his Ottoman successors as an enthusiast for the Italian Renaissance portrait.

Bellini in Istanbul

GENTILE BELLINI

24 *Young Greek Woman, 1479–81*

Pen in brown ink, 25.4 × 17.5 cm
Inscribed: *velo / filo bianco*
Musée du Louvre, Paris (4654)

25 *Seated Janissary, 1479–81*

Pen in brown ink, 21.5 × 17.5 cm
The British Museum, London (PP.1-19)

26 *Seated Woman, 1479–81*

Pen in brown ink, 21.5 × 17.6 cm
Inscribed: *orlo / rosso / oro / arzento / azuro / neg°*
The British Museum, London (PP.1-20)

WORKSHOP OF GENTILE BELLINI
(late fifteenth century)

27 *Standing Turk*

Pen in brown ink, 29.9 × 20.3 cm
Annotated: *Giovan Bellin venetus:*
Musée du Louvre, Paris (4655)

28 *Standing Man*

Pen in brown ink, 28 × 18 cm
Städelsches Kunstinstitut, Frankfurt (3957)

29 *Standing Young Man (called an Albanian)*

Pen in brown ink, 25.8 × 18 cm
Städelsches Kunstinstitut, Frankfurt (3956)

30 AFTER GENTILE BELLINI (sixteenth century)

Standing Turk

Pen in brown ink, 20.7 × 11.4 cm
Musée du Louvre, Paris (4653)

The ethnic and religious diversity of late-fifteenth-century Istanbul must have provided irresistible subjects for visiting artists like Gentile Bellini. Almost constant war, as well as commerce and trade, drew people from across the Mediterranean to the Ottoman capital. Using fine pen lines and careful shading, Gentile depicted some of the picturesque figures he encountered. The precise identification of these characters is elusive. Also somewhat uncertain is the attribution of the drawings, and this exhibition provides an opportunity to examine the group as a whole for the first time. These seven drawings share subject-matter and pen technique with the *Seated Scribe* (cat. 32), although that work has a rather different appearance since it was coloured and later cropped. Nonetheless, all the sheets arguably originated in the same workshop – since the fine parallel pen-strokes are Venetian in style, similar in particular to those used in the Bellini shop.

Like anthropological studies, the drawings are careful and detailed renderings of subjects new to the artist. Each figure is centrally placed on the sheet, and shown at rest. Careful patterns of hatched and cross-hatched lines convey shadows and the fall of light. Details of clothing and adornment – the organisation of turbans, the placement of buttons – have been rendered with precision, perhaps because of their unfamiliarity to the artist. In addition, the two drawings of women have

notes on the costumes. (In 1438, Pisanello had similarly annotated the exotic costumes of John VIII Palaiologos and his retinue.) The figures possess an air of calm composure that was a hallmark of Gentile's studio, seen particularly in narrative paintings such as *Saint Mark preaching in Alexandria* and *The Procession in Piazza San Marco* (figs 10 and 16).

Although Gentile Bellini seems to have made these drawings to record the striking figures he encountered in Istanbul, at least one of them, the *Seated Scribe*, may have been worked up for Mehmed II. It is unknown whether Bellini ever wanted to use the drawings for a large-scale narrative painting, but there are no direct transcriptions of the figures in his surviving works. However, the Umbrian artist Pintoricchio made extensive use of them, or copies after them, as three of the figures appear in his frescoes. In the Sala dei Santi of the Borgia Apartments in the Vatican, executed between 1492 and 1494, the *Seated Janissary* (cat. 25) is seen in reverse with the addition of a gesture commanding archers to shoot the eponymous saint in *The Martyrdom of Saint Sebastian*. The standing turbanned men depicted in cats 27 and 29 flank the Emperor Maximilian in *The Disputation of Saint Catherine* in the same room. The *Standing Turk* (cat. 27) appears again to the right of the pope in *The Arrival of Pius II in Ancona* in Siena's Piccolomini Library (1505–7).[1] Pintoricchio altered his

models by decorating their costumes in his customary gaudy fashion. This use of Gentile's motifs led Venturi to conclude that the sheets were actually by Pintoricchio, a suggestion correctly rejected by Frizzoni who stressed that the drawings were Venetian in style and some of the annotations in Venetian dialect. Indeed the figures do not at all resemble Pintoricchio's elegantly elongated forms, but look incongruous in the frescoes placed amid generic eastern types.

The drawings were thereafter usually attributed to Gentile or his workshop until 1980, when Andaloro and Raby separately assigned the entire group, including the *Seated Scribe*, to Costanzo 'da Ferrara' (more properly named 'di Myosis' see further p. 126), based largely on the assumption that Gentile Bellini was not good enough to have made such alluring drawings. Although Costanzo di Moysis was born in Venice, he worked principally in Naples and there is no evidence that he trained in Venice. Moreover, Costanzo's sole surviving work – the medal of Mehmed II which survives in two versions (cats 16 and 17, 18) – provides no stylistic basis for assigning the drawings to him.

While we know nothing definite about Costanzo di Moysis's activity as a draughtsman and painter, we are more reliably informed about Gentile Bellini's. The drawing style of repeating parallel strokes, exhibited by these sheets, is closely linked to redrawn sheets in Jacopo Bellini's Louvre drawing book (fig. 38), which Gentile Bellini owned. Gentile's self-portrait of about 1496 (cat. 31) in black chalk is also worked up with parallel hatching similar to the shading used in the seven Turkish drawings. The figure of the standing woman (cat. 24) is very close to a similar figure in Gentile Bellini's *Saint Mark preaching in Alexandria* (fig. 10) although she is attired in Mamluk dress (see further p. 118).

The ability to convey sensitively the changing appearance and tactility of fabric is one of Gentile Bellini's defining artistic characteristics. This is seen in all the drawings as well as in paintings such as *Caterina Cornaro* (cat. 8) and religious works (cat. 11). The detailed description of elements of dress, such as the thin veil held by the Greek woman (cat. 24), finds parallels in paintings like the True Cross cycle for the Scuola di San Giovanni Evangelista. The qualities of stillness and dignified composure exhibited in the drawings are paralleled in

Gentile's painted œuvre, where figures are meticulously observed but do not often interact. The seated women in the foreground of *Saint Mark preaching in Alexandria* and the participants in *The Procession in Piazza San Marco* (figs 10 and 16) share with these sheets a conspicuous and compelling sense of repose.

None of these drawings are spontaneous studies from life, although they undoubtedly derive from such sketches. All are measured and well thought-out compositions displayed on separate sheets of paper as finished works of art. Although they share a workshop style, there are differences in quality among the sheets. This is most evident in cat. 30, which exhibits a clumsy line and lacks three-dimensionality. The awkward outlines of the complex coat and mechanical hatching in the *Standing Man* (cat. 28), as well as the relative dimensions of arms in cat. 29 show that they, too, are copies. The drawings have therefore been variously divided between Gentile and his workshop, most scholars considering the British Museum sheets to be by Gentile and the rest to be by his followers. However, although these two drawings (cats 25 and 26) are well preserved and make an impressive pair, their pen work is less assured and fluent than that of the *Young Greek Woman* and *Seated Scribe* (cats 24 and 32). This led Tietze and Tietze-Conrat (1944) and Meyer zur Capellen (1985) to assign all seven sheets to copyists after Gentile; the latter also noted that the handwriting on cats 24 and 27 did not resemble Gentile's signatures on documents. However, in 1994 Meyer zur Capellen reassigned the London drawings to Gentile. In our view, the standing figure of a woman (cat. 24) exhibits a freedom of line like that found in the *Seated Scribe*. The two sheets in the British Museum may be considered clean copies made by Gentile Bellini based on earlier drawings. The *Standing Turk* (cat. 27) is also of high quality, but appears to be by an assistant in Gentile's workshop, like cats 28 and 29. The *Standing Young Turk*, cat. 30, seems to be a later, probably sixteenth-century, copy. Some of these replicas may have been produced for other artists – like Pintoricchio – perhaps because Gentile himself never had the opportunity to use them directly in his own paintings.

The variously attired figures cannot be identified easily, especially since most visual sources date from the sixteenth

FIG. 38
Jacopo Bellini (1400–1470), reworked
by Gentile Bellini's workshop
The Martyrdom of Saint Isisdore,
mid 15th century
Pen in brown ink, 38 × 26 cm
Musée du Louvre, Paris (RF1513)

century or later. The seated man (cat. 25) wears the typical felt headdress, dagger and bow with the quiver of a janissary (the hat is usually shown folded over in later images). The elite corps of the Ottoman army and the Sultan's personal guard, janissaries could easily have been observed by Bellini at Topkapı Palace, as could the Sultan's prestigious pages, one of whom is probably the subject of the *Seated Scribe*.

Two of the men wear turbans, and some are also dressed in caftans and cloaks for outdoor wear, however, they have all been carefully posed in manners associated with the studio. The *Seated Woman* (cat. 26) sits cross-legged and wears vertically striped garments similar to those worn by the Turkish men (cats. 27 and 29). Her conical headdress, swathed in red fabric (as the annotation tells us) bordered with strips of golden kufic script, is more distinctive. She has sometimes been considered a member of the Sultan's harem, but her headdress finds its closest parallels with those worn by women belonging to the Druse sect, as recorded in nineteenth-century anthropological photographs published by Karabacek. She cannot have been drawn outdoors, for she is unveiled and delicately holds a circular object, probably a mirror.

The scant chance that a Muslim woman would have sat to a male European – even a palace companion like Gentile Bellini – makes one wonder if the artist depicted a non-Muslim woman wearing a made-up costume that would have seemed Turkish (a solution Jean-Etienne Liotard adopted three centuries later when working in Istanbul). In contrast, the *Standing Woman* (cat. 24) may be a Greek Christian. Her head and neck are covered by a hat, veil and wimple, under which can be glimpsed the heavy necklace with which her

shapeless long outdoor tunic is adorned. She, too, has been carefully posed, down to the flowers she holds in her left hand. A century later, Cesare Vecellio in his famous costume book was to depict a similarly costumed figure as a 'Greek woman of Pera' with the comment that a large white veil was used out of doors.[2] AC/CC

NOTES
1 Reproduced and discussed in Scarpellini and Silvestrelli 2003, pp. 175, 176, 270.
2 Vecellio 1590, fols. 421r–v: 'Greca in Pera'.

PROVENANCE

CATS. 25, 26: Bequest of Richard Payne Knight, London, 1824.
CAT. 27: Pierre Crozat.
CATS. 28, 29: D'Argenville and Joubert collections.

SELECTED BIBLIOGRAPHY

As Gentile or workshop except as noted: Crowe and Cavalcaselle 1871, p. 125; Thuasne 1888, p. 76; Venturi 1898 (Pintoricchio); Frizzoni 1898; Martin 1906; Ricci 1912; Karabacek 1918, pp. 34–7; Venturi 1907, pp. 343–4 (not Venetian); Tietze and Tietze-Conrat 1944, pp. 66–7, 69–71 (attr.); Popham and Pouncey 1950, pp. 5–6; Collins 1970, pp. 199–203 (workshop); Andaloro 1980, pp. 202–3 (attr. Costanzo); Raby 1980, pp. 69–76 (Costanzo); Ames-Lewis 1981, pp. 87, 140; Meyer zur Capellen 1985, pp. 97–101, 168–72 (after Gentile); Raby in Washington 1991, p. 212 (Costanzo or after Costanzo); Meyer zur Capellen 1994; Mack 2002, pp. 157–8 (Costanzo).

25

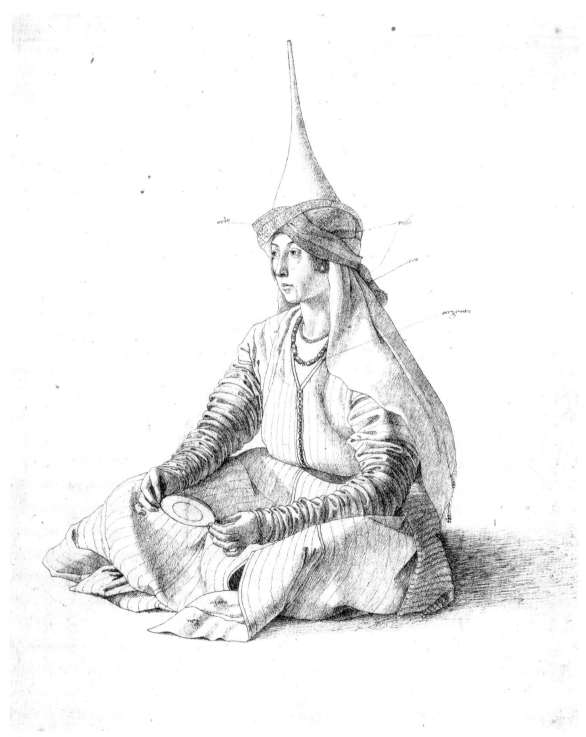

26

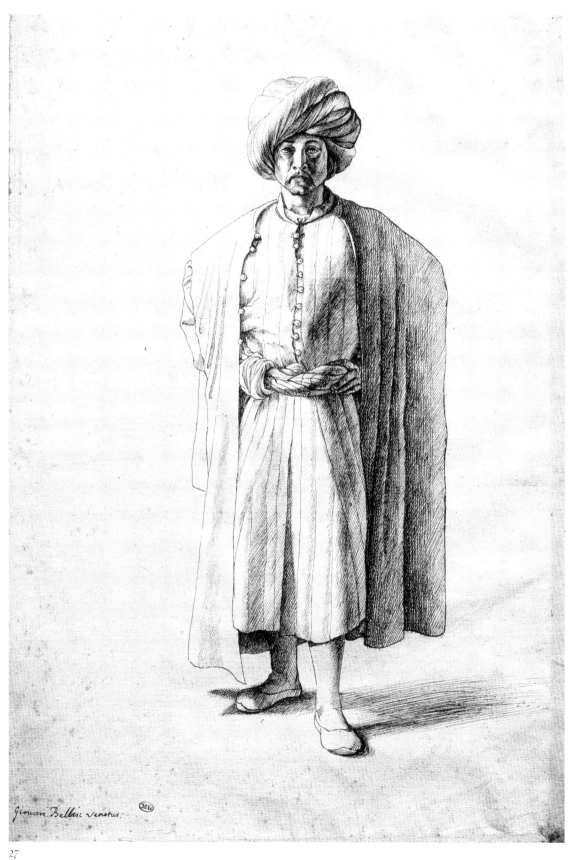

Giovan Bellin venetus.

27

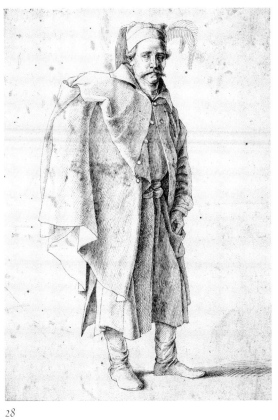

28

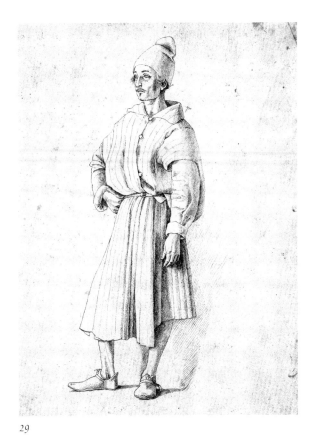

29

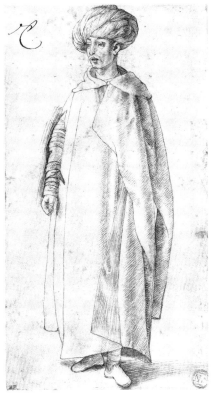

30

ALAN CHONG

Gentile Bellini in Istanbul: Myths and Misunderstandings

Gentile Bellini, a native of Venice and a very famous painter of this time, seems to be shedding glory not only on the territory of Venice but also, so to say, on all of Italy with his unheard of and admirable style of painting. He is so well endowed with grace in painting that he can be deservedly compared without injustice to any of the exquisite ancient painters, whether Greek or Latin.

JACOPO FILIPPO FORESTI DA BERGAMO, 1490[1]

In four disciplines, there are four ignoramuses...
in painting, comes the arrogant knight of the golden spur, Gentil Bellino.

ANDREA MICHIELI, 1490s[2]

Titian could not bear to follow the dry and laboured manner of Gentile.... Because of this, leaving this awkward Gentile, Titian attached himself to Giovanni Bellini: but his style did not entirely please him either, and he sought out Giorgione.

LODOVICO DOLCE, 1557[3]

Disdainful comments on Gentile Bellini are not surprising in the sixteenth century when he was called 'goffo' because he was old-fashioned. But they seem amazing in the twentieth It is as if the primitives had never been rediscovered.

CREIGHTON GILBERT, 1961[4]

Recipient of honours from emperors west and east, Gentile Bellini was condemned shortly after his death as a vain, self-promoting hack. Critics compared him unfavourably to his brother Giovanni and omitted him from the Venetian tradition that culminated in the glories of Giorgione and Titian. Gentile's one saving grace, especially for a nineteenth century besotted with Orientalism, was his journey to Istanbul, a fascination stoked by the discovery of works made by him in Turkey. Recently Gentile's stock has again fallen, with the result that many of his works have been re-assigned to the shadowy figure of Costanzo da Ferrara.

Further complicating this picture are the many myths that arose around Gentile Bellini's stay in Constantinople, or Istanbul as it became after its conquest by the Ottomans in 1453. We hear that the artist presented Mehmed II with one of his father's precious drawing books and was commissioned to paint not only Christian devotional images but also erotic scenes for private delectation. The Sultan allegedly provided a freshly severed human head as a model for a depiction of the beheading of the Baptist.[5] Gentile is also said to have produced a map of Istanbul, a panorama of Venice and records of ancient sculpture. None of this is provable, and it is the task of this essay to weigh the documentary and stylistic evidence for Gentile's activities in Turkey. In particular, we are mindful of a major shift in perception between fifteenth-century observers, who encountered Gentile and his work first-hand, and sixteenth-century writers like Giorgio Vasari and Francesco Sansovino, who were inclined to judge him by new standards. We need to re-evaluate the work of both Gentile Bellini and Costanzo 'da Ferrara' stripped of erroneous accretions.

'A good painter' for the Sultan

The months leading up to Gentile Bellini's departure for Constantinople must have been of great excitement in Venice. After sixteen ruinous years of war with the Turks, a peace treaty was concluded in January 1479. Although Venice was forced to surrender territory and costly tributes, the peace was greeted enthusiastically. On 27 April the Turkish ambassador was received in the Great Council Hall of the Doge's Palace, a space that Gentile Bellini was in the process of embellishing with monumental paintings. On 1 August of the same year the Venetian Senate received a request from Mehmed the Conqueror for a painter, followed some days later by an additional request for a sculptor and a bronze founder.[6] The diarist Marin Sanudo pointedly said that when the Sultan asked just for 'un bon pytor' (a good painter) without specifying the name of an artist, the city responded by sending Gentile – 'Zentil belin optimo pytor' (Gentile Bellini, an excellent painter).[7] The choice indicates the extreme importance of the mission for Venice, since Gentile was then the city's most prominent painter, engaged on its most prestigious public commission. Indeed, Venetian officials, while appointing Giovanni Bellini to work on the canvases in his brother's absence, insisted that Gentile resume painting them when he returned from Istanbul. Vasari's claim that Giovanni was first chosen to go but was too old to make the journey is incorrect.[8]

Additional factors may have contributed to Gentile's selection. Mehmed's ambassador may have commented favourably on his paintings in progress in the Doge's Palace. The artist's depictions of Cardinal Bessarion, the former Byzantine cleric, might have seemed useful preparation for work in the east. The Venetian diplomat who negotiated the peace with the Turks, Giovanni Dario, was a friend of Bellini's and may have suggested him for the assignment or – more crucially – persuaded him to accept the dangerous and uncertain task. Dario was certainly involved in the simultaneous arrangements to send a sculptor, and he visited Istanbul in the summer of 1480 while Gentile was there.[9]

In September 1479 Gentile departed for Istanbul accompanied by two of his assistants and two assistants of 'Master Bartolomeo, metal founder', probably the sculptor Bartolomeo Bellano, who seems to have sailed later.[10] Gentile travelled not just as a painter but also as a cultural ambassador for Venice. Italian states took such missions seriously, and Naples and Florence also responded immediately to Mehmed II's requests for artists. In 1461, the Sultan had asked the *condottiere* Sigismondo Malatesta to send him Matteo de' Pasti. Roberto Valturio's response on behalf of Malatesta praises the power of portraiture to assure fame and immortality, and acknowledges that the Sultan 'had asked most urgently to send Matteo de' Pasti of Verona . . . a wonderful artist of such things [faces portrayed in bronze], to paint and portray you'.[11]

Mehmed II's request of Venice was not as specific. Sanudo's testimony that only a painter was initally asked for is confirmed by contemporary observers, Giovanni Maria Angiolello and Francesco Suriano,[12] while another, Domenico Malipiero, stated that the Sultan wanted 'a good painter who knows how to make portraits'.[13] Two other fifteenth-century writers, Jacopo Filippo Foresti and Francesco Negro, claimed that Gentile Bellini had been specifically requested, but these encomia are

perhaps less trustworthy on this detail. Still less trustworthy is Giorgio Vasari's story that some of Gentile's portraits had been taken to Istanbul, and as a consequence the artist was summoned to paint the Sultan despite the Islamic injunction against portraits.[14] Vasari represented the event in such a way as to stress the power of Italian portraiture to astound Muslim viewers, a theme also found in Vasari's biography of Filippo Lippi: the artist was supposedly abducted by pirates and imprisoned in North Africa, but drew his captor so realistically that he was freed.[15]

The first published account of Gentile's eastern sojourn appeared in the 1490 edition of Jacopo Filippo Foresti da Bergamo's *Supplementum chronicarum*. First published in 1483, the vast chronicle of history since Creation proved so popular that it was updated regularly. The brief panegyric on Bellini that first appeared in 1486 was considerably expanded in 1490:

> His talent one day reached the ears of Mehmed, Prince of the Turks, who, burning with desire of seeing him, wrote humbly to the Venetian Senate with a request that it should as a great favour send [Gentile] to him in Istanbul as a gift. When he arrived, in order that [Mehmed] might test his skill, after he made him paint a great many marvellous and extraordinary paintings of himself and almost countless other subjects, finally, in order that his entire art might be tested even further, [Mehmed] required that he himself be rendered in his own form. And when the emperor beheld the image so similar to himself, he admired the man's powers and said that he surpassed all other painters who ever existed. He therefore immediately, as a sign of official favour, made him a member of his retinue and palace companion [*comes palatinus*], as well as a golden knight with his own insignia and chain. He praised him and sent him back to his homeland with abundant privileges and many gifts, and there he was received by the Venetian Senate itself with many an expression of joy. And he was sent back to painting in the palace the histories of the Venetian state that had been interrupted, with great profit.[16]

Published several times in Venice during Gentile's lifetime, this account may well have been provided by the artist; it is, at least, the closest thing we have to Gentile's own account of his sojourn in Istanbul. It is also possible that Gentile Bellini showed Foresti a version of his portrait of Mehmed II, for the writer described in detail the facial features of the Sultan 'as his own portrait reveals'.[17]

The text reveals Mehmed II's keen interest in the making of his own portrait, which appears to have been the main reason for calling a Venetian painter to court. Before commissioning his portrait, Mehmed made Gentile paint various subjects – a process of testing (*tentare* and *experiretur*) which recalls demands set by other courts. For example in 1504, Isabella d'Este wrote, 'we have resolved to test (*experimentare*) new painters' for the Camerino in Mantua. Gentile's own father Jacopo had painted a portrait of Leonello d'Este in a competition with Pisanello.[18]

It seems that one of the tests required of Gentile was a self-portrait. Although Foresti's Latin text of 1490 is somewhat ambiguous, the Italian version of the following year explicitly states that Mehmed asked Gentile to paint himself before making a portrait of the ruler.[19] This was a requirement unprecedented in the fifteenth century. While Renaissance painters sometimes included images of themselves in narrative scenes or fashioned self-portraits to advance their professional status, Gentile's self-portrait is the first said to have been made as an exercise.[20]

Gentile anticipates by a century and a half Rembrandt, who early in his career made numerous self-portraits in order to develop modes for fashionable commissions. Gentile's self-portrait was also a display of virtuosity at court. A similar *tour de force* may be found in Jan van Eyck's putative self-portrait of 1433 (National Gallery, London), which is boldly inscribed, 'As I can'. In the following century Parmigianino presented his *Self-portrait in a Convex Mirror* (1524; Kunsthistorisches Museum, Vienna) to Pope Clement VII as proof of his talent.[21]

Giorgio Vasari in 1550 also reported that Gentile painted a self-portrait in Istanbul, but reversed Foresti's sequence of events. According to Vasari, only after Gentile had painted the Sultan 'so well that it was considered a miracle' was the artist asked if he had the courage to make a self-portrait.[22] A painter's own portrait, in Vasari's view, could not function as a preparatory step but was an accolade and an accomplishment superior to any state portrait. Although Gentile's Turkish self-portrait does not survive, he afterwards included his own features in three history paintings (see figs 10, 16 and 17) and a drawing (cat. 31).[23]

Gentile's surviving portrait of Mehmed II (cat. 23) sets the Sultan's image behind a carefully shadowed arch seen in perspective – illusionistic features which heighten the verisimilitude that so impressed the sitter. Foresti's report could also explain the date inscribed on the portrait, 25 November 1480, which is more than a year after Gentile arrived in Turkey; could the long delay have been due to the Sultan's careful testing of his painter? While it is very likely that Gentile produced replicas of the portrait, the only genuine example to survive is that in the National Gallery, London. This work, or a similar lost portrait, was copied on several occasions. Often attributed to Gentile is a double portrait of the Sultan with a young prince (private collection). Although there has been much speculation about the identity of the second figure, the painting is clearly a later pastiche: the stiff arrangement of figures behind a long parapet is an unconvincing arrangement, nor does the boy's portrait appear to be based on Gentile's work. A portrait of the Sultan seen over the shoulder (fig. 29) is an early sixteenth-century variant of the portrait in London. [24]

There also exists a portrait medal of Mehmed II bearing Gentile Bellini's signature (cats 19, 20). However, while the artist may have provided the drawing for the profile, it seems unlikely that he actually carved the model or cast it himself. It is also uncertain whether it was made in Istanbul or in Venice after Gentile's return. Bertoldo di Giovanni's medal (cats 21, 22) seems to be based on Gentile's, and there is some circumstantial evidence that Bertoldo cast his work in Florence in the spring of 1480 (Lorenzo de' Medici may have commissioned the medal as a gift for the Sultan in gratitude for the extradition of the assassin of Giuliano de' Medici).[25] But this would mean Bellini, who had never made a medal before, designed his medal between November 1479 and March 1480; it is more likely that a drawing by Gentile of the Sultan was sent to Florence. The medal bearing Bellini's signature, which exists in several fine examples, was therefore probably made in Venice in 1481 or later.

Decorating the New Palace

Another reliable account of Gentile Bellini in Istanbul is furnished by Giovanni Maria Angiolello, an Italian who served Mehmed the Conqueror between 1474 and 1481, and therefore must have known Gentile and his work first-hand. He hints at other motivations for the request for a Venetian painter in his description of Mehmed's love of gardens and art:

> Gardens delighted him and painting pleased him, and because of this he wrote to the Signoria who sent him a painter. It sent Master Gentile Bellini, most skilful in art, to him, who was most happy to see him. He wished him to make a drawing of Venice and portraits of many persons, which pleased the Sultan. When the Sultan wanted to see someone noted for being a handsome man, he had him portrayed by the said Gentile Bellini. . . . This Gentile made several beautiful pictures, and most of all things of luxury, some beautiful in style, of which there were a large number in the palace. And on accession, his son Bayezid had them all sold in the Bazaar, where our merchants bought many of them. And this Bayezid said that his father was domineering and did not believe in Mohammed, and in fact this seems to be why everyone says that this Mehmed did not believe in any faith at all.[26]

Although Angiolello reports that Gentile made many portraits in Istanbul, surprisingly he does not mention one of the Sultan. Instead, he described Mehmed II's unusual request for a portrait of 'someone famed for being a handsome man' (bell'huomo), which led Bellini to paint a dervish discovered on the city streets. Artist and sovereign discussed the dervish in a frank and friendly manner, an episode which demonstrated their closeness.

Gentile's many paintings reportedly decorated the New Palace, known since the nineteenth century as Topkapı Palace. If we can believe Angiolello, they must have been made on canvas or wood, since they were removed and sold by Mehmed II's son and successor Bayezid II, who also sold Mehmed's Christian relics. 'Things of luxury' (cose di lussuria) has long been interpreted to mean erotic or obscene images, but lussuria was a term also employed by Renaissance writers to mean opulence, abundance and ostentation, and Patricia Fortini Brown has argued that Gentile's paintings may have depicted banquets or festivities – images celebrating court magnificence that would have been appropriate for Topkapı Palace.[27] Francesco Negro (supposedly relying on information from the artist) also reported that the painter went to Constantinople specifically to decorate the Sultan's palace.[28]

Gülru Necipoğlu points out that by 1465 the inner rooms of the palace had been opulently decorated and that the Sultan was already living in the Privy Chamber (fig. 39) when Gentile Bellini arrived, so it is most unlikely that he would have painted frescoes there.[29] Easel paintings could have been hung anywhere, but it is also possible that Gentile was asked to decorate one of the pavilions then under construction in the outer gardens of Topkapı. Angiolello wrote that three 'palazzi [seen in Vavassore's map, cat. 1] are made in various styles. One is made in the Persian style . . . the second is made in the Turkish style, the third in the Greek style, covered in lead.'[30] The Persian palazzo survives as the Tiled Kiosk, but details about the others are lacking. However, it is clear that the pavilions represented three corners of Mehmed's empire, exactly like the three crowns found in Gentile's

FIG. 39
The Privy Chamber of Topkapı Palace,
Istanbul

portrait and medal of the Sultan, and in the medallion given the artist. Mehmed
may have been planning one of these pavilions to be European or even specifically
Italian, since in 1480 he invited several Italian decorators to his court. In January of
that year he asked Venice to send him a 'proto sopra li murari' or master mason, and
in March he wrote to Florence for 'masters of carving and of wood and of intarsia'
in addition to bronze sculptors – all of whom were sent.[31] After the capture of the
southern Italian port of Otranto in August 1480 Mehmed could claim Italy as
another territory of his domain, and an Italian pavilion would have symbolised
an empire nearly as extensive as those of antiquity. Gentile may have provided the
painted decorations of such a building.

The Sultan's Madonna

We learn from Francesco Suriano, a Franciscan friar from Venice, that Mehmed II
collected and treasured Christian relics, which he stored in a 'precious cabinet in a
room where there was nothing else except a Greek image of the Madonna, in the
presence of which a golden lamp was always kept burning'. The Sultan took Gentile
Bellini 'into this room and showed him all the figures. And then he took one out
which he always kept on his chest under his robes, and asked him to paint one that
would be the most beautiful of all. Having made one in modern style [ala moderna],
he presented it. When he saw it, he was very pleased and said, "As long as I live, this
will never leave my chest". All this master Zambellino recounted in my presence,
when he returned to Venice.'[32]

 Suriano did not actually state the subject either of Mehmed's locket or of
Gentile's painting (which the Sultan also intended to wear), but simply said that
Bellini was asked to paint something similar to one of the Sultan's 'figures'.

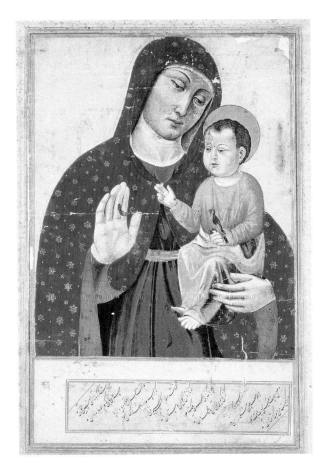

FIG. 40
Persian, after an Italian model
The Virgin and Child, late 15th century
Bodycolour and gold on paper, 27.3 × 23.5 cm
Istanbul University Library (F1422. fol.17b)

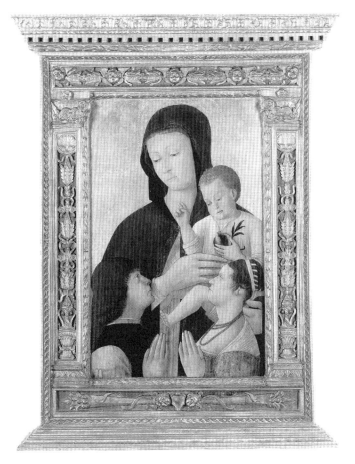

FIG. 41
Gentile Bellini
The Virgin and Child with Donors, 1460s
Tempera on wood (transferred to canvas), 73.5 × 45.5 cm
Gemäldegalerie, Staatliche Museen zu Berlin (1180)

Bernardino da Foligno, a less reliable source, wrote that the artist depicted the Virgin.[33] Mehmed II's collection of Christian relics is partly documented in an inventory drawn up in 1489 by his son Bayezid II, who offered to sell them to the King of France. Among the twenty-four relics was 'a very beautiful icon containing the image of the Virgin, and painted inside 300 saints, each holding a piece of a relic'.[34] This work seems too large to be the one worn by Mehmed, but may well be the icon placed in the room with a lamp. Mehmed II's interest in Christianity and Christian objects (he had ordered church relics brought to him intact and had refused to part with any of his relics, even for large sums) makes his commission to Gentile plausible.[35]

In 1980 Julian Raby argued at length that a manuscript illumination (fig. 40) in the Istanbul University Library was Gentile's lost painting of the Virgin made for Mehmed.[36] In 1932 Bernard Berenson had catalogued the work as by Gentile (without reference to the fifteenth-century reports) but in 1957 assigned it to a close follower.[37] David Roxburgh notes that the technique and style of the miniature is sixteenth-century Persian, and that the sheet has always been in an album assembled

in the 1550s or early 1560s for Shah Tahmasp.[38] Pasted beneath the image is a poem which alludes to the soul and immortality.[39]

Although the illumination is clearly not by Gentile Bellini, it descends from an Italian image of the mid-fifteenth century. The composition, drapery, and delineation of hands can be compared to Gentile's *Virgin and Child with Donors* (fig. 41) in Berlin as well as to Jacopo Bellini's paintings of the subject. On the other hand, the bulky outline of the Virgin, which lacks a convincing three-dimensionality, indicates the work of a copyist. It is possible that Gentile's original painting (or a copy of it) and his drawing of the *Seated Scribe* (cat. 32) were given to the Aqqoyunlu Turkmen rulers of Tabriz in the late fifteenth century and later absorbed into Safavid collections.[40] Indeed the *Seated Scribe* and the Persian *Madonna* were pasted into two closely related albums: the Boston drawing was in an album assembled in 1544–5 for Bahram Mirza, who was the brother of Shah Tahmasp, the owner of the album containing the Madonna.[41]

Other reports and rumours

Many of Gentile's reported activities in Istanbul cannot be confirmed by contemporary sources. For example, it is possible that Gentile Bellini sold or gave one of his father's two surviving drawing books to the Conqueror. Jacopo Bellini's album now in the Louvre was first recorded in Izmir (Smyrna) in 1728, with a story that it had been removed from Topkapı Palace.[42] However plausible this may seem, during the 250-year gap in the album's history it might have made its way to Turkey by a different route, especially since Izmir was an important trading port. No early source describes Gentile's gift of such an important object to the Sultan, nor does the album bear any inscription or mark indicating it had been in a Turkish collection. We may also wonder why Gentile would have parted with such a treasure-trove of compositional ideas that would have continued to inspire him and his brother Giovanni.

In 1702, Claude-François Menestrier published prints after drawings attributed to Gentile Bellini depicting the fourth-century Column of Theodosius, which had stood in the courtyard of Mehmed II's first palace in Istanbul.[43] It can be seen there in Vavassore's map (cat. 1), labelled '*Colona istoriata*'. The source for Menestrier's prints was a set of sixteenth-century drawings (fig. 42) very likely by Battista Franco.[44] Since the column was destroyed in 1517, Franco must have copied earlier sketches, although there is no way of determining whether these were by Gentile.[45] Access to the Old Palace was undoubtedly restricted and careful drawing of the immense column would have required scaffolding, privileges only granted a court artist. The Sultan was deeply interested in the ancient world and may well have commissioned drawings of a column which commemorated an ancient imperial victory. There is evidence that Gentile, too, was interested in antiquity: in his will he left to his assistants drawings of Rome – probably of ancient monuments.[46]

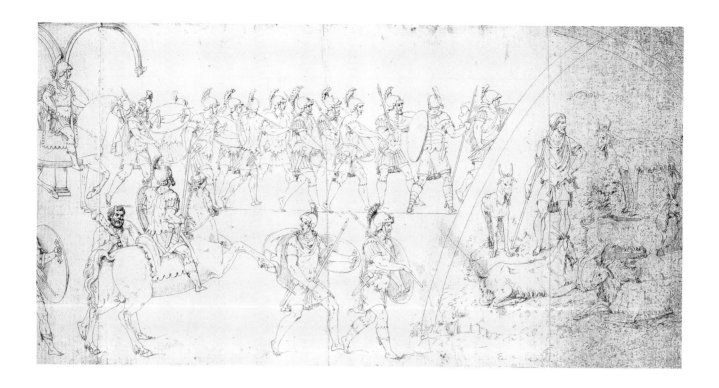

Honours

On 15 January 1481 Mehmed II drew up a letter praising Gentile Bellini, enumerating his new titles of golden knight and palace companion (*miles auratus ac comes palatinus*) and describing the gift of a gold medallion and chain.[47] Probably presented to the artist on his departure for Venice, the letter survives in a contemporary copy (fig. 43). Franz Babinger considered the document a deliberate forgery, but Julian Raby and Jürg Meyer zur Capellen have convincingly argued that it is an Italian transcription of the original.[48] The 1490 edition of Jacopo Filippo Foresti's *Supplementum chronicarum* confirms these honours; the 1491 Italian version translates '*equitem auratum*' as Knight of the Golden Spur, a European class of knighthood without Ottoman equivalent.[49]

Gentile Bellini had already been knighted and created a Count Palatine (*comes palatinus*) by the Holy Roman Emperor Frederick III in 1469, but these honours were entirely different from those received from the Conqueror.[50] Gentile never worked for the emperor, but was one of a large number of men granted honours, seemingly on demand, when the emperor toured Italy; Gentile's brother-in-law, Andrea Mantegna, rushed from Mantua to Ferrara to seek the same titles.[51] Venetian officials entertained Frederick III in hope that he would support their campaign against the Turks, and the titles seem to have been a polite way of excusing himself from costly Venetian wars.[52]

By the fifteenth century, it had become increasingly common to grant knighthoods to prominent artists, especially visitors from abroad whose unfamiliar styles might command attention and prestige.[53] Mehmed II is said to have knighted another Italian artist, Costanzo di Moysis, and the diplomat Giovanni Dario, was

similarly honoured and presented with sumptuous gifts.[54] In contrast to these purely formal investitures, Gentile Bellini was also welcomed into Mehmed's innermost household, as Foresti's account of 1490 specifies: 'He made him a member of his retinue [*familiarem*] and also palace companion as well as a golden knight [*comitem palatinum: equitemque auratum*; see note 16] with his own insignia and chain'. *Comes palatinus* in this case is not equivalent to the European title of Count Palatine, but has the more straightforward meaning of a palace companion.[55] This may signify that Gentile had joined the *müteferrika* corps of Mehmed's salaried household (one of several groups paid wages), which Angiolello described as numbering some two hundred courtiers paid monthly for their services.[56] The group included highly skilled doctors, philosophers, astrologers, jewellers and painters ('*depinatori*'), but Angiolello distinguishes within this rubric of courtiers an even more intimate group composed mainly of foreign nobles, 'which at this time the Great Turk kept close to him and with whom he kept good company'.[57]

According to Angiolello, the Sultan urged Bellini to speak freely, while the letter of commendation called the painter 'one of the most select and intimate members of the household'.[58] Gentile was thus one of the few artists to become a *familiaris* – a court intimate.[59] While Mehmed may have known of the European practice of conferring honours on artists, he may also have been seeking to emulate Alexander the Great, who, according to Pliny (*Natural History*, XXXV, 85–9), had an informal friendship with his favourite painter, Apelles, a member of his retinue. Given

FIG. 43
Copy of Mehmed II's letter of 1481 commending Gentile Bellini, about 1500
Tiroler Landesarchiv, Innsbruck

Detail of fig. 10

Mehmed's devotion to Alexander, his generosity to a prestigious painter should also be seen as strengthening his claim to universal rule.

Gentile's eastern honours were frequently described and depicted in Venice. Gambello's medal (fig. 45) shows the artist wearing a chain and medallion, presumably the gifts from Mehmed.[60] They can be more clearly seen in Gentile's last painting, *Saint Mark preaching in Alexandria* (fig. 10, detail left). The gold chain is formed by a double set of interlocking rings. The medallion is divided into two fields, the upper containing three five-pointed crowns vertically aligned in the arrangement also seen on Gentile's medal and portrait of the Sultan. The lower field contains an unclear ovoid form that may be the Conqueror's *tuğra*, the state insignia composed of the Sultan's title. The Sultan's letter states that the medallion bore an inscription and the Sultan's insignia. If this inscription is the *tuğra*, then the three-crown emblem appears to have been another official device of the Sultan. Although *Saint Mark preaching in Alexandria* was largely complete at the time of Gentile's death, it was finished by his brother Giovanni, who was responsible for Saint Mark and for much of the figure of Gentile himself. While Gentile may have planned to include his own portrait in the composition, as he had done in several other history paintings, the figure lacks the underdrawing seen in most of the canvas.[61] The prominence allotted Gentile, in red robes, standing further forward than any other figure, and wearing Ottoman insignia, undoubtedly represents Giovanni Bellini's homage to his recently deceased brother.

Gentile's signatures often use the title of knight without specifying whether the honour is imperial or Ottoman, but his medal depicting Mehmed (cats 19, 20) is boldly inscribed with his Turkish titles, *eques auratus* and *comes palatinus*.[62] Gentile's Ottoman honours were also explicitly and proudly proclaimed on his most prominently displayed painting, *The Departure of the Venetian Ambassadors*, on the north wall of the Great Council Hall of the Doge's Palace (destroyed in 1577), which was inscribed, 'Gentile Bellini has given these monuments to his homeland, having been summoned by the Ottoman, and made Knight as reward'.[63] Such a signature linking individual honour with a patriotic donation is unusual for the period. Gentile's display of his honours is sometimes dismissed as empty boasting, but this was not the common perception of contemporaries, even in the sixteenth century.[64] Vasari described Gentile's knighthood in positive terms and in his survey of knighthoods Francesco Sansovino cited the honour as a rare example of a European being created a knight by a non-Christian monarch.[65] In the 1490s, Francesco Negro took Gentile's Turkish titles to be proof of the superiority of Venetian painters. Negro specifically praised Gentile and Giovanni Bellini – 'servants of nature' – for contributing to the glory of the Venetian state and providing moral exemplars for its youth:

> At the request of Mehmed, King of the Turks, Gentile was sent all the way to Byzantium, where, demonstrating clearly by his skill and talent what Venetian blood is capable of, he both shed marvellous glory on Venetian painting and, rewarded with the rank of knight, adorned with a Phrygian mantle, a headdress, high boots and a gold collar, brought back to his homeland gold in the form of a wreath, the reward for his powers. With these things showing what is possible, let your youth attempt to practise [the art of painting], since it is a remedy for constant study and, what is more, an honourable relaxation for both mind and body that approaches virtue.[66]

Central to this exhortation is the recognition that Gentile received as Venice's cultural emissary to the east. The public proclamation of honours bestowed by Mehmed II, whether inscribed on a canvas in the Great Council Hall or on the medallic portrait of the Sultan, should be considered an act of patriotic pride rather than personal vanity.

Drawings at court

In Istanbul Gentile Bellini probably lived near Topkapı Palace, perhaps next to the workshop of royal painters – the *nakkaşhane* – on the Hippodrome, but as a courtier he frequented the palace's Third Court. At one corner stood the Privy Chamber (fig. 44), the residence of the Sultan, while diagonally opposite was the Inner Treasury, the repository for Mehmed's collection of books and art objects. This restricted enclosure also functioned as a school that trained boys to become the administrators and warriors of the Ottoman empire.[67] Kritovoulos describes these imperial pages as 'indeed of signal physical beauty and nobility and talent of soul . . . they were of high and renowned ancestry and splendid physique, and well trained in the royal palace'.[68] Besides academic subjects, the pages were also taught singing and painting, and in Mehmed II's reign young palace companions, especially nobles and princes, were given lessons with the pages.[69] As a palace companion, Gentile encountered these talented and picturesque pages daily. The sumptuously dressed youth depicted in the *Seated Scribe* (cat. 32) is undoubtedly just such an imperial page. He gazes calmly but steadily at the blank page in front of him and we cannot tell if he will begin to write or draw.

FIG. 44
The Third Court of the Topkapı Palace, Istanbul, with the Privy Chamber at upper right

When Frederick Martin discovered the *Seated Scribe* in Istanbul in 1905, he believed it was by Gentile Bellini, an attribution generally accepted until 1980, when Maria Andaloro and Julian Raby separately assigned it to Costanzo da Ferrara (more properly known as Costanzo di Moysis), along with seven related drawings in pen and brown ink (cats 24–30). However, both writers were less convincing in their attempts to reconstruct the œuvres of Gentile and Costanzo, and in 1985 Jürg Meyer zur Capellen returned the *Seated Scribe* to Gentile.[70] Since then the issue has escaped discussion, although several authors have simply adopted the attribution to Costanzo without comment.[71] This consensus seems altogether premature, since nothing is known of Costanzo apart from two portrait medals of Mehmed II and a handful of documentary references. These furnish no basis for attributing the *Seated Scribe* or indeed any other known work of art to him. It is perhaps the age-old bias against Gentile and the allure of a new artistic personality that have encouraged these reassignments.[72]

The *Seated Scribe* is finely drawn with pen in brown ink, with shadows rendered in delicate parallel lines which taper subtly. Watercolour was then applied over this initial drawing. The colour has covered the faint outline of the youth's profile, but the underlying pen lines are visible under magnification and in infrared reflectography. The depictions of foliage at the upper and lower left have no pen drawing and employ a different watercolour technique, and thus appear to be later additions. The colouring is unusual for an Italian drawing of this period – the pigment is not as thick and opaque as in manuscript illuminations – but parallels can be found in Jacopo Bellini's album in the Louvre, where a few of the drawings are coloured in similar fashion.[73] Gentile may have coloured his drawing in response to Ottoman court taste and in order to present the work to Mehmed II. The watercolour appears to have been applied by Gentile himself, since it carefully reinforces the three-dimensionality of the figure: the nuanced variation of tone in the red sleeves follows the pen drawing precisely in both outline and shadow. The blue robe was built up in parallel brushstrokes and then shaded, a technique which has no parallel in Ottoman fifteenth-century illumination. (Later strengthening of some of the folds with a darker pigment can be seen in the infrared reflectograph.) Gentile Bellini certainly knew how to mix watercolours and apply gilding to paper since he provided such recipes to a compiler of a nautical handbook.[74]

The pen technique and handling of the *Seated Scribe* is very similar to that of the seven other drawings of single figures. The treatment of the sleeves, for example, is nearly identical in cats 25–6. However, the other drawings are less spontaneous than the *Seated Scribe*, which has led to suspicions that they are close copies made by Gentile's workshop after lost originals. Even the finest of the drawings (cats 24–6), by Gentile should be considered clean versions based on earlier sketches, which explains the occasionally hesitant outlines. The remaining drawings (cats 27–30) appear to be by the artist's workshop or later followers.

Strongly Venetian in character, the pen work of these drawings (including the *Seated Scribe*) relates closely to that found in Jacopo Bellini's drawing book in the Louvre (see fig. 38). There is some disagreement whether the album's drawings are entirely by Jacopo Bellini, or whether the delicate sketches in metal point or black chalk were later strengthened in pen by workshop assistants, perhaps even including Gentile

and Giovanni Bellini. This practice is documented: in 1493 Gentile told an agent of the Marquis of Mantua that a drawing of Venice by Jacopo Bellini was so faint that it had to be 'worked in pen' ('*tocarlo con penna*'), a task that would take at least two months.[75] After the Louvre album had been inherited by Gentile Bellini, it is likely that his assistants retraced the sheets in pen. It is clear that Gentile's workshop possessed a common drawing style, characterised by delicate parallel pen-lines, often structured in moiré patterns – a style which can also be seen in the Turkish figure drawings.

Only a few drawings can be securely connected to paintings by Gentile Bellini and these are much later than the drawings made in Istanbul. Two quick pen sketches (cats 9–10) can be associated with several architectural drawings in Munich, and perhaps an earlier drawing of the Crucifixion inserted into Jacopo Bellini's Louvre sketchbook.[76] A self-portrait of 1496 (cat. 31) displays parallel strokes in black chalk which echo the shading employed in the *Seated Scribe*.[77]

The Turkish drawings also consistently display stylistic features encountered in Gentile's paintings. The crinkly folds of fabric which are common to all the figure drawings are seen again in paintings like *The Virgin and Child* in Berlin (fig. 41), particularly in the sleeves of the Christ Child's raised arm and the back of the female donor's dress. Caterina Cornaro's sleeve (cat. 8) is similarly treated. A sense of calm and composure pervades the drawings and many of Bellini's paintings, for example the group of serene, veiled women seated in the foreground of *Saint Mark preaching in Alexandria* (fig. 10). These portions of the painting were complete at the time of Gentile's death.[78] Indeed the standing veiled woman to the right of Saint Mark is based on one of the drawings made in Istanbul (cat. 24, see detail below). Although she now wears Mamluk garb, the pose and handling of the figure are very similar. This rare use of an Ottoman motif by Gentile Bellini (although reformulated for a different context) provides direct evidence that the entire group of pen drawings is by him and his workshop.

Far left cat. 24 (detail)

Left fig. 10 (detail)

31 *Self-portrait, 1496 or earlier*

Black chalk (pricked), 23.2 × 19.4 cm
Staatliche Museen zu Berlin, Kupferstichkabinett (KDZ 5170)

Gentile Bellini made more self-portraits than any other
fifteenth-century Venetian artist. He can be made out in the
crowds in three of his monumental narrative paintings (figs
10, 16 and 17), and, in Istanbul, Mehmed II reportedly required
him to paint a self-portrait as proof of his abilities before he
was allowed to begin the Sultan's portrait (see pp. 108–9).
Although the Turkish self-portrait does not survive, this
drawing might give some idea of its format. Crisp, angular
outlines contain more freely rendered shading made up of
long, repeated strokes of black chalk. Similar shading can also
be seen in the initial pen drawing of the *Seated Scribe* (cat. 32).
The outlines of Gentile's self-portrait have been densely
pricked with a fine pin to transfer the design to Gentile's
Procession in Piazza San Marco, which is dated 1496 (fig. 16).
The dimensions of the head are identical in both works.
Gentile appears on the left side of the canvas, apparently near
the figure of his brother Giovanni, with Giovanni Dario in
front of them.

Despite these strong connections, Tietze and Tietze-
Conrat doubted that the drawing could be a self-portrait
since Gentile did not look directly out as in a mirror, and
they wondered whether Giovanni Bellini might have drawn
his brother. However, as Rearick noted, many Renaissance
self-portraits do not gaze directly at the viewer because they
were made with two mirrors. Gentile's other self-portraits
in *The Miracle at the San Lorenzo Bridge* and the *Saint Mark
preaching in Alexandria* look away from the viewer, as do, for
example, the self-portraits of Titian.

This drawing is similar in style to a portrait of a young
man also in Berlin (KDZ 5136). More stiffly sketched, the
young man was probably drawn by Gentile's workshop in
preparation for *The Procession in Piazza San Marco*, which
contains many similar types. Opinions on the relationship
of the two drawings have varied widely: Tietze and Tietze-
Conrat (1944) and Goldner (2004) thought that the exhibited
drawing was by Giovanni and the young man by Gentile;
Rearick (2003) reversed the assignments. Meyer zur Capellen
and Schulze Altcappenberg attributed both to Gentile.
Giovanni Bellini's drawings have also presented difficulties,
although a generally convincing reconstruction of his drawn

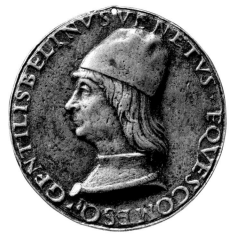

FIG. 45
Vittorio Gambello (1455/60–1537)
Medal of Gentile Bellini, about 1490
Bronze, diameter 5.9 cm
The British Museum, London (C&M 1936-8-3-1)

œuvre has been recently advanced by George Goldner. In
style and technique, the exhibited self-portrait drawing has
little in common with the sheets he attributes to Giovanni
Bellini. For example, it is entirely different in intensity from
the *Portrait of a Man* in black chalk (Christ Church Picture
Gallery, Oxford), which Goldner now assigns to Giovanni. AC

PROVENANCE

Adolf von Beckerath, Berlin (by 1886); acquired by the museum in 1902.

SELECTED BIBLIOGRAPHY

Attributed to Gentile Bellini except as noted: Berlin 1899, p. 53; Hadeln 1925,
p. 44; London 1930, no. 695; Tietze and Tietze-Conrat 1944, p. 68 (Giovanni
Bellini?); Gibbons 1963, p. 256 (Giovanni?); Collins 1970, pp. 205–6 (not
Gentile); Meyer zur Capellen 1985, pp. 162–3; Fletcher 1992, p. 48; Schulze
Altcappenberg 1995, no. 4; Bambach 1999, p. 106 (Giovanni or Gentile);
Goldner 2004, pp. 253–4 (Giovanni); Rearick 2002, pp. 153–4.

32 *Seated Scribe, 1479–81*

Annotated on attached cartouche upper right in Persian:

عمل ابن مؤذن كه از استادان مشهور فرنگ است

amal-i ibn-i mu'azzin ki az ustâdân-i mashhûr-i firang-ast (The work of ibn-i mu'azzin, who is among the well-known masters of Europe)

Pen in brown ink, with watercolour and gold, on paper, 18.2 × 14 cm
Isabella Stewart Gardner Museum, Boston (P15e8)

This drawing of a young man, probably a page at Mehmed II's court, forms an important link between east and west. Gentile Bellini first drew the figure, who is about to draw or write, in pen and ink before colouring and gilding it in a manner apparently inspired by Islamic techniques. In 1906 Frederick Martin ascribed the sheet to Gentile, a theory for the most part accepted until 1980, when Andaloro and Raby separately attributed it to Costanzo di Moysis. Meyer zur Capellen (1985) returned it to Gentile. The major difficulty in assigning the *Seated Scribe* and a related group of drawings (cats 24–30) to Costanzo is that the only documented works by the artist are two medals of Mehmed II (cats 16–18), which provide no basis for attributing these delicate pen drawings. On the other hand the drawings can be directly associated with Gentile Bellini's workshop, and one motif can be connected with a painting by the artist (see pp. 118–19).

The *Seated Scribe* was probably sent to the Aqqoyunlu court in Tabriz in the fifteenth century and was certainly at the Persian Safavid court by 1544–5,[1] when it was mounted into an album (Topkapı H2154) prepared by Dust Muhammad for Bahram Mirza, the youngest son of Shah Isma'il.[2] At that time a cartouche, attributing the work to 'son of muezzin', was pasted on the upper right of the sheet.[3] In 1907, the word 'muezzin' (the caller to prayer) was creatively interpreted as a misreading of a Greek rendition of Bellini.[4] Alternatively, Andaloro and Raby proposed in 1980 that 'Ibn-i Mu'azzin' was a rendering of 'de Moysis', Costanzo's patronymic. Although this reading has since been called proof of Costanzo's authorship, it too is unconvincing. Costanzo di Moysis simply means 'Costanzo son of Moses' and the artist would not have been called by his patronymic alone, 'di Moysis', in either Italian or Turkish practice. Costanzo, a form of the name Constantine (which the artist sometimes also used), and Moisè (Musa in Ottoman) must have been extremely familiar names in Istanbul in the late fifteenth century and it is difficult to imagine that they were garbled. Moreover, David Roxburgh's discovery that the album containing the *Seated Scribe* was compiled in Persia in 1544–5 means that the enigmatic inscription, added more than sixty years after the drawing's creation, cannot be taken as direct evidence of an attribution.

In the context of the Bahram Mirza album as a whole (Topkapı H2154), the importance of the inscription is its claim that the *Seated Scribe* was by a famous European artist. The album's preface specifically notes that 'the custom of portraiture flourished so in the lands of Cathay and the Franks [Europe]',[5] and indeed the album originally contained several Ming dynasty drawings (and others done in Chinese style) and, to represent European art, not only the *Seated Scribe* but also a sixteenth-century Italian portrait of a boy in oils. Furthermore, Roxburgh's analysis of the album shows that its texts delighted in jokes and puns, so the reference to 'son of muezzin' – an enigmatic use of a familiar term – is less likely an attribution than wordplay.[6] In this Persian album, Gentile's drawing became a paragon of European art. Worthy of emulation, the *Seated Scribe* was copied by at least two Persian artists who undoubtedly studied it in the Bahram Mirza album. AC

NOTES

1 Necipoğlu 2000, p. 30 n. 32
2 Roxburgh 1998 and Roxburgh 2005, pp. 245–307.
3 Transcribed and transliterated by Wheeler Thackston, who notes that the Persian is not simply an attribution to a son of a muezzin (*ibn al-mu'azzin*).
4 Sarre 1907; Martin 1907.
5 Thackston 2001, p. 12.
6 Roxburgh 2005, pp. 245–50, 283.

PROVENANCE

In Persia by 1544–5, mounted into the album belonging to Bahram Mirza; probably given to the Ottoman court (possibly 1568 or 1576); several sheets were removed from the album in the nineteenth century; acquired in Istanbul by Frederick Martin around 1905; sold in 1907 to Isabella Gardner, Boston.

SELECTED BIBLIOGRAPHY

Attributed to Gentile unless noted: Martin 1906, 1907, 1910; Sarre 1906, 1907; Hendy 1931, pp. 32–4; Berenson 1932, p. 68; Atıl 1973, pp. 112–13 (uncertain); Hendy 1974, pp. 16–17; Andaloro 1980, pp. 197–8 (attr. Costanzo); Raby 1980, pp. 61–76 (Costanzo); Meyer zur Capellen 1986, p. 125–6; Blair and Bloom 1994, p. 325 note 55 (Costanzo?); Roxburgh 1998, pp. 39–40, 50–1 (uncertain); Mack 2002, pp. 157, 175–6 (Costanzo); Spinale in Chong et al. 2003, p. 97; Barry 2004, pp. 42–4; Roxburgh 2005, pp. 301–2 (uncertain).

33 *Seated Artist, about 1600*

Watercolour with gold on paper, 20 × 14.4 cm
(with a decorated border, mounted on a page, 33.4 × 27.4 cm)
Annotated lower left in Arabic script: Bihzad/[89?]
Dar al-Athar al-Islamiyyah at the
Kuwait National Museum (LNS 57 MS)

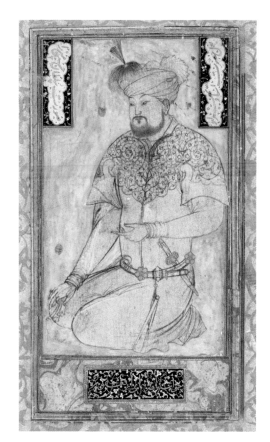

FIG. 46
Persian (Timurid), late 1400s
Portrait of Sultan Husayn Mirza
Ink, watercolour and gold on paper, 18 × 11 cm
Arthur M. Sackler Museum,
Harvard University Art Museums, Cambridge (Mass.)
Gift of John Goelet, formerly in the collection of
Louis J. Cartier (1958.59)

This reversed copy of Gentile Bellini's *Seated Scribe* (cat. 32) was probably based not directly on the original but on another copy of it in the Freer Gallery of Art (fig. 47). Although the painting is generally considered to be Mughal – and the Freer version Ottoman – several features suggest that both works are strongly linked to a Safavid context (the Safavid dynasty ruled Persia from 1501 to 1732). Both here and in the Freer painting the design of the scribe's costume (as seen in the work in the Gardner Museum) has been reinterpreted as a cloud collar, emphasised even further in this image by the contrast between the red of the artist's garment and the blue ground of his collar. The cloud collar is highly reminiscent of one worn by the Timurid Sultan Husayn Mirza (ruled 1470–1506) in a late fifteenth-century portrait (fig. 46) once bound in the same album as the Gardner *Scribe* (Topkapı H2154). The creator of the Kuwait painting may have had access to the entire album. In addition to their own Persianate appearance, both the Freer and the Kuwait *Seated Artists* are painting figures in Persian costume – rather than Ottoman or Mughal – on the sheet in front of them.

The sensitive treatment of the artist's face in the Kuwait miniature finds parallels in both Mughal and Safavid art. The fact that numerous Safavid artists emigrated to India in the sixteenth century as well as both cultures' close and deliberate dependence on Timurid artistic models explain their stylistic affinities and shared admiration for the late Timurid artist Bihzad (about 1450–1535/6), to whom the Freer and the Kuwait paintings have been spuriously attributed (as has fig. 46). While the Gardner *Scribe* may have been incorporated into the Bahram Mirza album of 1544–5 as a specimen of a foreign, even 'illicit' mode of depiction, these later paintings attest to the success of Bellini's portrait among Safavid and possibly Mughal audiences.[1] The Venetian had struck a chord with his eastern courtly audiences, consisting of practitioners and patrons alike. The three incarnations of the *Seated Artist* or *Scribe* demonstrate that this once foreign model was incorporated into the intertextual dialogue between the visual cultures of the Ottoman, Safavid and Mughal courts. EF

NOTE

1 Roxburgh 2005, pp. 295–304.

PROVENANCE

Martine Béarn de Behague, Paris; acquired before 1981.

SELECTED BIBLIOGRAPHY

All as Mughal: Jenkins 1983, p. 139; Meyer zur Capellen 1985, p. 126; Atıl 1990, pp. 221, 246 (by W. Denny), no. 79; Blair and Bloom 1994, p. 325, note 55; Barry 2004, p. 44.

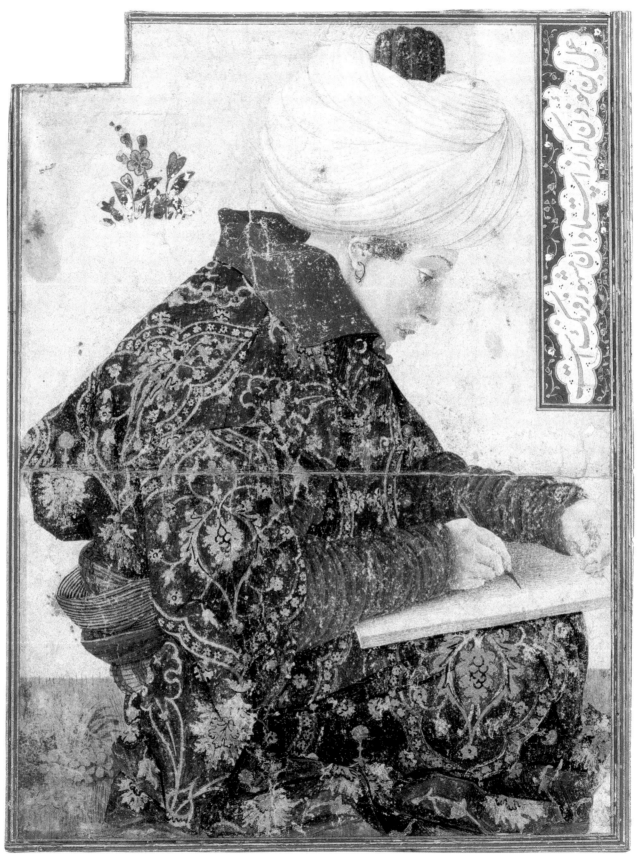

32

33

FIG. 47
Persian (Safavid)
Seated Artist, late 16th century
Opaque watercolour and gold on paper, 18.8 × 12.7 cm
Freer Gallery of Art, Smithsonian Institution,
Washington, DC (F1932.28)

The artist formerly known as Costanzo da Ferrara

Costanzo di Moysis's first medal of Mehmed II (cat. 16) is boldly modelled and impressive in scale, although the solitary surviving example has casting flaws and shows no original chasing; the reverse is a less inventive derivation of Pisanello's half-century-old medal of John VIII Palaiologos (fig. 26). The second version of the medal (cats 17, 18) is more awkward and George Hill even wondered whether it might be by a copyist.[79] Besides these two medals, nothing by Costanzo survives. Much of our knowledge of the artist comes from a letter of 1485 written by Battista Bendidio, the Ferrarese ambassador in Naples, to Eleonora of Aragon, Duchess of Ferrara.

> … this master, who has painted the above-mentioned Signore, your son [Ferrante d'Este], is named Master Costantio, who is said to be from Ferrara because he spent a long time there and has for a wife one of our Ferrarese women: and he is the one sent now many years ago by His Majesty the King to the Grand Turk when he asked him to send a painter from these parts; and he stayed there many years and was well looked after by this Grand Turk, who made him a knight.[80]

Bendidio also reported that Costanzo deposited money from his wife's dowry with someone named Baldisera. Ferrarese documents prove that Costanzo's wife was Caterina, the daughter of Titolivio, a well-known painter at the Ferrara court. A dispute concerning Caterina's dowry, part of which was indeed deposited in the bank of Baldissario Macchiavelli, records Costanzo in Ferrara in January 1474, July 1476 and October 1485.[81] In these documents the artist is called Costantino de Moysis (or Museto) and said to be originally from Venice.[82] Costanzo is termed a citizen of Ferrara in 1476 but not two years earlier, which suggests that he had taken citizenship in the interim, probably in order to work in the city, although despite this and his relationship to an Este court artist no payment to Costanzo is recorded in the Ferrarese archives, which are unusually extensive.

Bendidio's report that Costanzo went to Istanbul is not confirmed by any other source, but it parallels aspects of Gentile Bellini's experience in the east. Mehmed II seems to have asked Ferrante I of Naples for a painter, without specifying an individual; one was sent and, after a successful residency, was knighted for his service. In contrast to the pride Venice took in Gentile's Ottoman titles, Costanzo's knighthood is not otherwise mentioned.

There has been unnecessary confusion over the artist's name. Bendidio wrote simply that Costanzo was 'said to be from Ferrara', not that his name was Costanzo da Ferrara – a form which appears in no contemporary document. The signatures on his two surviving works read *Constantius* and *Constantii*, Latin forms of Costanzo. In Naples, the artist was consistently named Costanzo di Moysis – in 1483, 1485, 1488, 1491 and 1492[83] – while in Ferrara he was called Constantino di Moysis.

These documents also help isolate the probable date of Costanzo's visit to Istanbul, since Costanzo di Moysis is not recorded in Italy between 1476 and 1483. Mehmed II must have asked the King of Naples for a painter during one of the rare intervals when the two nations were not at war. The diplomatic record is hazy since Naples and the Ottomans never finalised a peace treaty, but tentative negotiations took place in 1467

and in 1477–9. In April 1467 the Neapolitan ambassador to Istanbul was instructed to determine what gifts from Naples might be pleasing to Mehmed II.[84] Unfortunately the ambassador's reply does not survive. Because Costanzo is not recorded at all before 1474 and seems to have been still living in 1524, it is more likely that he was sent to Istanbul after Ferrante I began peace negotiations with the Turks in late 1477 or early 1478.[85] The peace treaty which Venice concluded with the Ottomans in January 1479 came as a shock to the other European states, and ambassadors from Naples, Hungary and the Holy Roman Emperor hurried to Istanbul to parry Venice's advantage, although it is doubtful that Naples would have sent an artist during this tense period.[86] It therefore seems most likely that Costanzo di Moysis was in Istanbul in 1478 and that the treaty with Venice in January 1479 signalled the end of his tenure. If Costanzo was recalled by Naples or dismissed by the Sultan early in 1479, he would never have met Gentile Bellini. Indeed the request for a Venetian painter, while celebrating the new rapprochement with Venice, may have been partly occasioned by Costanzo's departure.

Otherwise, Costanzo's artistic activities were entirely confined to Naples. Besides painting Ferrante d'Este in 1485, Costanzo decorated a room at the villa La Duchesca in 1488, painted religious pictures in 1491 for the monastery of San Marcellino, and made a wooden arch the following year (the last two projects in collaboration with others).[87] In 1524 Pietro Summonte surveyed Neapolitan art in a letter to the Venetian connoisseur Marcantonio Michiel: 'Returning therefore to our painters, I say that we have not had a distinguished painter here since Colantonio. For the last forty years we have had here a master, the Lombard Costanzo, who has lived in this city – a painter of good drawing, more than anything else, from whose hand is a painted room in Poggio Reale …'.[88] Summonte's late, lukewarm notice has been misinterpreted as a strong endorsement of Costanzo's talents and support for the attribution of the Turkish figure studies to him.[89] In this context, *disegno* might be understood as creative invention, rather than skilful drawing, in contrast to naturalistic handling of colour. The statement that Costanzo was Lombard is, strictly speaking, mistaken, although he was associated with nearby Ferrara. Finally, the attribution to him of a *camera dipinta* in Poggio Reale may be a confusion with frescoes by Pietro and Ippolito Donzelli, which were of the same subject as Costanzo's paintings at La Duchesca.[90] It is therefore quite possible that Summonte is not even describing the work of Costanzo di Moysis.

We should be wary of the inflated claims made for Costanzo di Moysis's abilities. In 1930, George Hill praised Costanzo's first medal of Mehmed II (cat. 16) as 'easily the finest presentation of Mohammed II extant. Those who are looking for traces of Gentile Bellini's work at Constantinople would do well to remember Costanzo, of whose painting traces may perhaps remain there'.[91] The medal has even been called 'one of the finest portraits of the Renaissance',[92] but caution is required in reconstructing Costanzo's œuvre in the absence of stylistic evidence.

Italian engravings

Angiolello tells us that Gentile Bellini's Turkish paintings were all sold at the Bazaar after Mehmed II's death in 1481; Costanzo di Moysis's works, apart from the medal of the Sultan, have been lost. At least a few of the Italian medals of the Conqueror were preserved because his exiled son Cem distributed them in Italy.[93] In addition, an album in Topkapı (H2153) contains a number of drawings and prints associated with Mehmed II. The album seems to have been originally compiled for the Aqqoyunlu Turkmen ruler Ya'qub Beg and his successors at the end of the fifteenth century. It made its way to Istanbul in the sixteenth century, after which a few works connected with Mehmed were pasted into the album.[94]

These additions include two Turkish portraits of the Sultan based on the work of Gentile and Costanzo. *Mehmed II smelling a Rose* (fig. 35) duplicates the angle and shading of the face as painted by Bellini in the portrait in London (cat. 23), but the rest of the composition is entirely different and may reflect a lost work by Bellini.[95] The second portrait (fig. 34) closely resembles the image on Costanzo's medal.[96] Two bust-length drawings in the album depicting a young janissary and a Greek merchant are also Turkish emulations of Italian works.[97] The network of white lines used for highlights and the shading of the truncated busts echo western techniques of perspectival drawing, while the interest in different figural types encountered in Istanbul parallels Gentile's pen studies.

The same album also contains fifteen Florentine and Ferrarese engravings, which may constitute a collection owned by Mehmed II, although nothing is documented of their early history.[98] (For the suggestion that the prints may have come to Istanbul via Tabriz, see above, p. 93.) All the engravings date from around 1470 and many are coloured and folded in an identical manner. Because they were added to the album H2153 at the same time as were the portraits of the Sultan, it is plausible that they all belonged to Mehmed II. The faded and speckled state of the prints (in which they differ from the core of the album) hints that they were frequently displayed. How the prints came into the Sultan's possession is a mystery, although an Italian traveller must have brought them to Turkey. Raby suggested that the source may have been Benedetto Dei, a Florentine merchant in Istanbul between 1460 and 1466.[99]

Among the prints is an engraving inscribed *El Gran Turco*, the Sultan's most common Italian epithet (fig. 28). This imagined portrait of Mehmed II and the themes shared among the prints hint that the group was specially chosen as a gift for the Sultan. The deliberate variety of imagery constitutes a virtual survey of Italian printmaking around 1470: a devotional print is accompanied by several illustrations from the lives of Saints Jerome, Gregory and Sebastian, and by secular subjects including a *tarocchi* card. Many of the prints represent aspects of the nude, as seen in the depictions of Saint Sebastian, of dancing nudes and putti at a winepress and of Hercules and the Hydra. An additional image of a vine with putti and phalluses has long been thought to belong to this group (Arthur Hind was criticised for his prudishness in omitting it from his catalogues), but the work is in fact a sixteenth-century Northern European (perhaps South German or Swiss) pen drawing which could not have belonged to Mehmed II.[100]

The group of prints conveniently encapsulates the principal aspects of Mehmed II's fascination with the west, for the images represent the ancient world, Christianity, the Italian Renaissance and, in one case, portraiture. Indeed the engraving *El Gran Turco* is an early manifestation of the Sultan's long-standing preoccupation with creating a portrait of himself. This allegorical portrait of the Sultan, made before any Italian had depicted him from life, may have been presented merely to amuse and delight – the original engraver could never have imagined that the print would make its way into Mehmed II's hands. However, the print may have further encouraged him to seek out Italian sculptors and painters who would depict his features in naturalistic fashion. This resulted in several commissions for portrait medals and culminated in Gentile Bellini's rendering of Mehmed in paint – an intensely characterised portrait made just a few months before the Sultan's death.

Notes

DEBORAH HOWARD:
VENICE, THE BAZAAR
OF EUROPE

1 Meyer zur Capellen 1985, pp. 109–11, docs 14–21.
2 This sketchbook is now in the Louvre: see Eisler 1989, pp. 94, 100, 180, 464–74.
3 Howard 2000, pp. 20, 23–5, 172.
4 Kritovoulos 1954, p. 74; Barbaro 1969, p. 22.
5 Pertusi 1983, p. 72.
6 Kritovoulos 1954, pp. 76–7.
7 Ibid., p. 93.
8 Restle 1981, p. 361; Raby 1982, p. 7. Renowned for its size and magnificence, this mosque was destroyed by an earthquake in 1766 and completely rebuilt. It is therefore difficult to assess how far Byzantine or Italian elements were incorporated into its design, although spoils from the Apostoleion were probably incorporated.
9 Bianchi and Howard 2003.
10 Raby 1982, p. 7; Necipoğlu 1991, p. 14.
11 Restle 1981; Necipoğlu 1991, p. 14–15.
12 Raby 1982, p. 7; Necipoğlu 1991, pp. 9–10, 137–8.
13 Filarete 1965, I, p. xviii.
14 Restle 1981, p. 361; Raby 1982, p. 7; Necipoğlu 1991, p. 10.
15 Fiore 1988, pp. 62–5.
16 Raby 1987, p. 176.
17 Raby 1982, p. 7.
18 Babinger 1978, p. 410, based on unspecified Venetian diplomatic sources. This is also a recurrent theme in Kritovoulos's narrative.
19 Kritovoulos 1954, pp. 44–6, 51–2.
20 Imber 1990, pp. 192–218, summarised in Inalcık 1973, p. 28.
21 Imber 1990, p. 201.
22 Ibid., pp. 219–20, 236–41.
23 Brown 1988, pp. 71–2, 290.
24 Babinger 1978, p. 372.
25 Freely 2004.
26 Schulz 1978; Howard 1997.
27 Howard 2000, pp. 62–4.
28 Ibid., pp. 67–71.
29 Ibid., pp. 18–19, 219–21.
30 Ibid., p. 38; Bianchi and Howard 2003, pp. 240, 247.
31 Bianchi and Howard 2003; Howard 2003. See also Vallet 1999.
32 Meyer zur Capellen 1985, p. 144, nos. B8a–c, figs 87–9.
33 Sauvaget 1945, pp. 5–12; Cuneo 1991.
34 Brown 1920; Nicol 1988, pp. 60–4, 88–90.
35 Nicol 1988, pp. 198–200, 289–94.
36 Zorzi 1981, p. 13.
37 Barbaro 1969, pp. 72–4.
38 Cacciavillani 1995, p. 55.
39 Sanudo 1879, XXXIV, col. 158. See also Finlay 1984, p. 79.
40 Lehmann 1977; Raby 1982, pp. 35, 41–3; Meyer zur Capellen 1985, pp. 89–98, 131–2; Brown 1988, pp. 74–5, 203–9, 291–5; Raby 1991,

pp. 77–80; Mack 2002, p. 165; Scarpa 1997.
41 Vasari (1966, III, p. 437) mentions that the gold chain was still in the hands of Bellini's heirs.
42 Newett 1907, p. 129; Kinser 1973, p. 493.
43 Pedani Fabris 1993, p. 14; Concina 1997, pp. 118, 140, 240–4; Howard 2000, pp. 126, 223 n. 54.
44 Pedani Fabris 1991, p. 15.
45 Preto 1975, pp. 132–3; Tucci 1985, pp. 51–5; Concina 1997, pp. 219–40.
46 Howard 2000, pp. 34, 64.
47 Preto 1975, pp. 120–8; Zele 1989; Pedani Fabris 1994.
48 Raby 1991, p. 79.
49 Auld 1989, p. 186.
50 The idea was first challenged by Huth (1970). Auld (1989) still preferred to keep open the possibility of Muslim metalworkers active in Venice.
51 Brown 1988, pp. 70–1, 290–1.
52 The issues are clearly summarised in Mack 2002, pp. 139–47.
53 Bianchi and Howard 2003, pp. 252–3.
54 Vasari 1966, I, pp. 168–9.
55 Allan 1986.
56 Ward 1993, p. 103; Auld 2004, pp. 104–7.
57 Robinson 1967, pp. 169–73; Auld 1989, p. 185.
58 Hobson 1989; Rogers 1999, p. 139; Mack 2002, pp. 127–35.
59 Babinger 1978, pp. 378–80; Raby 1982, pp. 4–5; Meyer zur Capellen 1985, p. 109, doc. 14c (Francesco Suriano).
60 McCray 1999, pp. 135, 145–6.
61 Contadini 1999, pp. 2–3.
62 Howard 2000, pp. 189–216.
63 Bianchi and Howard 2003, p. 249.
64 Landau and Parshall 1994, p. 43.
65 Marshall 1984; Brown 1988, p. 194.
66 Contadini 1999, pp. 4, 18–19; Pixley 2003.
67 Thornton 1997, pp. 33–43, 77–93.
68 New York 1984, pp. 26, 30, nos. 29–32, 37. See also Shalem 1998.
69 Jardine 1996, for example pp. 5–12.
70 Mack 1997, pp. 60–3; Mack 2002, pp. 82–4.
71 Mack 2002, pp. 54–62.
72 Longo 1994; Pedani Fabris 1996, pp. 4–7.
73 Babinger 1978, p. 411.
74 Hind 1933, p. 279; Raby 1981, pp. 44–6; Raby 1982, pp. 5–6; Landau and Parshall 1994, pp. 91–5.
75 Kritovoulos 1954, pp. 209–10. On Mehmed's interest in Italian cartography see especially Landau and Parshall 1994, p. 94.
76 Meyer zur Capellen 1985, p. 110, doc. 14g.
77 Bonfiglio Dosio 1987, pp. 203–4.
78 Babinger 1978, p. 371.
79 Avery 2003.
80 Meyer zur Capellen 1985, p. 110, doc. 14g; Eisler 1989, p. 94.
81 Meyer zur Capellen 1985, p. 110, doc. 14g.

CAROLINE CAMPBELL:
THE BELLINI, BESSARION
AND BYZANTIUM

This essay is dedicated to Jennifer Fletcher, who has inspired me and many others to study the Bellini family. I would like to acknowledge her generous support, as well as that of Luke Syson and Deborah Howard.

1 Biblioteca Nazionale Marciana, Venice, cod. Lat. XIV 14 (=4235), transcribed by Mohler 1942, III, pp. 541–3; translated by Martin Lowry in Chambers and Pullan 1992, pp. 357–8.
2 Venice 1994, pp. 381–2, no. 1.
3 Geanakoplos 1962, p. 81.
4 Zorzi 1994a, p. 220.
5 For Bessarion's other probable gifts to Venice see Venice 1974, no. 113; Venice 1994, pp. 454–5, no. 68; New York 2004, pp. 138–9, no. 74. For his use of Greek artefacts and patronage of contemporary art as diplomatic tools see Lollini 1994; Finocchi Ghersi 1994; Harris 1996a; Effenberger 2004, p. 211; New York 2004, pp. 231–3, no. 139.
6 For the lack of interest taken initially in Bessarion's library by the Venetian government, see Chambers and Pullan 1992, p. 355.
7 The act of donation is transcribed in Schioppalba 1767, pp. 123–32. Earlier the same month Bessarion also gave the Scuola a small reliquary containing another part of Christ's robe: Venice 1994, pp. 454–5.
8 For the contentious identification of this princess, see Schioppalba 1767; New York 2004; Polacco 1994. Polacco (1992, p. 89 n. 19) summarises the various contenders.
9 Schioppalba 1767, pp. 112, 119.
10 Pullan 1971, pp. 37–8; Pignatti 1981, pp. 30–5. There were four Scuole Grandi until 1489, when the Scuola di San Rocco, founded in 1478, was added to their ranks.
11 29 August 1463. See Schioppalba 1767, p. 123.
12 Schioppalba 1767, p. 132; Polacco 1994, pp. 369, 378 n.8.
13 For Bessarion's ecumenical coat of arms, see Palladino 2003, p. 85, no. 43, and Christie's, London, 20 November 2002 (lot 27), pp. 48–9, no. 27.
14 Constantoudaki-Kitromilides 1998. For the suggestion that Bessarion inspired Venetian representations of Jerome and Augustine, see Brown 1994.
15 Pullan 1971, pp. 52–3.
16 Ibid., pp. 34–40; Brown 1988, p. 21.
17 Brown 1988, pp. 135, 139–40. For the representation of the reliquary in Titian's *The Vendramin Family* (NG 4452) see Pouncey 1938.
18 For a comparison of the efficacy of the two Holy Cross reliquaries, see Welch 1997, pp. 151–2.

19 Polacco 1992; Lollini 1994.

20 For a summary of this debate see Lazarev 1967, p. 408; New York 2004, pp. 540–1, no. 325.

21 For a summary of Palaiologan painters in active in Crete and Venice in the fourteenth and fifteenth centuries, see Georgopoulou 2004, pp. 491–2 n. 27; for Bessarion's connections to Crete, see Geneakoplos 1962, ch. 5.

22 Michiel 1903, p. 132.

23 Polacco 1992, p. 93. These sources are also Florentine, see Lieberman 1972, pp. 171–2; 347–56.

24 Schioppalba 1767, pp. 136–41. The commissioners were Jacopo Parleone, Gualtiero Giustiniano and Jacopo Sceba. Bessarion died in the Venetian governor's house in Ravenna on 18 November 1472.

25 Schioppalba 1767, pp. 142–5.

26 Ibid., p. 144.

27 Ibid., pp. 144–5.

28 Ibid., p. 145.

29 Rosand 1982, p. 234, doc. 19.

30 Vast 1878, p. 432. These included the anniversary of Bessarion's death and the feasts of the Blessed Virgin, Corpus Christi and Good Friday.

31 Schioppalaba 1767, p. 153.

32 Sansovino 1581, p. 100; Schioppalalba 1767, p. 148.

33 Sansovino 1581, p. 100. The portrait was stolen in 1540, and a copy (which can still be seen in the Carità's albergo) was commissioned from Giovanni Bellini's pupil Cordegliaghi in 1540. See Schioppalalba 1767, p. 149.

34 Michiel 1903, p. 132; Schioppalalba 1767, pp. 147–9.

35 For Aliotti's sonnet see Testi 1909, II, p. 159 n. 2.

36 Meyer zur Capellen 1985, pp. 144–5, no. B9; Brown 1988, pp. 269–70, 271–2; for Jacopo Bellini's banner for the confraternity see Pignatti 1981, p. 33, for the four Bellini workshop Carità triptychs see Moschini Marconi 1955, II, pls 78–81.

37 Weiss 1967, p. 4 n. 20.

38 Piccolomini 1960, p. 69. For Bessarion's beard, see Labowsky 1994, pp. 285–6; Lollini 1994a, p. 275; Bianca 1999, pp. 159–67, appendix III.

39 Wright 2000, p. 98.

40 Labowsky 1994, pp. 289, 294; Meyer zur Capellen 1985, p. 56. For Gentile's later painting of Bessarion in the Hall of the Great Council see Sansovino 1581, p. 131; Ridolfi 1914, I, p. 56, 'Vita di Gentile Bellino Pittore e Cavaliere'.

41 Weiss 1967, p. 4, pl. II.

42 Bessarion had been elected a member of the Venetian Great Council in 1461: see Zorzi 1994, p. 8.

43 Geanakoplos 1976, p. 178.

44 Georgopoulou 2004, p. 489.

45 Thiriet 1959, p. 436.

46 Nicol 1988, pp. 414–18.

47 Fedalto 2002, p. 92.

48 Imhaus 1997, pp. 56–60, 85–129, 435–75, appendix A; Harris 1996, p. 25.

49 Geanakoplos 1962, pp. 37–9, 58; Lowry 1979; Sansovino 1581, p. 132.

50 Manussacas 1992, p. 12.

51 In this justly celebrated portrait Loredan is turned at a slight angle to the picture space so that half of his face appears light, the other dark. This is not the first example of this pose in dogal portraiture, as is sometimes supposed. Gentile had used a similar semi-frontal position for his lost 1492 portrait of Doge Enrico Dandolo (Meyer zur Capellen 1985, p. 142, no. B6), who had led the 1204 sack of Constantinople. In both paintings the sitter's head and shoulders protrude above a parapet-like marble bust. However, the exceptionally subtle lighting of Loredan's face gives him the dignified appearance of a sculpted image brought to life. This is enhanced by the restrained colouristic harmonies of his costume.

52 Fedalto 2002, p. 94; Chambers and Pullan 1992, pp. 333–6.

53 Ferrara 1991.

54 Gallo 1967, p. 176; Hills 1999, p. 21.

55 Brown 1996, pp. 17–20.

56 Chambers and Pullan 1992, p. 8.

57 Belting 1994, pp. 4–5; Gallo 1967, p. 146.

58 Goffen 1975, p. 509; Sanudo 1879, III, p. 632.

59 Rizzi 1972, p. 269, no. 23.

60 Venice 1993, pp. 28–9, no. 1.

61 For an exhaustive list of saints' body-parts in late fifteenth-century Venice, see Sanudo 1980, pp. 46–7, 157–65.

62 Goffen 1975 p. 506 n. 111.

63 Zorzi 1994a, p. 216.

64 Frulow 1961, pp. 155–8.

65 Sanudo 1980, pp. 48–9.

66 Howard 2000, p. 1; Brown 1996, pp. 11–24.

67 For Gentile Bellini's posthumous portrayal of Lorenzo Giustinian (1381–1456), Venice's first Patriarch, signed and dated 1465, see Meyer zur Capellen 1985, pp. 136–7, no. A22.

68 Goffen 1975, p. 487 n. 2. The upturned hat (corna) which the Doge alone was entitled to wear (seen in fig. 20) traced its ancestry to the Phrygian cap associated with the ancient city of Troy on the Asian shores of the Dardanelles. The Byzantine Greeks, as well as the Venetians, claimed descent from the Trojans: aspects of Phrygian dress formed part of the ceremonial costumes of both their rulers.

69 Howard 2002, pp. 24–5; Hills 1999, p. 40.

70 Humfrey 1993, p. 24.

71 Brown 1988, pp. 33–6.

72 Demus 1984, I, pp. 5–8.

73 Ibid., pp. 6–7; Merkel 1989; Pächt 2003, pp. 43–4.

74 Demus 1984, I, p. 8.

75 Hills 1999, p. 47.

76 Brown 1988, p. 33.

77 Ibid., pp. 263–5.

78 Demus 1984, I, p. 6.

79 Brown 1996, pp. 118–28.

80 For the altarpieces see Robertson 1968, pp. 83–7, 87–9, nos. 1, 116; Humfrey 1993, p. 29; p. 347, no. 27; p. 348, no. 38; pp. 352–3, no. 62; Pächt 2003, pp. 225–31.

81 Hills 1999, p. 157.

82 Robertson 1968, pp. 128–30; Humfrey 1993, p. 356, no. 81.

83 For Codussi and the Greek revival, see Brown 1996, pp. 174–6; Howard 2002, pp. 137–41.

84 Psalm 13: 2: 'God looked down from Heaven upon the Children of Men to see if there were any that did understand and seek God'.

85 Pächt 2003, p. 230.

86 Humfrey 1993, p. 355, no. 77.

87 Penny 2004, pp. 110–12.

88 Meyer zur Capellen 1985, pp. 87–94, 131–2, no. A14.

89 Howard 2000, p. 88; Brown 1988, p. 209.

90 Brown 1988, p. 208, fig. 124; Howard 2000, p. 90, fig. 94.

91 Brown 1988, p. 293, no. XIX, doc. 2b.

92 Ibid., p. 144.

93 Demus 1984, II:i, pp. 193–4.

94 Vasari 1966, II, pp. 24, 35–7.

95 Bettini 1933, pp. 11–12.

96 Such as Mansueti's Healing of the Daughter of Ser Benvegnudo and Carpaccio's The Arrival of the Ambassadors, reproduced in Brown 1988, pl. 90, and Nepi Scirè 1998, p. 65.

97 Constantoudaki-Kitromilides 1982, pp. 265–7; Imhaus 1997, pp. 437, 452.

98 Cattapan 1972, p. 211.

99 For a summary see Georgopoulou 2004, pp. 492, 606 nn. 33–9.

100 Cattapan 1972, pp. 211–14.

101 Chatzidakis 1974, II, p. 87.

102 Heinemann 1962, I, p. 51, no. 168; II, p. 116, fig. 85.

103 Chatzidakis 1974, II, p. 87, fig. 57.

104 Meyer zur Capellen 1985, p. 109, doc. 14d.

105 Hills 1999, pp. 143–4.

106 Goffen 1975, esp. pp. 487, 510–11; Christiansen 2004, p. 9.

107 Robertson 1968, p. 79.

108 Chambers and Pullan 1992, pp. 357–8.

109 See note 1 above; Mohler 1942, vol. 3, p. 543 ('. . . quasi alterum Byzantium').

J. M. ROGERS: MEHMED
THE CONQUEROR

1 For a survey of the Ottoman sources see Inalcık 1991.

2 Raby 1980, pp. 242–6.

3 Raby 1987a.

4 Babinger 1953.

5 Lopez 1934.

6 Dorini and Bertelè 1956, pp. 136–7.

7 Necipoğlu 1991, p. 210, maestri d'intaglio, e di legname, e di tarsie: evidently, therefore, wood-workers.

8 Babinger 1953. It is generally agreed that the five-pointed star plan of Mehmed's fortress of Yedikule in Istanbul (completed 1458) was of Italian origin. It has sometimes been attributed to Antonio Filarete, who was in the service of the Sforzas at Milan, and the trefoil-plan of the fortress of Kilidü'l-Bahir on the Dardanelles (completed 1452) is certainly characteristic of his designs. However, although in 1465 he considered travelling to Istanbul he never seems to have got there.

9 Deissmann 1933; Raby 1987a.

10 Raby 1983.

11 Babinger 1951.

12 Like other contemporary treatises on battle machines, this was more science fiction than a practical manual. Marchis (in Ricossa 1988, pp. 117–41) describes it as 'bella e inutile' and 'piu archeologica che didascalica', with simple mechanical principles put to fantastic uses, regardless of the structural requirements of the machines or the scale of their components.

13 Karabacek 1918, p. 2.

14 Printed at Verona in 1472. Cf. Weiss 1964.

15 Bibliothèque nationale de France, Paris, ms. lat. 7239. The manuscript bears the seal of Bayezid II, in whose reign Mehmed's library was inventoried. Banfi 1954.

16 Two medical works were copied for him by the famous late fifteenth-century Turkish calligrapher, Hamdullah. Interestingly, in view of Mehmed's interest in Italian figural art, no illustrated Persian or Turkish works bear his book-plate, and, like the Venice Iskender-nāme, a version of the Alexander Romance but actually more of a miscellany of exotica (Marciana, Venice, Cod. O. XC (=57); Grube 1987; cf. Çağman 1974), the few illustrated works datable to his reign are not to be compared in quality with the books he commissioned.

17 Sohrweide 1970; Tanındı 2000.

18 Ünver 1995; Rogers 199.

19 H2152, H2153, and H2160.

20 Raby 1981.

21 Çağman 1981. Certainly, the seal of Selim I (r. 1512–20) occurs sporadically in both H2153 and H2160, but since it continued to be used long after, on both objects and later in the Ottoman Treasury, its occurrence here is no indication of the date of their compilation. Nor is the absence of Mehmed's seal from any of these albums conclusive, for it very rarely appears even on the books he commissioned for his library.

22 Ünver 1995a, IV.

23 H2324. Ünver 1995b.

24 Raby 1987.

25 Jacobs 1927.

26 Raby 2000.

27 Karabacek 1918, pp. 30–1. Julian Raby (Istanbul 2000, pp. 69–71, 82) attributes fig. 35 to Şiblizâde Ahmed and fig. 34 to Sinan Beg.

28 Pedani Fabris 1994a, pp. 8–9, nos 20a–d. The toponym has not been identified.

29 Syson and Gordon 2001, passim.

30 Raby 1987b, pp. 141–2.

31 Ibid.

32 Meyer zur Capellen, pp. 174–5, no. F11.

33 Müller-Wiener 1977, pp. 31–2; Necipoğlu 1991, pp. 4–8.

34 Painters attached to a 'Turanian' embassy to Mehmed's court which allegedly reached Istanbul about 1478–80, described in volume I (fols 14b–15a) of the *Hünernâme* by the Court chronicler, Lokmân, in the early 1580s, are said to have made pictures of the Topkapı Saray to explain its unusual layout to the ruler of their homeland.

35 Necipoğlu 1991, 135–6. Bibliothèque nationale de France, fonds français 5594; cited Babinger 1956.

36 Phillips 1955.

37 Woods 1999, pp. 89, 253.

38 The *Kânûnnâme-i Âl-i 'Osmân* (1477–81), compiled by Nişancı Leysizade Mehmed Efendi, was a formalisation of pre-existing conventions, so doubtless reflected Court behaviour in the last decade or so of Mehmed's reign. Of course, as Sultan he could break his own rules, but he was conforming, inter alia, to the accepted norms of Royal behaviour, not merely in Turkey but in the Islamic world of the fifteenth century as a whole.

39 Babinger 1962a; Meyer zur Capellen 1985, p. 111, doc. 21; and see ibid. pp. 116–17, doc. 55.

40 Ménage 1965.

41 In one of the earliest extant Ottoman registers of rewards, allowances and gratuities to courtiers and Court employees, dating from 909/1503–4, these were already highly systematised. Gifts of silver were restricted to foreign embassies or major tributaries, and the only recipient of gold jewellery in the register (Barkan 1979, p. 373 item no. 419) was the Khan of the Crimea, Mengli Giray Khan, who as a direct descendant of Jenghis Khan was deemed worthy by the Ottomans of the highest honours.

42 The career of the renegade, Ludovico Gritti, the illegitimate son of the Doge Andrea Gritti, who was highly influential at the court of Süleyman the Magnificent in the 1520s and 1530s (Kretschmayr 1897, pp. 1–106), is some indication that Begs in the Sultan's service need not have been Muslims by birth. His splendid palace is commemorated in the modern Turkish name for the district of Galata in Istanbul, Beyoğlu.

43 Pakalın 1971, vol. II, pp. 637–8.

44 Although sixteenth-century writers on the Turks like Luigi Bassano (1963, p. 108) assert that the Turks disapproved of painting – *In Turchia non si trova ne dipentura n'immagine di nessun relieva. Sono in questo grossissimi, e meglio tra noi i fanciulli ch'i loro maestri . . .* – he, rather oddly, confuses the suppression of figural painting with the incompetence of Ottoman artists in figure-drawing.

45 Angiolello 1909, p. 121.

46 Topkapı Saray Archives, D. 10026.

47 Rogers 1987.

48 Giovio 1551, pp. 107–8; Raby 2000.

49 Bağcı 1999, pp. 111–25.

ALAN CHONG: GENTILE BELLINI IN ISTANBUL

I am grateful to Gülru Necipoğlu and Stephen Campbell for their invaluable advice and suggestions. I am also indebted to David Roxburgh, Cynthia Damon, Wheeler Thackston, Patricia Fortini Brown, David Kim and Jan Ziolkowski.

1 Foresti 1490, fol. 258v (see note 16 for the original text). When the passage first appeared in 1486 (Foresti 1486, fol. 293r), the artist was said to be from Padua; cited by Brown 1988, p. 55.

2 Meyer zur Capellen 1985, p. 121: '*In quattro facultà quattro ignoranti si trova . . . / Ma poi in pittura segue lo arroganti/ cavalier spiron d'or Gentil Bellino*'.

3 Roskill 1968, p. 186: '*non poteva soffrir di seguitar quella via secca e stentata . . . Per questo Titiano lasciando quel goffo Gentile, hebbe meso di accostarsi a Giovanni Bellino: ma ne anco quella maniera compiutamente piacendogli, elesse Giorgio da Castel franco*'.

4 Gilbert 1961, p. 37.

5 Ridolfi (1648) 1914, pp. 57–8.

6 Meyer zur Capellen 1985, p. 110: 13 August 1479: '*unum sculptorem et funditorem eris*'.

7 For Sanudo's account see Meyer zur Capellen 1985, p. 109, doc. 14a. Sanudo's further statement that Gentile departed on 3 September is confirmed by Signoria records (ibid., pp. 110–11, doc. 17).

8 Brown 1988, pp. 273–4: '*qui cum redierit Venetias sit etiam obligatus predictum opus prosequi*' (see also pp. 52–6). Vasari 1966, vol. 3, p. 436.

9 Brown 1988, pp. 64–5. Brown also convincingly suggests that Dario arranged for Gentile to work for the Scuola Grande in the 1490s.

10 Meyer zur Capellen 1985, pp. 110–11: '*Magistri Bertholomei, fusoris metalli*'.

11 Raby 1987, p. 187: '*Matheum Pastum Veronensem . . . mirificum harum rerum artificem, ad te pingendum effi[n]gendumque mitti summopere postules*'. The antecedent is '*expressi vultus per aenea*'. Raby 1987, p. 176, translates *effingendumque* as '*sculpt*'. See also Spinale 2003, pp. 44–9, 314–18. On his way to Constantinople, Matteo de' Pasti was arrested by Venetian forces on Crete, probably because he was carrying military treatises and sensitive maps of Italy, although it is sometimes thought this was because Venice wanted to safeguard its own cultural initiatives; however, in 1461 Venice had no such contacts. While Malatesta was widely distrusted, he was often allied with Venice and in 1464–5 battled Turkish forces on their behalf. See Babinger 1978, pp. 201–2; Raby 1987, p. 175.

12 For Angiolello, see below. Suriano 1900, pp. 94–5; Meyer zur Capellen 1985, p. 109. Suriano's text was published in 1524, but was based on information he received from Gentile much earlier; Suriano mistakenly gives the year as 1477.

13 Meyer zur Capellen 1985, p. 109: '*un bon depentor che sapia retrazer*'. On Malipiero's trustworthiness see Brown 1988, p. 243 n. 8.

14 Vasari 1966, vol. 3, p. 435 (1550 edn).

15 Vasari 1966, vol. 3, pp. 329–30 (1550 and 1568 edns).

16 Foresti 1490, fol. 258v: '*Gentilis Bellinus natione venetus pictor celeberrimus hijs temporibus non modo orbem venetum: sed & (ut ita dixerim) italiam totam suo inaudito & admirando pingendi modo illustrare videtur: cui tanta collata est pingendi gratia: ut cum qualiscunque antiquis & exquisitis pictoribus tam grecis quam latinis sine iniuria merito comparari possit: Cuius quondam virtutes cum etiam ad aures mahumeti turcorum principis pervenisset: desiderio vedendi eius fragrans ad senatum venetum supplex scripsit: ut illum sibi dono Constantinopolim per singulari beneficio mittere dignaret: Ad quem tandem accedens: ut ipsius peritias tentare posset: non plurimas & incredibiles eius picturas: atque alia prope innumerabilia eum depingere fecit: denique ut omnis industria magis ac magis experiretur: se ipsum in propria forma reduci coegit: cuius quidem imaginem sibi simillimam cum imperator conspexisset: admiratus viri virtutem dixit illum cunctos pictores qui unquam fuere excedere & propterea confestim benevolentie & legalitatis signum ipsus suum familiarem constituens etiam comitem palatinum: equitemque auratum cum quibusdam suis insignibus & monile creavit: & a se laudatum cum celebri privilegio & donis multis in patriam remisit: ubi ab ipso senatu veneto cum multo hilaritatis vultu exeptus est: Et ad pingendas in palatio dominij venetorum historias intermissas cum magno premio remissus est*.' Translated by Cynthia Damon; abbreviations in the Latin have been expanded. There are further Latin editions of 1492, 1500, 1503 and 1506, and many after Gentile's death; in 1575 Francesco Sansovino updated it and translated it again into Italian. On Foresti and his work see Krümmel 1992.

17 Foresti 1490, fol. 260v: '*Eius autem facies (ut ex eius pictura ostenditur) hominis faciem pre se ferebat: Cuius quidem aspectus horridus & atrox erat: oculi fedi haud recti: sed in angulis reflexi: videlicet quum aliquem aspiciebat. Frons alta erat: & posterior capitis pars eminens. Nasus in medio tumidus: qui supra labrum deferebatur incurvus. Macilenta enim facies intra maxillas concavata & pallidissima ostendebatur. Corpus robustum ossibus ac nervis firmum: quod communem hominis magnitudinem aliquantulum excedebat. . .*'. The passage first appears in the edition of 1486, fol. 290r. Noted by Thuasne 1888, p. 36.

18 For Isabella d'Este, see Negro and Roio 2001, p. 159, letter of 10 November 1504: '*havemo deliberato experimentare novi pictori . . .*' The competition between Jacopo Bellini and Pisanello was described by Ulisse Aliotti and Angelo Decembrio; the texts appear in Cordellier 1995, pp. 96–100, 120–2.

19 Foresti 1491, fol. 294r: '*tande essendo arivato accio potesse experimentare la suoa peritia fece pingere se medesimo dapoi molte & incredibile picture & altre cose quasi innumerabile: finalmente accio che la industria suoa fusse mazormente experimentalo astrinse che si reducesse se medesimo in propria forma*'. The Latin is not entirely clear about Gentile's paintings of himself, but the text appears to contrast these with his paintings of other subjects.

20 The now extensive literature on Venetian self-portraiture does not address this practice – Fletcher 1992, Suzuki 1996, Brown 2000, Rearick 2002 and, more generally, Woods-Marsden 1998.

21 Vasari 1966, vol. 4, pp. 534–5. In addition, the Flemish painter Joris Hoefnagel travelled with a self-portrait that he showed to the Duke of Bavaria as proof of his ability: Campbell 1990, p. 216.

22 Vasari 1966, vol. 3, p. 436 (1550 edn): '*dopo aver veduto molte sperienze di quell'arte, dimandò Gentile se gli dava il cuor di dipignere se medesimo*'. Vasari must have known Foresti's text.

23 Gentile was also apparently portrayed by his brother Giovanni in a canvas in the Great Council Hall of the Doge's Palace, *Otto before the Emperor*, destroyed in 1577. The many Venetian notables in the hall's paintings were

listed by Sansovino 1581, fol. 132r, although the sequence of canvases is not quite clear.

24 Surprisingly, the double portrait has usually been accepted as by Gentile: Babinger 1961; Raby 1980, pp. 90–2; Meyer zur Capellen 1985, pp. 129–30; Longo 1995, p. 511; Pächt 2003, p. 143. Collins 1970, pp. 79, 138, was more hesitant. Marinesco 1962 (also citing Fritz Heinemann); and Glover 1999, p. 24, reject the attribution. Andaloro 1980, pp. 198–9, implausibly assigned it to Costanzo.

The portrait seen over the shoulder was attributed to Gentile by Babinger 1962 (also Pedani Fabris 1996, p. 10), but rejected by Meyer zur Capellen 1985, p. 130, fig. 20; and Collins 1970, pp. 79–80, 137–8.

In addition, Raby 1980, p. 91, figs 20, 21, believed that two gouaches in the Nationalbibliothek, Vienna, were derived from lost works by Gentile, but these caricatured faces have nothing to do with the artist. Also, Karabacek 1918, p. 47, as Costanzo da Ferrara.

25 Raby 1987, pp. 180–1. It should be stressed that neither Gentile's nor Bertoldo's medal is dated, and that the accounts of the exchanges between Florence and Istanbul in 1480 do not mention any medals. Syson 2004, p. 127 n. 28, believes that Bellini's medal was 'almost certainly not commissioned by the Sultan himself', which seems contrary to Mehmed's interest in the genre and Bellini's avoidance of it otherwise.

26 Angiolello 1909, pp. 119–21: 'si dilettava de' giardini et haveva piacere di pitture et per questo scrisse all'Illustrissima Signoria che gli mandasse un pittore. Li fu mandato Domino Gentil Bellin, peritissimo nel'arte, qual vidde volontieri. Volse che gli facesse Venetia in disegno et retraisse molte persone, si ch'era grato al Signore. Quando il Signore voleva veder qualch'uno che haveva fama di esser bell'huomo, lo faceva retrahere dal detto Gentile Bellin, et poi lo vedeva . . . Fu dal detto Gentil fatto diversi belli quadri, et massime di cose di lussuria in alcune cose belle in modo che ne haveva nel serraglio gran quantità, et all'intrar che fece il figliuolo Baiasit Signor il fece vendere tutti in Bazzaro, et per nostri mercanti ne furono comprati assai, et disse il detto Baiasit che suo padre era padrone, et che non credeva in Maccometto, et in effetto era così per quello dicono tutti questo Mehemet non credeva in fede alcuna.' On Mehmed's interest in gardens, see Necipoğlu 1991, p. 202. Kritovoulos 1954, p. 208, described the gardens at Topkapı in 1465 as having various plants, fruit trees, supplies of water, birds, and animals. Sanudo also wrote that Mehmed commissioned a view of Venice; Brown 1988, p. 247 n. 26: 'et si feze dipinzer alchune cosse maxime una veniexia'.

27 On the traditional interpretation of Angiolello's passage see: Thuasne 1888, p. 39; Setton 1978, pp. 329–30; Babinger 1978, p. 378 ('probably obscene paintings'); Raby 1980, p. 94 ('intended no doubt to revive the Sultan's flagging senses'; and in n. 85 cites the recipe for an aphrodisiac); Raby 1982, p. 22. For the Renaissance use of lussuria as luxury, see Battaglia 1975, vol. 9, p. 330, citing Aretino and Tasso; and Brown 1988, p. 55.

28 From Negro's manuscript, Cosmodystychia, written between 1503 and 1513; Mercati 1939, p. 39*: 'qui ad Muhametum Ottomanum Turcarum imperatorem a Venetis decorandi palatii sui gratia missus. . .'. Much later, in 1566, Francesco Sansovino also wrote that Gentile 'had been called to Constantinople to paint some of his rooms'; Sansovino 1570, fol. 11v (also in 1566 edn, fol. 8r).

29 Necipoğlu 1991, pp. 143–4, citing, for 1465, Kritovoulos 1954, p. 207.

30 Necipoğlu 1991, pp. 210–13; for Angiolello, p. 298 n. 1: 'sono fatti in diversi modi. Uno è fatto alla Persiana. . . il secondo è fatto alla Turchesa; il terzo alla Greca, coperto di piombo'.

31 On 7 January 1480 the Sultan asked Venice for a bronze caster and a builder. The Signoria replied on 17 April 1480 to say that the builder – 'uno maistro muraro' – was too ill to travel: Raby 1987, p. 188. In March, Mehmed asked Florence for 'maestri d'intaglio e di legname e di tarsie, e adimandò e Fiorentini di Maestri di scholture di bronzo': Dei 1985, p. 176.

32 Suriano 1900, pp. 94–5. 'Zambellino', Venetian dialect for Giovanni Bellini, is undoubtedly a mistake. First published in 1524, the passage seems more reliable than an almost identical account by Bernardino da Foligno, according to Raby 1980, pp. 94–5, 342–50, who carefully weighed the reliability of the two writers. The Venetian Suriano returned from the Holy Land in 1484 and remained in Italy until 1493, during which time he could have easily met Gentile. Fra Bernardino da Foligno had no connection with Venice and the date sometimes assigned to his text, about 1482, is merely a date mentioned in the work. Francesco Negro also said that Mehmed II especially admired a Greek painting of the Virgin and Child (Mercati 1939, p. 39*). Theodoros Spandouginos (Sathas 1890, p. 169) wrote that the Sultan always kept relics of saints with many lamps burning before them, either to enhance their value or out of genuine devotion.

33 Raby 1980, p. 347.

34 Babinger 1963, p. 112, fig. 6: 'Item una cona bellissima dove sta la Imagine de nostra donna & puntati trecento sancti

dintro, che ciascuno tene uno pezo dela reliquie in mano'. General inventories of the Inner Treasury of Topkapı Palace were drawn up in 1496 and 1505 but they do not list any paintings by Gentile or medals of Mehmed II: Necipoğlu 1991, pp. 134–6. At least one relic, the stone on which Christ was supposedly born, was kept in Mehmed II's library, which seems to contradict Suriano's report that nothing else was in the room besides the cabinet with relics, the image of the Virgin and a gold lamp.

35 Necipoğlu 1991, pp. 135–6; Babinger 1956; Raby 1980, pp. 96–100. On the Sultan's interest in Christianity, see also Babinger 1978, pp. 410–12.

36 Raby 1980, pp. 100–7; see also Raby 1981, p. 43, which connects a miniature of a head of a woman (Topkapı Palace Museum, H2153, fol. 48v) with the Virgin and Child in the Istanbul University Library; however, the two images are unrelated.

37 Berenson 1932, p. 68; besides the 'Madonna and Child blessing (?)', he listed a seated Turkish scholar (Istanbul University Library, Album F. 1422, fol. 34a; Roxburgh 1996, fig. 85); Berenson's photographs of these works are at Villa I Tatti, Florence. Berenson 1957, p. 29 (but he attributed to Gentile the drawing of Mehmed II smelling a Rose, fig. 35).

38 Roxburgh 1996, pp. 364, 352–3; Roxburgh 2005, p. 204 (the model as perhaps European, 14th–16th century). See also Dickson and Welch 1981, p. 182; Meyer zur Capellen 1985, p. 152 (not by or after Gentile). I am grateful to David Roxburgh for discussing this miniature with me.

39 'A thousand thanks that that intimate of the soul has come back. Why speak of the soul? It is eternal life that has come to me./ From the distress of separation my body had fallen down when suddenly he came over me with kindness./ My heart blossomed from the aroma of the breeze of joy when my fresh rose came back to the garden./ From now on what concern have I of the unkindness of the celestial sphere? Now that that kind moon has come in my direction./ You arrived from the dust of the road and shook your tresses. Thereby the breeze of kindness became musk-shedding/ With union with the beloved, truly my heart found life. Now my life and the death of enemies has come.' Translated by Wheeler Thackston.

40 Necipoğlu 2000, p. 30 n. 32. The Aqqoyunlu ruled Tabriz until 1501, when it became the capital of the Safavids. Mehmed II or his son Bayezid II may have exchanged gifts with the Aqqoyunlu ruler Ya'qub (r. 1478–90).

41 For the Bahram Mirza 1544–5 album see Roxburgh 1998; Roxburgh 2004, pp. 245–307. (Mack 2002, p. 157 incorrectly states that the Seated Scribe remained in Istanbul.) For the Shah Tahmasp album, compiled c. 1558, see Raby 1980, pp. 105–6; Roxburgh 1996, esp. p. 364; Roxburgh 2004, pp. 196–212, esp. p. 204.

42 Jean Guérin, an agent for Louis XV, described the album in some detail in 1728; Degenhart and Schmitt 1980, vol. 6, pp. 294–5. Guérin attempted to buy the album from the widow of a dragoman and also reported that an ambassador in Turkey between 1670 and 1679 had already tried to buy the book.

43 Menestrier 1702, with etchings by Jérôme Vallet based on sixteen drawings (Ecole des Beaux-Arts, Paris) made after Franco's drawings in the Louvre. The position of the column in the Old Palace courtyard is also reported by Angiolello; Necipoğlu 1991, p. 4.

44 See Becatti 1960, pp. 111–14, figs 77–80; Meyer zur Capellen 1985, pp. 170–1, figs 128–31. Hammer 1828, p. 179, wrote that Lorenzo de' Medici commissioned 'the Florentine painter Bellino' to make drawings of ancient monuments, but no source is given.

45 Hammer 1828, p. 670, cited a letter of 10 November 1517 by a Venetian agent saying the column had recently been toppled by a hurricane. Becatti 1960, pp. 111–14, reports doubts on the identification of the column depicted in the drawings and prints; some scholars suggested that they might represent the Column of Arcadius, which was preserved until 1715. However, fragments of the Column of Theodosius incorporated into the foundations of a sixteenth-century bath built on the site (Müller-Wiener 1977, p. 265, fig. 301; and two additional fragments examined in April 2005) are recorded in the Louvre drawing by Battista Franco.

46 Meyer zur Capellen 1985, p. 120: 'mea omnia designa retracta de Roma'. Tietze and Tietze-Conrat 1944, p. 97, state that this 'passage has been misinterpreted to mean that Gentile Bellini had visited Rome' and that the drawings were probably by Jacopo Bellini. However, Gentile's will seems to refer to his own drawings depicting Rome; he had gone to Istanbul, why not to Rome?

47 Babinger 1962a, p. 88; Meyer zur Capellen 1985, p. 111.

48 Babinger 1962a, pp. 88–92; Raby 1980, pp. 111–17; Meyer zur Capellen 1985, pp. 20–1. Raby argues that the inaccurate appearance of the tuğra is the result of its having been copied by a European, probably Genovese, scribe (Raby 1980, p. 423 n. 129), while the

opening salutation in Latin is identical to other documents from the Istanbul court, which had a Latin clerk. Babinger noted that the date was not in Venetian style, but it would not be if it was written in Istanbul.

49 Foresti 1491, fol. 294r: '*Conte palladino & Cavaliere a spiron doro*'. This is probably the source for Michieli, as cited at the head of this essay and note 2. Foresti 1491 omits the passage on Gentile being made a *familiaris*, although it appears in later Latin editions.

50 In 1501 a notary transcribed Gentile's patent of honours received from the Holy Roman Emperor on 13 February 1469: '*Gentilis belinus Venetus et Eques q. dominj Iacobi Comes palatinus . . .*' (Meyer zur Capellen 1985, pp. 116–17).

51 Lightbown 1986, p. 120. On the title Count Palatine, see Warnke 1993, pp. 157–8.

52 Brown 1988, pp. 51–2, who also suggests that Gentile may have been honoured for a cycle of paintings in the Doge's Palace depicting Cristoforo Moro preparing for battle against the Turks. However, it is not known if these paintings could be viewed in 1469 or whether Gentile was involved with the project (ibid., pp. 271–2). Peter Humfrey in *Arte veneta* 20 (1986), pp. 244–5, says that Gentile must have been knighted for a portrait of Frederick III, but this is unlikely.

53 Warnke 1991, pp. 156–7, 168.

54 Brown 1988, pp. 64, 248 n. 73. Dario was knighted on the conclusion of the peace treaty in January 1479: Soranzo 1915, p. 346.

55 Thuasne 1888, p. 49 n. 2, first suggested this: '*Il faut le prendre dans sa signification la plus large, celle d'attaché au sérail, à la maison impériale; et non, comme une coïncidence historique, purement fortuite*'. Raby 1980, p. 113, additionally theorised that 'palace companion' meant enrolment in the *müteferrika*.

56 Angiolello 1909, pp. 133–4. See also Raby 1980, pp. 55, 113–14. I am grateful to Gülru Necipoğlu for sharing her thoughts on this issue.

57 Angiolello 1909, p. 134. Under Bayezid II and Selim I, a separate organization of court workshops was established: Necipoğlu 1992, pp. 204, 209–10; Necipoğlu 2005, pp. 153–7. Spandouginos (1997, pp. 118–19; the text was originally written in the early 1500s) says that they 'are the sons of noblemen and number about 100 at present since Suleiman has reduced their number by about a half . . . their main duties are to follow the Sultan when he goes to camp'.

58 Meyer zur Capellen 1985, p. 111: '*tanquam in uno de nostris domesticis intimis & electis contulisse putemus*'.

59 Angiolello 1909, pp. 120–1. On the artist as *familiaris*, see Warnke 1991, pp. 111–15.

60 Inscribed on obverse: GENTILIS BELINUS VENETUS EQUES. COMESQ (Gentile Bellini, a Venetian, knight and count): Hill 1930, no. 439. Pixley 2003, p. 9, contends that Carpaccio's *Martyrdom of the Pilgrims and Funeral of St Ursula* (Accademia, Venice) shows Mehmed's three-crown emblem on a banner, but these crowns are horizontally aligned and probably unconnected with Mehmed II's device, which cannot have been widely known in Venice.

61 Infrared reflectographs and X-radiographs in the fototeca of the Pinacoteca di Brera, Milan, document the facture of the painting.

62 Gentile's patent of knighthood from the Holy Roman Emperor did not include the modifier *auratus* (Meyer zur Capellen 1985, p. 116); Raby in Istanbul 2000, p. 87, considers the medal's inscription a mixture of the eastern and western titles. The *Procession in Piazza San Marco* (fig. 16) is signed, *Gentilis Bellini veneti equitis crucis/amore incensus opus* (The work of Gentile Bellini, Venetian, knight, inflamed by love of the cross). The *Miracle at the San Lorenzo Bridge* (fig. 17) also originally carried the artist's signature as a knight (Meyer zur Capellen 1985, p. 135).

63 '*Gentilis patriae dedit haec monumenta Belinus, Othomano accitus, munere factus Eques*': Sansovino 1581, fol. 127v; Brown 1988, pp. 55, 278. This unusual signature is not discussed in recent articles on Venetian signatures: Matthews 1998, p. 624 (claiming that Gentile 'invariably' signed himself 'Veneti'); Gilbert 2000; Goffen 2001.

64 Compare Syson 2004, p. 127 n. 28.

65 Sansovino 1570, fols. 11r–11v: '*Ma notabil cosa è questa & vera, che il Turco ha creato anco egli Cavalieri, & io come testimone lo affermo, perche ho veduto un privilegio fatto a Gentil Bellino pittore eccelente de suoi tempi, da Mahommet secondo, ilquale ho haveva chiamato a Constantinopoli per dipingere alcune sue sale. Et oltre al privilegio della Cavaleria, gli donò una bellissima collana, come fanno gl'imperadori. Ma non voglio hora in questo luogo discorrere, s'il Bellino fosse legittimo cavaliere o nò, & s'effendo Christiano dovesse ammettersi ne gli honori, poi ch'era obligato a Principe non fedele.*'

66 From Negro's manuscript, *Peri archon* (Biblioteca Apostolica Vaticana, Lat. 4033, fol. 86r), written 1493–8: Mercati 1939, pp. 80, 108, text on p. 38*: '*Gentilis, Muhameto Turcarum rege poscente, Bizantium usque transmittitur, ubi arte et ingenio suo quid Venetus sanguis valeat [sic for valeret] non obscure demonstrans, et Venetam picturam mirifice illustravit, et equestri dignitate donatus, coronarium aurum, virtutis suae praemium, phrygio etiam amiculo, tyara, cothurnis ac torque*

aureo decoratus, in patriam reportavit. Hanc igitur sub talium virorum auspicio imitari conentur adolescentes vestri, quod assiduae lucubrationis remedium sit et non minus ad virtutem accedens [sic for discedens] et animi et corporis honesta remissio'. Translated by Cynthia Damon. The importance of the text is first discussed by Brown 1988, pp. 68–9. Another copy of the manuscript, with slight variations, is in the Biblioteca Nazionale Marciana, Venice, Ms Lat. VI, 6 (=2753), fols. 109r–109v.

67 Necipoğlu 1991, pp. 111–58.

68 Kritovoulos 1954, p. 86.

69 Necipoğlu 1991, pp. 116 (citing a wage register of 1478–80), 117, 125.

70 Andaloro 1980 assigned to Costanzo a double portrait by a follower of Gentile, a Turkish miniature in Topkapı, and a drawing by an entirely different hand in the Harvard University Art Museums (ibid., figs. 8, 11, 13, 21). Raby 1980, pp. 62–71, attributed to Gentile the double portrait, as well as (pp. 90–2, 100–5) two gouaches in Vienna (mediocre derivatives of the double portrait) and the Iranian miniature of *The Virgin and Child* in the Istanbul University Library (fig. 40).

71 For example, Jardine and Brotton 2000, pp. 32, 42 (they also attribute the version in the Freer Gallery of Art, Washington, to Bihzad). This is repeated in Brotton 2002, pp. 137–8. See also Blair and Bloom 1994, p. 325 n. 55 (probably Costanzo); Mack 2002, p. 176 (attributed to Costanzo).

72 See for example, Raby 1980, pp. 65, 69: the *Seated Scribe* reveals, I believe, a sensitivity Gentile was incapable of'. Raby 1982, p. 60, asserted that Gentile even derived motifs from the anonymous *Reception of Venetian Ambassadors in Damascus* (cat. 2), now known to date from 1511.

73 Louvre Drawing Book, fols. 41r, 56v, 62r. See Eisler 1989, pls. 209, 247, 2.

74 In 1487: Bonfiglio Dosio 1987, pp. 203–4. I am grateful to Deborah Howard for this reference.

75 Eisler 1989, pp. 100–1 (Eisler presents a balanced treatment and the best illustrations). Mariani Canova 1972 theorised that some of the sheets were retraced by Giovanni or Gentile Bellini. On the other hand, Röthlisberger 1956 and Degenhart and Schmitt 1990, vol. 6, pp. 252–9, believe that the sheets are entirely by Jacopo (the latter did not take into account the codicological analysis of the album by Albert Elen in Eisler 1989).

The document for the 1493 episode is quoted by Meyer zur Capellen 1985, p. 114, doc. 39.

76 Eisler 1989, p. 101, pl. 213 (Louvre drawing book, fol. 63r). Eisler suggests

that another sheet may be by Gentile, fol. 75v, pl. 59 (see also p. 104).

77 Other drawings assigned to Gentile by Meyer zur Capellen (1985, pp. 163–7) cannot be accepted. The group of three men (Biblioteca Reale, Turin) is a copy of a section of *Procession in Piazza San Marco*. The *Procession in Campo San Lio* (Uffizi, Florence), which is related to Mansueti's painting of the same subject, is rendered in blocks of shadow in the buildings and figures which are unlike Gentile's other drawings. Miller 1978, p. 109, suggested Lazzaro Bastiani; Petrioli Tofani 1986, p. 539, attributed it to Mansueti.

78 Infrared reflectographs and X-radiographs in the fototeca of the Pinacoteca di Brera, Milan, show distinct stages of work on the painting; summarised by Brown 1988, pp. 203–6. Most of the architecture and the figural groups have underdrawing and appear to have been finished by Gentile, but the figures of Saint Mark and Gentile Bellini have little underdrawing, are built up in a different manner, and seem to be largely by Giovanni.

79 Hill 1930, p. 80; Hill 1931, p. 56. I am grateful to Eleonora Luciano for sharing her observations on the medal.

80 Venturi 1891; republished by Andaloro 1980, p. 187. The letter is dated 24 August 1485.

81 Franceschini 1995, doc. 77: '*Magistri Constantini de Museto de Veneciis pictoris*' (Master Constantine son of Museto from Venice, painter), doc. 169: '*Magister Constantinus de Venetiis pictor, civis Ferrarie*' (Master Constantine from Venice, painter, citizen of Ferrara) and doc. 520.

82 Documents related to Costanzo's work at Castelcapuano, Naples, in 1488 also call the artist '*pictore Veniciano*': Strazzullo 1975, p. 146. In one of the Ferrarese documents, he is said to be from Padua, which is probably a confusion with his father-in-law who was from that city.

83 Filangeri 1891, pp. 198, 199, 230, 326; Strazzullo 1975, pp. 146–9; Andaloro 1980, p. 188 n. 17.

84 Spinale 2003, pp. 120–1, citing Trinchera 1866, p. 100. Instructions were sent to Bernardo Lopis on 5 April 1467: '*quale cose li fossero in piacere che nui havessimo in questo nostro regno et fossero in Italia acio possiamo adaptarne de haverne et mandarneli et farli de la demonstracione de amore secundo havemo desiderio et voluntà de fare.*' This period of rapprochement had ended by 1470, with the Turkish capture of Negroponte.

85 In late 1477 or early 1478 Ferrante made peace overtures to Mehmed. See Babinger 1978, p. 359; Spinale 2003, pp. 114–15. Raby 1980, pp. 58–9 (and Raby 1987, p. 178, with an editing

mistake in date), says that Costanzo could have been in Turkey 1464–7 or 1475–8. See also Andaloro 1980, p. 189.

86 Raby 1980, p. 322, citing a Venetian Senate decision of 21 May 1479.

87 Strazzullo 1975; Nicolini 1925, pp. 246–9; Andaloro 1980; and Norris 1984.

88 Nicolini 1925, p. 163: '*Ritornando dunque alli pittori nostri, dico che nullo pictor nobile avemo avuto qua poi Colantonio. Da circa quarant'anni in qua ebbimo un maestro Constanzo lombardo, che vixe in questa città: pictor di bon disegno più che di altra cosa, di mano del quale è una camera dipinta in Poggio Reale*'

89 Raby 1980, pp. 73–4; J. Raby in: New York 1994, p. 87, asserts that Costanzo was said 'to have been particularly gifted as a draftsman'; in Washington 1991, p. 211, Summonte is translated as saying that Costanzo was 'above all else an outstanding draughtsman'. The first line in Summonte's passage quoted above has been omitted in discussions of Costanzo.

90 Nicolini 1925, pp. 237–9, 246–9; Hersey 1969, pp. 65, 70–5. Costanzo was paid for frescoes depicting Marino Marzano, Prince of Rossano. Given Costanzo's experience in Turkey, it is somewhat surprising that he was not selected to paint frescoes of the Siege of Otranto, under way at the same time.

91 Hill 1931, p. 56; see also Hill 1930, p. 321. M. Salton, in *The Dictionary of Art*, London 1996, vol. 8, p. 14, repeats the opinion. At first, Hill (1926, pp. 288–9), had thought that cat. 16 was a weaker later version of the medal.

92 Raby 1982, p. 4, called Costanzo's medal 'one of the finest portraits of the Renaissance', an opinion repeated in Raby 1987, p. 176, while in Washington 1991, p. 79, the quote is said to be Hill's. See also J. Raby in New York 1994, p. 88; and Raby 2000, p. 89.

93 Recorded on 14 March 1489 in Modena: Pastor 1959, p. 259.

94 Raby 1981; Çağman 1981, pp. 32–4.

Raby 1981, p. 47, notes that H2153 contains a calligraphy that dates to 1493–7. Closely associated is the Topkapı album H2160 which has a calligraphy dated 1511–12.

95 Gray 1932 (Costanzo). J. Raby in Istanbul 2000, pp. 69–71, 82, attributes the work to Şiblizâde Ahmed, although no documented work by this artist survives; see also London 2005, no. 231.

96 Gray 1932 (copy after Gentile); Atıl 1973, p. 109–10 (Costanzo, coloured by a Turkish artist); J. Raby in Istanbul 2000, pp. 69–70, 90 (Turkish, attr. Sinan Bey, perhaps based on a lost preparatory drawing by Costanzo).

97 Topkapı Palace Museum, H2153, fol. 46v: 17.7 × 14.4 and 20.8 × 14.8 cm; Raby 1981, fig. 28.

98 Hind 1933 (all reproduced). They are also reproduced in Hind 1938, A.I.21, A.I.44, A.I.50, A.I.51, A.I.76, A.II.6, A.II.12, A.II.13, A.II.14, A.IV.21, D.I.3, D.I.5, E.I.12a, E.III.31 and E.III.38.

99 Raby 1981, pp. 45–6. Benedetto Dei's brother Milano was a goldsmith connected to Antonio del Pollaiuolo, whose work influenced two of the prints in the group. See also Landau and Parshall 1994, pp. 94–5.

100 Raby 1980, p. 169; see Hind 1933 and Hind 1938. Landau and Parshall 1994, p. 91, call it a print and caption it (p. 94, fig. 84) a drawing. Caroline Campbell and I are grateful for permission to examine the prints and drawing in album H2153; these conclusions are based on discussions with her.

Bibliography

Allan 1989
J. W. Allan, 'Venetian-Saracenic metalwork: the problems of provenance' in Grube 1989, pp. 167–83

Ames-Lewis 1981
Francis Ames-Lewis, *Drawing in Early Renaissance Italy*, New Haven 1981

Andaloro 1980
Maria Andaloro, 'Costanzo da Ferrara: gli anni a Costantinopoli alla corte di Maometto II', *Storia dell'arte*, no. 38/40 (1980), pp. 185–212

Angiolello 1909
Giovanni Maria Angiolello, *Historia turchesca (1300–1514)*, ed. I. Ursu, Bucharest 1909 [as by Donado da Lezze]

Angiolello 1982
Giovanni Maria Angiolello, *Viaggio di Negroponte*, ed. Cristina Bazzolo, Vicenza 1982

Armand 1883
Alfred Armand, *Les médailleurs italiens des quinzième et seizième siècles*, vol. 1, Paris 1883 [1st edn 1879]

Atasoy et al., 2001
Nurhan Atasoy et al., *Ipek: The Crescent and the Rose: Imperial Ottoman Silks and Velvets*, London 2001

Atıl 1973
Esin Atıl, 'Ottoman miniature painting under Sultan Mehmed II', *Ars Orientalis* 9 (1973), pp. 103–20

Atıl 1978
Esin Atıl, *The Brush of the Masters: Drawings from Iran and India*, exh. cat. Freer Gallery of Art, Washington, 1978

Atıl 1990
Esin Atıl, ed., *Islamic Art and Patronage: Treasures from Kuwait*, New York 1990

Auld 1989
Sylvia Auld, '"Veneto-Saracenic" metalwork: objects and history', Ph.D. thesis: University of Edinburgh, 1989

Auld 1989a
Sylvia Auld, 'Master Mahmud: objects fit for a prince' in Grube 1989, pp. 185–201

Auld 2004
Sylvia Auld, *Renaissance Venice, Islam and Mahmud the Kurd: A Metalworking Enigma*, London 2004

Avery 2003
Victoria J. Avery, 'State and private bronze foundries in Cinquecento Venice: new light on the Alberghetti and di Conti workshops', *Studies in the History of Art*, vol. 64 (2003), pp. 241–75

Babinger 1951
Franz Babinger, 'Ja'qûb Pascha, ein Leibartz Mehmeds II: Leben und Schicksale des Maestro Jacopo aus Gaeta', *Rivista degli studi orientali* 26 (1951), pp. 87–113

Babinger 1951a
Franz Babinger, 'An Italian map of the Balkans, presumably owned by Mehmed II, the Conqueror (1452–53)', *Imago Mundi* 8 (1951), pp. 8–15

Babinger 1953
Franz Babinger, 'Fatih Sultan Mehmed ve Italya', *Belleten* 17 (1953), pp. 41–82

Babinger 1956
Franz Babinger, *Reliquienschacher am Osmanenhof im XV. Jahrhundert: zugleich ein Beitrag zur Geschichte der osmanischen Goldprägung unter Mehmed II., dem Eroberer*, Munich 1956

Babinger 1961
Franz Babinger, 'Ein weiteres Sultansbild von Gentile Bellini?', *Österreichische Akademie der Wissenschaften, Philosophisch-historische Klasse: Sitzungsberichte* 237, no. 3 (1961)

Babinger 1961a
Franz Babinger, 'Un ritratto ignorato di Maometto II, opera di Gentile Bellini', *Arte veneta* 15 (1961), pp. 25–32

Babinger 1961b
Franz Babinger, *Johannes Darius (1414–1494), Sachwalter Venedigs im Morgenland und sein griechischer Umkreis*, Munich 1961

Babinger 1962
Franz Babinger, 'Ein weiteres Sultansbild von Gentile Bellini aus russischem Besitz', *Österreichische Akademie der Wissenschaften, Philosophisch-historische Klasse: Sitzungsberichte* 240, no. 3 (1962)

Babinger 1962a
Franz Babinger, 'Ein vorgeblicher Gnadenbrief Mehmeds II. für Gentile Bellini (15. Jänner 1481)', *Italia medioevale e umanistica* 5 (1962), pp. 85–101

Babinger 1963
Franz Babinger, *Spätmittelalterliche fränkische Briefschaften aus dem großherrlichen Seraj zu Stambul*, Munich 1963

Babinger 1963a
Franz Babinger, 'Lorenzo de' Medici e la corte ottomana', *Archivio storico italiana* 121 (1963), pp. 305–61

Babinger 1978
Franz Babinger, *Mehmed the Conqueror and his Time*, ed. William C. Hickman, Princeton 1978

Baca 1990
Albert R. Baca, ed., *Aeneas Silvius Piccolomini, Epistola ad Mahomatem II*, New York 1990

Bağcı 1999
Serpil Bağcı, 'From Iskender to Mehmed II: change in royal imagery' in *Art turc: actes, 10ème Congrès international d'art turc, Genève, 17–23 septembre 1995*, Geneva 1999, pp. 111–25

Bagrow 1939
Leo Bagrow, *Giovanni Andreas di Vavassore, A Venetian Cartographer of the 16th Century: A Descriptive List of his Maps*, Jenkintown (Penn.) 1939

Baker and Henry 2001
Christopher Baker and Tom Henry, eds, *The National Gallery Complete Illustrated Catalogue*, London 2001

Baldinucci 1681
Filippo Baldinucci, *Notizie de' professori del disegno da Cimabue in qua*, 6 vols., Florence 1681–1728

Bambach 1999
Carmen C. Bambach, *Drawing and Painting in the Italian Renaissance Workshop: Theory and Practice, 1300–1600*, Cambridge 1999

Banfi 1954
Florio Banfi, 'Two Italian maps of the Balkan Peninsula', *Imago Mundi* 11 (1954), pp. 17–36

Barbaro 1969
Nicolò Barbaro, *Diary of the Siege of Constantinople, 1453*, trans. J. R. Jones, New York 1969

Barkan 1979
Ömer Lutfi Barkan, 'İstanbul Saraylarına ait Muhasebe Defterleri', *Belgeler* 9, no. 13 (1979), pp. 1–380

Barry 2004
Michael Barry, *Figurative Art in Medieval Islam and the Riddle of Bihzâd of Herât (1465–1535)*, Paris 2004

Bassano 1963
Luigi Bassano, *Costumi et i modi particolari della vita de' Turchi*, ed. Franz Babinger, Munich 1963 (reprint of edn Rome 1545)

Battaglia 1975
Salvatore Battaglia, *Grande dizionario della lingua italiana*, vol. 9, Turin 1975

Becatti 1960
Giovanni Becatti, *La colonna coclide istoriata: problemi storici, iconografici, stilistici*, Rome 1960

Belting 1994
Hans Belting, *Likeness and Presence: A History of the Image before the Era of Art*, Chicago 1994

Berenson 1894
Bernhard Berenson, *The Venetian Painters of the Renaissance with an Index to their Works*, New York 1894

Berenson 1932
Bernard Berenson, *Italian Pictures of the Renaissance*, Oxford 1932

Berenson 1957
Bernard Berenson, *Italian Pictures of the Renaissance: A List of the Principal Artists and their Works with an Index of Places: Venetian School*, 2 vols., London 1957

Berger 1994
Albrecht Berger, 'Zur sogenannten Stadtansicht des Vavassore', *Istanbuler Mitteilungen* 44 (1994), pp. 329–55

Berlin 1899
Ausstellung von Kunstwerken des Mittelalters und der Renaissance aus Berliner Privatbesitz, exh. cat. Alte Akademie der Künstler, Berlin, 1898 [edn 1899], ed. Wilhelm Bode

Berlin 1989
Europa und der Orient, 800–1900, exh. cat. Martin-Gropius-Bau, Berlin, 1989

Berlin 2002
Kunstsinn der Gründerzeit: Meisterzeichnungen der Sammlung Adolf von Beckerath, exh. cat. Kupferstichkabinett, Berlin, 2002–3

Bertelli 2003
Carlo Bertelli, 'Il Cairo di Gentile' in *Studi in onore di Umberto Scerrato*, eds Maria Vittoria Fontana and Bruno Genito, Naples 2003, vol. 1, pp. 105–20

Bettini 1933
Sergio Bettini, *La pittura di icone cretese-veneziana e i madonneri*, Padua 1933

Bianca 1999
Concetta Bianca, *Da Bisanzio a Roma: studi sul cardinale Bessarione*, Rome 1999

Bianchi and Howard 2003
Francesco Bianchi and Deborah Howard, 'Life and death in Damascus: the material culture of Venetians in the Syrian capital in the mid-fifteenth century', *Studi veneziani* 46 (2003), pp. 233–300

Blair and Bloom 1994
Sheila S. Blair and Jonathan M. Bloom, *The Art and Architecture of Islam, 1250–1800*, New Haven 1994

Bonfiglio Dosio 1987
Giorgetta Bonfiglio Dosio, ed., *Ragioni antique spettanti all'arte del mare et fabriche de vasselli: manoscritto nautico del sec. XV*, Venice 1987

Boschini 1660
Marco Boschini, *La carta del navegar pitoresco: dialogo*, Venice 1660

Boschini 1966
Marco Boschini, *La carta del navegar pitoresco: editione critica*, ed. Anna Pallucchini, Rome 1966

Breydenbach 1486
Bernhard von Breydenbach, *Prefatio in opus transmarine peregrinationis [Peregrinatio in terram sanctam]*, Mainz 1486

Brotton 2002
Jerry Brotton, *The Renaissance Bazaar: From the Silk Road to Michelangelo*, Oxford 2002

Brown 1920
Horatio Brown, 'The Venetians and the Venetian quarter in Constantinople to the close of the twelfth century', *Journal of Hellenic Studies* 40 (1920), pp. 68–88

Brown 2000
Katherine T. Brown, *The Painter's Reflection: Self-portraiture in Renaissance Venice, 1458–1625*, Florence 2000

Brown 1988
Patricia Fortini Brown, *Venetian Narrative Painting in the Age of Carpaccio*, New Haven 1988

Brown 1994
Patricia Fortini Brown, 'Sant'Agostino nello studio di Carpaccio: un ritratto nel ritratto?' in Venice 1994, pp. 304–18

Brown 1996
Patricia Fortini Brown, *Venice and Antiquity: The Venetian Sense of the Past*, New Haven 1996

Brown 2004
Patricia Fortini Brown, *Private Lives in Renaissance Venice: Art, Architecture, and the Family*, New Haven 2004

Butterfield 1997
Andrew Butterfield, *The Sculptures of Andrea del Verrocchio*, New Haven 1997

Byam Shaw 1984
James Byam Shaw, 'Gentile Bellini and Constantinople', *Apollo* 120 (1984), pp. 56–8

Cacciavillani 1995
Ivone Cacciavillani, *Andrea Gritti nella vita di Nicolò Barbarigo*, Venice 1995

Çağman 1974
Filiz Çağman, 'Sultan Mehmed II. dönemine ait minyatürlü bir yazma: Külliyat-ı Kâtibî', *Sanat Tarihi Yıllığı* 6 (1974–75), pp. 333–45

Çağman 1981
Filiz Çağman, 'On the contents of the four Istanbul albums H2152, H2153, H2154, and 2160', *Islamic Art* 1 (1981), pp. 31–36 [Colloquies on Art and Archaeology in Asia, no. 10]

Çağman and Tanındı 1986
Filiz Çağman and Zeren Tanındı; ed. J. M. Rogers, *The Topkapı Saray Museum: The Albums and Illustrated Manuscripts*, Boston 1986

Campbell 1990
Lorne Campbell, *Renaissance Portraits: European Portrait-Painting in the 14th, 15th and 16th Centuries*, New Haven 1990

Campbell 2002
Caroline Campbell, 'Cardinal Bessarion with the Bessarion Reliquary', *The National Gallery Review: April 2001–March 2002* (London 2002), pp. 24–5

Cattapan 1972
Mario Cattapan, 'Nuovi elenchi e documenti dei pittori in Creta dal 1300 al 1500', *Thesaurismata* 9 (1972), pp. 202–35

Chambers and Pullan 1992
David Chambers and Brian Pullan, with Jennifer Fletcher, *Venice: A Documentary History, 1450–1630*, Oxford 1992

Chatzidakis 1974
Manolis Chatzidakis, 'Essai sur l'école dite "italogreque"' in *Venezia e il Levante fino al secolo XV*, ed. Agostino Pertusi, Florence 1974, vol. 2, pp. 69–124

Chatzidakis 1985
Manolis Chatzidakis, *Icons of Patmos: Questions of Byzantine and Post-Byzantine Painting*, Athens 1985

Chong et al. 2003
Alan Chong, Richard Lingner and Carl Zahn, eds. *Eye of the Beholder: Masterpieces from the Isabella Stewart Gardner Museum*, Boston 2003

Christiansen 2004
Keith Christiansen, 'Giovanni Bellini and the practice of devotional painting' in *Giovanni Bellini and the Art of Devotion*, ed. Ronda Kasl, Indianapolis 2004, pp. 8–57

Coco and Manzonetto 1985
Carla Coco and Flora Manzonetto, *Baili veneziani alla Sublime Porta: storia e caratteristiche dell'ambasciata veneta a Costantinopoli*, Venice 1985

Collins 1970
Howard F. Collins, 'Gentile Bellini: A monograph and catalogue of works', Ph.D. dissertation: University of Pittsburgh, 1970

Commynes 1969
Philippe de Commynes, *The Memoirs of Philippe de Commynes*, ed. Samuel Kinser, 2 vols., Columbia (S.C.) 1969–73

Concina 1997
Ennio Concina, *Fondaci: architettura, arte, e mercatura tra Levante, Venezia, e Alemagna*, Venice 1997

Constantoudaki-Kitromilides 1982
Maria Constantoudaki-Kitromilides, 'A fifteenth-century Byzantine icon-painter working on mosaics in Venice: unpublished documents', *Jahrbuch der Österreichischen Byzantinistik* 32 (1982), pp. 265–72

Constantoudaki-Kitromilides 1998
Maria Constantoudaki-Kitromilides, 'Ο Άγιος Ιερώνυμος μέ τόν λέοντα' in *Studi celebrativi scritti dai borsisti dell'Istituto ellenico di studi bizantini e postbizantini di Venezia*, ed. Nikolaos Panagiotakes, Venice 1998, pp. 193–226

Constantoudaki-Kitromilides 2002
Maria Constantoudaki-Kitromilides, 'Le icone e l'arte dei pittori greci a Venezia: maestri in rapporto con la confraternita greca' in Tiepolo and Tonetti 2002, pp. 569–641

Contadini 1999
Anna Contadini, 'Artistic contacts: current scholarship and future tasks' in *Islam and the Italian Renaissance*, eds Charles Burnett and Anna Contadini, London 1999, pp. 1–60

Conti 1977
A. Conti, 'Un ambasciata del 1512, da Gentile Bellini e Benedetto Diana' in *Per Maria Cionini Visani: scritti di amici*, Turin 1977, pp. 58–61

Cordellier 1995
Dominique Cordellier, ed., 'Documenti e fonti su Pisanello (1395–1581 circa)', *Verona illustrata* 8 (1995)

Crowe and Cavalcaselle 1871
J. S. Crowe and G. B. Cavalcaselle, *A History of Painting in North Italy*, 2 vols., London 1871

Cuneo 1991
Paolo Cuneo, 'Sulla raffigurazione della città di Damasco in una tela di scuola belliniana conservata al Louvre' in *Venezia e l'oriente vicino: città e civiltà*, ed. Calogero Muscarà, Venice 1991, pp. 43–51

Cunnally 1984
John Cunnally, 'The role of Greek and Roman coins in the art of the Italian Renaissance', Ph.D. dissertation: University of Pensylvania, 1984

Cunnally 2000
John Cunnally, 'Changing patterns of antiquarianism in the imagery of the Italian Renaissance medal' in *Perspectives on the Renaissance Medal*, ed. Stephen K. Scher, New York 2000, pp. 115–35

Davies 1961
Martin Davies, *National Gallery Catalogues: The Earlier Italian Schools*, London 1961 (1st edn 1951)

Degenhart and Schmitt 1990
Bernhard Degenhart and Annegrit Schmitt, *Corpus der italienischen Zeichnungen, 1300–1450: Teil II, Venedig: Jacopo Bellini*, vols. 5–8, Berlin 1990

Dei 1985
Benedetto Dei, *La cronica dell'anno 1400 all'anno 1500*, ed. Roberto Barducci, Florence 1985

Deissmann 1933
Adolf Deissmann, *Forschungen und Funde im Serai, mit einem Verzeichnis der nichtislamischen Handschriften im Topkapu Serai zu Istanbul*, Berlin 1933

Demus 1984
Otto Demus, *The Mosaics of San Marco*, 4 vols., Chicago 1984

Dickson and Welch 1981
Martin Bernard Dickson and Stuart Cary Welch, *The Houghton Shahnameh*, 2 vols., Cambridge (Mass.), 1981

Dorini and Bertelè 1956
Umberto Dorini and Tommaso Bertelè, *Il libro dei conti (Costantinopoli 1436–1440)*, Rome 1956 [account book of Giacomo Badoer]

Draper 1992
James David Draper, *Bertoldo di Giovanni, Sculptor of the Medici Household: Critical Reappraisal and Catalogue Raisonné*, Columbia (Missouri) 1992

Dresden 1995
Im Lichte des Halbmonds: Das Abendland und die türkische Orient, exh. cat. Staatliche Kunstsammlungen, Dresden; Kunst- und Ausstellungshalle, Bonn, 1995

Dunkerton et al. 1991
Jill Dunkerton et al., *Giotto to Dürer: Early Renaissance Painting in the National Gallery*, London 1991

Edhem and Stchoukine 1933
Fehmi Edhem and Ivan Stchoukine, *Les manuscrits orientaux illustrés de la Bibliothèque de l'Université de Stamboul*, Paris 1933

Effenberger 2004
Arne Effenberger, 'Images of personal devotion: miniature mosaic and steatite icons' in New York 2004, pp. 209–14

Eisler 1989
Colin T. Eisler, *The Genius of Jacopo Bellini: The Complete Paintings and Drawings*, New York 1989

Ettlinger 1978
Leopold D. Ettlinger, *Antonio and Piero Pollaiuolo: Complete Edition with a Critical Catalogue*, Oxford 1978

Fasanelli 1965
James Fasanelli, 'Some notes on Pisanello and the Council of Florence', *Master Drawings* 3 (1965), pp. 36–47

Fedalto 1967
Giorgio Fedalto, *Ricerche storiche sulla posizione giuridica ed ecclesiastica dei greci a Venezia nei secoli XV e XVI*, Florence 1967

Fedalto 2002
Giorgio Fedalto, 'La Comunità greca, la Chiesa di Venezia, la Chiesa di Roma' in Tiepolo and Tonetti 2002, pp. 83–102

Ferrara 1991
Daniele Ferrara, 'Il ritratto del doge Leonardo Loredan: strategie dell'abito tra politica e religione', *Venezia Cinquecento* 1, no. 2 (1991), pp. 89–108

Ferri 1995
Fabrizio Ferri, *Ordini cavallereschi e decorazioni in Italia*, Modena 1995

Filarete 1965
Filarete's *Treatise on Architecture, being the Treatise by Antonio di Piero Averlino, known as Filarete*, ed. John R. Spencer, 2 vols., New Haven 1965

Filarete 1972
Filarete, *Trattato di architettura*, eds Anna Maria Finoli and Liliana Grassi, 2 vols., Milan 1972

Finlay 1984
Robert Finlay, 'Al servizio del Sultano: Venezia, i turchi e il mondo cristiano, 1523–1538' in *Renovatio urbis: Venezia nell'età di Andrea Gritti (1523–1538)*, ed. Manfredo Tafuri, Rome 1984, pp. 78–118

Finocchi Ghersi 1994
Lorenzo Finocchi Ghersi, 'Bessarione e la basilica romana dei Santi XII Apostoli' in Venice 1994, pp. 129–36

Fiore 1988
Francesco Paolo Fiore, 'Francesco di Giorgio e le origini della nuova architettura militare' in *L'architettura militare veneta del Cinquecento*, ed. Daniela Lamberini, Milan 1988, pp. 62–75

Fletcher 1992
Jennifer Fletcher, '"Fatto al specchio": Venetian Renaissance attitudes to self-portraiture', *Fenway Court 1990–1991* (1992), pp. 45–60

Fogolari 1922
Gino Fogolari, 'La teca del Bessarione e la croce di San Teodoro di Venezia', *Dedalo* 3 (1922–3), pp. 139–60

Foresti 1486
Jacopo Filippo Foresti da Bergamo, *Supplementum cronicarum*, Venice 1486

Foresti 1490
Jacopo Filippo Foresti da Bergamo, *Supplementum chroncarum*, Venice 1490

Foresti 1491
Jacopo Filippo Foresti da Bergamo, *Cronache de tuto mondo vulgare. Supplemento dele chroniche*, Venice 1491 [translated into Italian by 'Francesco C.']

Franceschini 1995
Adriano Franceschini, *Artisti a Ferrara in età umanistica e rinascimentale: Testimonianze archivistiche: parte II, tomo I: dal 1472 al 1492*, Ferrara 1995

Fredericksen and Zeri 1972
Burton B. Fredericksen and Federico Zeri, *Census of Pre-Nineteenth-Century Italian Paintings in North American Public Collections*, Cambridge (Mass.), 1972

Freely 2004
John Freely, *Jem Sultan: The Adventures of a Captive Turkish Prince in Renaissance Europe*, London 2004

Frizzoni 1898
Gustavo Frizzoni, 'Zu den vermeinten Zeichnungen Pinturicchio's für das Appartamento Borgia', *Repertorium für Kunstwissenschaft* 21 (1898), pp. 284–5

Frolow 1961
A. Frolow, *La relique de la Vraie Croix: recherches sur le développement d'un culte*, Paris 1961

Frolow 1965
A. Frolow, *Les reliquaires de la Vraie Croix*, Paris 1965

Galerkina 1970
Olympiade Galerkina, 'On some miniatures attributed to Bihzad in the Leningrad collections', *Ars Orientalis* 8 (1970), pp. 121–38

Gallo 1967
Rodolfo Gallo, *Il tesoro di S. Marco e la sua storia*, Venice 1967

Geanakoplos 1962
Deno John Geanakoplos, *Greek Scholars in Venice: Studies in the Dissemination of Greek Learning from Byzantium to Western Europe*, Cambridge (Mass.) 1962

Geanakoplos 1976
Deno John Geanakoplos, *Interaction of the 'Sibling' Byzantine and Western Cultures in the Middle Ages and Italian Renaissance (330–1600)*, New Haven 1976

Gendle 1980
Nicholas Gendle, *Icons in Oxford: Byzantine, Greek and Russian Icons*, exh. cat. Christ Church Picture Gallery, Oxford, 1980

Georgopoulou 2004
Maria Georgopoulou, 'Venice and the Byzantine sphere' in New York 2004, pp. 489–94

Gibbons 1963
Felton Gibbons, 'New evidence for the birth dates of Gentile and Giovanni Bellini', *The Art Bulletin* 45 (1963), pp. 54–8

Gilbert 1961
Creighton Gilbert, 'A Sarasota notebook', *Arte veneta* 15 (1961), pp. 33–45

Gilbert 2000
Creighton E. Gilbert, 'A preface to signatures (with some cases in Venice)', *Fashioning Identities in Renaissance Art*, ed. Mary Rogers, Aldershot 2000, pp. 79–89

Giovio 1551
Paolo Giovio, *Elogia virorum bellica virtute illustrium veris imaginibus*, Florence 1551 [edn Basel 1575 contains woodcuts by Tobias Stimmer]

Giraldi 1976
Philip Mark Giraldi, 'The Zen family, 1500–1550: patrician office holding in Renaissance Venice, Ph.D. thesis: University of London, 1976

Glover 1999
Rhian Glover, 'Gentile Bellini and the Orient: influence and effect', MA thesis: Courtauld Institute of Art, University of London, 1999

Goffen 1975
Rona Goffen, 'Icon and vision: Giovanni Bellini's half-length Madonnas', *The Art Bulletin* 57 (1975), pp. 487–518

Goffen 1989
Rona Goffen, *Giovanni Bellini*, New Haven 1989

Goffen 2001
Rona Goffen, 'Signatures: inscribing identity in Italian Renaissance art', *Viator* 32 (2001), pp. 303–70

Goffman 2002
Daniel Goffman, *The Ottoman Empire and Early Modern Europe*, Cambridge 2002

Goldner 2004
George Goldner, 'Bellini's drawings' in *The Cambridge Companion to Giovanni Bellini*, ed. Peter Humfrey, Cambridge 2004, pp. 226–55

Gray 1932
Basil Gray, 'Two portraits of Mehmet II', *The Burlington Magazine* 61 (1932), pp. 4–6

Greene 2000
Molly Greene, *A Shared World: Christians and Muslims in the Early Modern Mediterranean*, Princeton 2000

Grube 1987
Ernst J. Grube, 'The date of the Venice Iskandar-nama', *Islamic Art* 2 (1987), pp. 187–202

Grube 1989
Ernst J. Grube, ed., *Arte veneziana e arte islamica: atti del primo simposio internazionale* [*Venezia e l'oriente vicino*], Venice 1989

Guiffrey 1911
Jules Guiffrey, 'La collection de Madame Louis Stern: I. Les tableaux', *Les Arts* 119 (November 1911), pp. 15–22

Habich 1924
Georg Habich, *Die Medaillen der italienischen Renaissance*, Stuttgart 1924

Hadeln 1925
Detlev Freiherr von Hedeln, *Venezianische Zeichnungen des Quattrocento*, Berlin 1925

Hammer 1828
Joseph von Hammer, *Geschichte des osmanischen Reiches, grossentheils aus bisher unbenützten Handschriften und Archiven*, vol. 2, Pest 1828

Hankins 1995
James Hankins, 'Renaissance crusaders: Humanist crusade literature in the age of Mehmed II', *Dumbarton Oaks Papers* 49 (1995), pp. 111–207

Harris 1996
Jonathan Harris, *Greek Emigrés in the West*, Camberley 1996

Harris 1996a
Jonathan Harris, 'Cardinal Bessarion' in *The Grove Dictionary of Art*, London 1996, vol. 3, p. 876

Harrison et al. 2004
Colin Harrison et al., *The Ashmolean Museum: Complete Illustrated Catalogue of Paintings*, Oxford 2004

Heinemann 1962
Fritz Heinemann, *Giovanni Bellini e i belliniani*, 3 vols., Venice 1962–91

Heiss 1885
Aloïss Heiss, *Les médailleurs de la Renaissance* [vol. 5: *Niccolò Spinelli. . .*], Paris 1885

Hendy 1931
Philip Hendy, *The Isabella Stewart Gardner Museum: Catalogue of the Exhibited Paintings and Drawings*, Boston 1931

Hendy 1974
Philip Hendy, *European and American Paintings in the Isabella Stewart Gardner Museum*, Boston 1974

Heraeus 1828
C. G. Heraeus, *Bildnisse der regierenden Fürsten und berühmter Männer vom vierzehnten bis zum achtzehnten Jahrhunderte in einer Folgereihe von Schaumünzen*, Vienna 1828

Hersey 1969
George L. Hersey, *Alfonso II and the Artistic Renewal of Naples, 1485–1495*, New Haven 1969

Hill 1905
G. F. Hill, *Pisanello*, London 1905

Hill 1926
G. F. Hill, 'Medals of Turkish sultans', *Numismatic Chronicle* 6 (1926), pp. 287–98

Hill 1930
George Francis Hill, *A Corpus of Italian Medals of the Renaissance before Cellini*, 2 vols., London 1930

Hill 1931
George Francis Hill, *The Gustave Dreyfus Collection: Renaissance Medals*, Oxford 1931

Hill and Pollard 1967
G. F. Hill, revised by Graham Pollard, *Renaissance Medals from the Samuel H. Kress Collection at the National Gallery of Art*, London 1967

Hills 1999
Paul Hills, *Venetian Colour: Marble, Mosaic, Painting and Glass, 1250–1550*, New Haven 1999

Hind 1910
Arthur Mayger Hind, *Catalogue of Early Italian Engravings preserved in the Department of Prints and Drawings in the British Museum*, London 1910 [volume of plates: 1909]

Hind 1933
A.M. Hind, 'Fifteenth-century Italian engravings at Constantinople', *Print Collector's Quarterly* 20 (1933), pp. 279–96

Hind 1938
A.M. Hind, *Early Italian Engraving: A Critical Catalogue with Complete Reproduction of all the Prints Described*, 7 vols., London 1938

Hobson 1989
Anthony Hobson, 'Islamic influence on Venetian Renaissance bookbinding, in Grube 1989, pp. 111–23

Howard 1997
Deborah Howard, 'Venice as a dolphin: further investigations into Jacopo de' Barbari's view', *Artibus et Historiae* 35 (1997), pp. 101–11

Howard 2000
Deborah Howard, *Venice and the East: The Impact of the Islamic World on Venetian Architecture, 1100–1500*, New Haven 2000

Howard 2002
Deborah Howard, *The Architectural History of Venice*, London 2002

Howard 2003
Deborah Howard, 'Death in Damascus: Venetians in Syria in the mid-fifteenth century', *Muqarnas* 20 (2003), pp. 143–57

Humfrey 1993
Peter Humfrey, *The Altarpiece in Renaissance Venice*, New Haven 1993

Huth 1970
Hans Huth, 'Sarazenen in Venedig' in *Fest-schrift für Heinz Ladendorf*, eds Peter Bloch and Gisela Zick, Cologne 1970, pp. 58–68

Imber 1990
Colin Imber, *The Ottoman Empire 1300–1481*, Istanbul 1990

Imber 2002
Colin Imber, *The Ottoman Empire, 1330–1650: The Structure of Power*, New York 2002

Imhaus 1997
Brunehilde Imhaus, *Le minoranze orientali a Venezia*, Rome 1997

Inalcık 1973
Halil Inalcık, *Ottoman Empire: The Classical Age 1300–1600*, London 1973

Inalcık 1991
Halil Inalcık, 'Mehemmed II' in *The Encyclopaedia of Islam*, new edn, vol. 6, Leiden 1991, pp. 978–81

Istanbul 1999
Ressam, sultan ve portresi: The Artist, the Sultan and his Portrait, exh. cat., Yapı Kredi Kültür Sanat Yayıncılık, Istanbul, 1999–2000

Istanbul 2000
The Sultan's Portrait: Picturing the House of Oman, exh. cat. Topkapı Palace Museum, Istanbul, 2000

Jacobs 1927
Emil Jacobs, 'Die Mehemmed-Medaille des Bertoldo', *Jahrbuch der Preußischen Kunstsammlungen* 48 (1927), pp. 1–17

Jaffé 1994
Michael Jaffé, *The Devonshire Collection of Italian Drawings: Venetian and North Italian Schools*, London 1994

James 1996
Liz James, *Light and Colour in Byzantine Art*, Oxford 1996

Jardine 1996
Lisa Jardine, *Worldly Goods: A New History of the Renaissance*, London 1996

Jardine and Brotton 2000
Lisa Jardine and Jerry Brotton, *Global Interests: Renaissance Art between East and West*, London 2000

Jenkins 1983
Marilyn Jenkins, ed., *The al-Sabah Collection: Islamic Art in the Kuwait National Museum*, London 1983

Kafescioğlu 1996
Çiğdem Kafescioğlu, 'The Ottoman capital in the making: The reconstruction of Constantinople in the fifteenth century', Ph.D. dissertation: Harvard University, 1996

Karabecek 1918
Josef von Karabecek, *Abendländische Künstler zu Konstantinopel im XV. und XVI. Jahrhundert: I. Italienische Künstler am Hofe Muhammeds II des Eroberers, 1451–1481*, Vienna 1918 [Kaiserliche Akademie der Wissenschaften in Wien, Philosophisch-historische Klasse: Denkschriften, vol. 62, no. 1]

Kraatz et al., 1990
Martin Kraatz et al., eds, *Das Bildnis in der Kunst des Orients*, Stuttgart 1990

Krahn 1988
Volker Krahn, *Bartolomeo Bellano: Studien zur Paduaner Plastik des Quattrocento*, Munich 1988 [dissertation: Munich, 1986]

Kretschmayr 1896
Heinrich Kretschmayr, *Ludovico Gritti: Eine Monographie*, Vienna 1896

Kritovoulos 1954
Kritovoulos of Imbros, *History of Mehmed the Conqueror*, Princeton 1954

Krümmel 1992
Achim Krümmel, *Das 'Supplementum Chronicarum' des Augustinermönches Jacobus Philippus Foresti von Bergamo: Eine der ältesten Bilderchroniken und ihre Wirkungsgeschichte*, Herzberg 1992 [Osnabrück, 1991]

Kubiski 2001
Joyce Kubiski, 'Orientalizing costume in early fifteenth-century French manuscript painting (Citè des Dames Master, Limbourg brothers, Boucicaut Master, and Bedford Master)', *Gesta* 40 (2001), pp. 161–80

Kunsthistorisches Museum 1965
Katalog der Gemäldegalerie: I. Teil: Italiener, Spanier, Franzosen, Engländer, Vienna 1965 [Kunsthistorisches Museum, Vienna]

Kurz 1975
Otto Kurz, *The Decorative Arts of Europe and the Islamic East*, Leiden 1975

Labowsky 1967
Lotte Labowsky, 'Bessarione' in *Dizionario biografico degli italiani*, vol. 9, Rome 1967, pp. 686–98

Labowsky 1994
Lotte Labowsky, 'Per l'iconografia del cardinal Bessarione' in Venice 1994, pp. 285–95

Landau and Parshall 1994
David Landau and Peter Parshall, *The Renaissance Print, 1470–1550*, New Haven 1994

Lauts 1962
Jan Lauts, *Carpaccio: Paintings and Drawings*, London 1962

Layard 1887
Austen Henry Layard, ed., *Handbook of Painting: The Italian Schools: Based on the Handbook of Kugler, originally edited by Sir Charles L. Eastlake*, London 1887

Lazarev 1966
Viktor Lazarev, 'Saggi sulla pittura veneziana dei sec. XIII–XIV: la maniera greca e il problema della scuola cretese (IIº)', *Arte Veneta* 20 (1966), pp. 43–61

Lazarev 1967
Viktor Lazarev, *Storia della pittura bizantina*, Turin 1967

Legrand 1892
Emile Legrand, *Cent-dix lettres grecques de François Filelfe*, Paris 1892

Lehmann 1977
Phyllis Williams Lehmann, *Cyriacus of Ancona's Egyptian Visit and its Reflections in Gentile Bellini and Hieronymus Bosch*, Locust Valley (N.Y.) 1977

Lentz and Lowry 1989
Thomas W. Lentz and Glenn D. Lowry, *Timur and the Princely Vision: Persian Art and Culture in the Fifteenth Century*, exh. cat. Arthur M. Sackler Gallery, Washington; Los Angeles County Museum of Art, 1989

Levenson 1973
Jay A, Levenson, Konrad Oberhuber and Jacquelyn L. Sheehan, *Early Italian Engravings from the National Gallery of Art*, Washington 1973

Lierbermann 1972
Ralph. E. Lierberman, 'The Church of Santa Maria dei Miracoli in Venice', Ph.D. dissertation: New York University, 1972

Lightbown 1986
Ronald Lightbown, *Mantegna: with a Complete Catalogue of the Paintings, Drawings, and Prints*, Berkeley 1986

Lillie 2003
Sophie Lillie, *Was einmal war: Handbuch der enteigneten Kunstsammlungen Wiens*, Vienna 2003

Lippmann 1881
F. Lippmann, 'Unbeschriebene Blätter des XV. bis XVII. Jahrhunderts im Kupferstichkabinet: 2. Männliches Bildniss: "El Gran Turco", *Jahrbuch der Königlich Preußischen Kunstsammlungen* 2 (1881), pp. 215–19

Lloyd 1977
Christopher Lloyd, *A Catalogue of the Earlier Italian Paintings in the Ashmolean Museum*, Oxford 1977

Lollini 1986
Fabrizio Lollini, 'Il Cardinale Bessarione e le arti figurative', tesi di laurea: Università degli studi di Bologna, 1986–7

Lollini 1994
Fabrizio Lollini, 'Bessarione e le arti figurative' in Venice 1994, pp. 149–68

Lollini 1994a
Fabrizio Lollini, 'L'iconografia di Bessarione: *Bessarion pictus*' in Venice 1994, pp. 275–83

London 1930
Exhibition of Italian Art 1200–1900, exh. cat. Royal Academy of Arts, London, 1930

London 1983
Carpets in Paintings, exh. cat. National Gallery, London, 1983, by John Mills

London 1988
Süleyman the Magnificent, exh. cat. British Museum, London, 1988, by J. M. Rogers and R. M. Ward

London 1993
Old Master Drawings from Chatsworth, exh. cat. British Museum, London, 1993–4, by Michael Jaffé

London 1999
Renaissance Florence: The Art of the 1470s, exh. cat. National Gallery, London, 1999–2000, by Patricia Lee Rubin and Alison Wright

London 2005
Turks: A Journey of a Thousand Years, 600–1600, exh. cat. Royal Academy of Arts, London, 2005, ed. David J. Roxburgh

Longo 1995
Oddone Longo, 'Una "soasa" per il Conquistatore: Gentile Bellini e Maometto II', *Atti dell'Istituto veneto di scienze, lettere ed arti: Classe di scienze morali, lettere ed arti* 153 (1994–5), pp. 509–30

Longstreet 1935
Gilbert Wendel Longstreet, *The Isabella Stewart Gardner Museum, Fenway Court: General Catalogue*, Boston 1935

Lopez 1934
Roberto Lopez, 'Il principio della guerra Veneta-Turca nel 1463', *Archivio veneto* 15 (1934), pp. 45–131

Lorenzi 1983
Giovanna di Lorenzi, *Medaglie di Pisanello e della sua cerchia*, exh. cat. Museo Nazionale del Bargello, Florence, 1983

Louvre 1981
Catalogue sommaire illustré des peintures du musée du Louvre: II. Italie, Espagne, Allemagne, Grande-Bretagne et divers, Paris 1981

Lowry 1979
Martin Lowry, *The World of Aldus Manutius: Business and Scholarship in Renaissance Venice*, Oxford 1979

Lucchetta 1968
Francesco Lucchetta, 'L'affare Zen in Levante nel primo Cinquecento', *Studi veneziani* 10 (1968), pp. 110–219

Lucchetta 1985
Giuliano Lucchetta, 'I viaggiatori veneti dal medioevo all'età moderna' in *Viaggiatori veneti alla scoperta dell'Egitto*, ed. Alberto Siliotti, Venice 1985, pp. 43–68

Ludwig 1903
Gustav Ludwig, 'Archivalische Beiträge zur Geschichte der venezianischen Malerei', *Jahrbuch der Königlich Preußischen Kunstsammlungen* 24 (1903), Beiheft, pp. 1–118

Lugt
Frits Lugt, *Les marques de collections de dessins et d'estampes*, 2 vols., Amsterdam / The Hague 1921–56

Lymberopoulou 2003
Angeliki Lymberopoulou, 'The *Madre della Consolazione* icon in the British Museum: post-Byzantine painting, painters and society on Crete', *Jahrbuch der österreichischen Byzantinistik* 53 (2003), pp. 239–55

Mack 1997
Rosamond E. Mack, 'Lotto, a carpet connoisseur' in *Lorenzo Lotto, Rediscovered Master of the Renaissance*, exh. cat. National Gallery of Art, Washington, et al., 1997, pp. 59–67

Mack 2002
Rosamond E. Mack, *Bazaar to Piazza: Islamic Trade and Italian Art, 1300–1600*, Berkeley 2002

Manners 1997
Ian R. Manners, 'Constructing the image of a city: the representation of Constantinople in Christopher Buondelmonti's *Liber insularum archipelagi*', *Annals of the Association of American Geographers* 87 (1997), pp. 72–102

Manussacas 1992
Manussos Manussacas, et al., *Guida al Museo di icone e alla chiesa di San Giorgio dei Greci*, Venice 1992

Mariani Canova 1972
Giordana Mariani Canova, 'Riflessioni su Jacopo Bellini e sul libro dei disegni del Louvre', *Arte veneta* 26 (1972), pp. 9–30

Marinesco 1962
Constantin Marinesco, 'A propos de quelques portraits de Mohammed II et d'un dignitaire byzantin attribués à Gentile Bellini', *Bulletin de la Société nationale des antiquaires de France* (1962), pp. 126–34

Marshall 1984
David R. Marshall, 'Carpaccio, Saint Stephen, and the topography of Jerusalem', *The Art Bulletin* 66 (1984), pp. 610–20

Martin 1906
F. R. Martin, 'A portrait by Gentile Bellini found in Constantinople', *The Burlington Magazine* 9 (1906), pp. 148–9

Martin 1907
F. R. Martin, 'The miniature by Gentile Bellini found in Constantinople', *The Burlington Magazine* 11 (1907), pp. 115–16

Martin 1910
F. R. Martin, 'New originals and oriental copies of Gentile Bellini found in the East', *The Burlington Magazine* 17 (1910), pp. 5–6

Martin 1912
F. R. Martin, *The Miniature Painting and Painters of Persia, India, and Turkey, from the 8th to the 18th Century*, London 1912

Matthews 1998
Louisa Matthews, 'The painter's presence: signatures in Venetian Renaissance pictures', *The Art Bulletin* 80 (1998), pp. 616–48

McCray 1999
W. Patrick McCray, *Glassmaking in Renaissance Venice: The Fragile Craft*, Aldershot 1999

Ménage 1965
V. L. Ménage, 'Seven Ottoman documents from the reign of Mehemmed II' in *Documents from Islamic Chanceries*, First Series, ed. S. M. Stern, Cambridge (Mass.) 1965, pp. 81–118

Menestrier 1702
Claude-François Menestrier, *Description de la belle et grande colonne historiée dressée à l'honneur de l'empereur Théodose, dessinée par Gentile Bellin*, Paris 1702

Mercati 1939
Giovanni Mercati, 'Appendice alla memoria su P. Francesco Negro' in Giovanni Mercati, *Ultimi contributi alla storia degli umanisti*, Rome 1939, vol. 2, pp. 1*–75*

Merkel 1989
Ettore Merkel, 'Mosaici e pittura a Venezia' in *La pittura nel Veneto: il Quattrocento*, ed. Mauro Lucco, Milan 1989, vol. 1, pp. 223–46

Meyer zur Capellen 1983
Jürg Meyer zur Capellen, 'Das Bild Sultan Mehmets des Eroberers', *Pantheon* 41 (1983), pp. 208–30

Meyer zur Capellen 1985
Jürg Meyer zur Capellen, *Gentile Bellini*, Stuttgart 1985

Meyer zur Capellen 1994
Jürg Meyer zur Capellen, 'Gentile Bellini' in *Saur: Allgemeines Künstler-Lexikon: die bildenden Künstler aller Zeiten und Völker*, vol. 8, Munich, 1994, pp. 485–8

Michiel 1903
Marcantonio Michiel, *The Anonimo*, trans. Paolo Mussi, London 1903

Miller 1978
Sandra Miller, 'Giovanni Mansueti, a little master of the Venetian Quattrocento', *Revue roumaine d'histoire de l'art: série beaux-arts* 15 (1978), pp. 77–115

Millet 1916
Gabriel Millet, *Recherches sur l'iconographie de l'évangile aux XIVe, XVe et XVIe siècles, d'après les monuments de Mistra, de la Macédonie et du Mont-Athos*, Paris 1916

Mills 1991
John Mills, 'Carpets in paintings: the "Bellini", "Keyhole" or "Re-entrant" rugs', *Hali* 13, no. 4 (1991), pp. 86–103

Mohler 1923
Ludwig Mohler, *Kardinal Bessarion als Theologe, Humanist, und Staatsmann: Funde und Forschungen*, 3 vols., Paderborn 1923–42

Mordtmann 1889
A. D. Mordtmann [pseud. Caedicius], *Ancien plan de Constantinople imprimé entre 1566 et 1574*, Istanbul 1889

Moschini Marconi 1955
Sandra Moschini Marconi, *Gallerie dell'Accademia di Venezia: Opere d'arte dei secoli XIV e XV*. Rome 1955

Müller-Wiener 1977
Wolfgang Müller-Wiener, *Bildlexikon zur Topographie Istanbuls: Byzantion, Konstantinopolis, Istanbul bis zum Beginn des 17. Jahrhunderts*, Tübingen 1977

Necipoğlu 1991
Gülru Necipoğlu, *Architecture, Ceremonial, and Power: The Topkapı Palace in the Fifteenth and Sixteenth Centuries*, New York 1991

Necipoğlu 1992
Gülru Necipoğlu, 'A *kânûn* for the state, a canon for the arts: conceptualizing the classical synthesis of Ottoman art and architecture' in *Soliman le Magnifique et son temps: actes du colloque de Paris*, ed. Gilles Veinstein, Paris 1992, pp. 195–216

Necipoğlu 2000
Gülru Necipoğlu, 'The serial portraits of Ottoman sultans in comparative perspective' in Istanbul 2000, pp. 22–61

Necipoğlu 2005
Gülru Necipoğlu, *The Age of Sinan: Architectural Culture in the Ottoman Empire*, London 2005

Negro and Roio 2001
Emilio Negro and Nicosetta Roio, *Lorenzo Costa, 1460–1535*, Modena 2001

Nepi Scirè 1998
Giovanna Nepi Scirè, ed., *The Accademia Galleries in Venice*, Milan 1998

Newett 1907
M. Margaret Newett, ed., *Canon Pietro Casola's Pilgrimage to Jerusalem in the Year 1494*, Manchester 1907

New York 1984
The Treasury of San Marco, Venice, exh. cat. The Metropolitan Museum of Art, New York, 1984, by Guido Perocco et al.

New York 1994
The Currency of Fame: Portrait Medals of the Renaissance, exh. cat. Frick Collection, New York; National Gallery of Art, Washington, 1994, ed. Stephen K. Scher

New York 2004
Byzantium: Faith and Power (1261–1557), exh. cat. Metropolitan Museum of Art, New York, 2004, ed. Helen C. Evans

Nicol 1988
Donald M. Nicol, *Byzantium and Venice: A Study in Diplomatic and Cultural Relations*, Cambridge 1988

Nicol 1993
Donald M. Nicol, *The Last Centuries of Byzantium, 1261–1453*, 2nd edn, Cambridge 1993

Nicolini 1925
Fausto Nicolini, *L'arte napoletana del Rinascimento e la lettera di Pietro Summonte a Marcantonio Michiel*, Naples 1925

Norris 1984
Andrea Norris, 'Costanzo (C. da Ferrara)' in *Dizionario biografico degli italiani*, vol. 30, Rome 1984, pp. 394–6

Nottingham and London 1983
Drawing in the Italian Renaissance Workshop, exh. cat. University Art Gallery, Nottingham; Victoria & Albert Museum, London, 1983, by Francis Ames-Lewis and Joanne Wright

Oberhummer 1902
Eugen Oberhummer, *Konstantinopel unter Sultan Suleiman dem Grossen, aufgenommen im Jahre 1559 durch Melchior Lorichs aus Flensburg*, Munich 1902

Ortolani 1948
Sergio Ortolani, *Il Pollaiuolo*, Milan 1948

Pacioli 1494
Luca Pacioli, *Summa de arithmetica, geometria, proportioni & proportionalita*, Venice 1494

Pächt 2003
Otto Pächt, *Venetian Painting in the 15th Century: Jacopo, Gentile and Giovanni Bellini and Andrea Mantegna*, eds Margareta Vyoral-Tschapka and Michael Pächt, London 2003

Pagani 1875
Zaccaria Pagani, *Viaggio di Domenico Trevisan, ambasciatore veneto al gran sultano del Cairo nell'anno 1512*, Venice 1875

Pakalin 1971
Mehmet Zeki Pakalin, *Osmanlı tarih deyimleri ve terimerli sözlüğü*, 3 vols., Istanbul 1971

Palladino 2003
Pia Palladino, *Treasures of a Lost Art: Italian Manuscript Painting of the Middle Ages and Renaissance*, exh. cat. Cleveland Museum of Art et al., 2003–4 [Metropolitan Museum of Art, New York]

Paris 1996
Pisanello, le peintre aux sept virtus, exh. cat. Musée du Louvre, Paris, 1996

Paris 2004
 Le ciel dans un tapis, exh. cat. Institut du monde arabe, Paris, 2004–5, ed. Roland Gilles

Pastor 1959
 Ludwig von Pastor, *Storia dei papi dalla fine del medio evo*, rev. edn, vol. 3, Rome 1959

Pedani Fabris 1993
 Maria Pia Pedani Fabris, 'Presenze islamiche a Venezia', *Levante: Rivista trimestrale del Centro per le relazioni italo-arabe* 35, no. 4 (1993), pp. 13–20

Pedani Fabris 1994
 Maria Pia Pedani Fabris, *In nome del Gran Signore: Inviati ottomani a Venezia dalla caduta di Costantinopoli alla guerra di Candia*, Venice 1994

Pedani Fabris 1994a
 Maria Pia Pedani Fabris, *I documenti turchi dell'Archivio di Stato di Venezia*, Rome 1994

Pedani Fabris 1996
 Maria Pia Pedani Fabris, 'Simbologia ottomana nell'opera di Gentile Bellini', *Atti dell'Istituto veneto di scienze, lettere ed arti: Classe di scienze morali, lettere ed arti* 155, no. 1 (1996–7), pp. 1–29

Pedani Fabris 1999
 Maria Pia Pedani Fabris, 'The portrait of Mehmed II: Gentile Bellini, the making of an imperial image' in *Art turc: Actes, 10ème Congrès international d'art turc, Genève, 17–23 septembre 1995*, Geneva 1999, pp. 555–8

Penny 2004
 Nicholas Penny, *National Gallery Catalogues: The Sixteenth Century Italian Paintings, Volume 1: Paintings from Bergamo, Brescia and Cremona*, London 2004

Pertusi 1983
 Agostino Pertusi, *Testi inediti e poco noti sulla caduta di Costantinopoli*, Bologna 1983

Petrioli Tofani 1986
 Annamaria Petrioli Tofani, *Gabinetto disegni e stampe degli Uffizi: Disegni esposti [Inventario]*, 2 vols., Florence 1986–7

Phillips 1955
 John Goldsmith Phillips, *Early Florentine Designers and Engravers*, Cambridge (Mass.) 1955

Piccolomini 1960
 Aeneas Silvius Piccolomini, *Memoirs of a Renaissance Pope: The Commentaries of Pius II*, trans. Florence Gragg, London 1960

Pigler 1967
 Andor Pigler, *Katalog der Galerie Alter Meister*, 2 vols., Budapest 1967

Pignatti 1981
 Terisio Pignatti, ed., *Le scuole di Venezia*, Milan 1981

Pixley 2003
 Mary L. Pixley, 'Islamic artifacts and cultural currents in the art of Carpaccio', *Apollo* 158 (2003), pp. 9–18

Planiscig 1928
 Leo Planiscig, 'Jacopo und Gentile Bellini (neue Beiträge zu ihrem Werk)', *Jahrbuch der Kunsthistorischen Sammlungen in Wien* 3 (1928), pp. 41–62

Poeschel 1999
 Sabine Poeschel, *Alexander Maximus: Das Bildprogramm des Appartamento Borgia im Vatikan*, Weimar 1999

Polacco 1992
 Renato Polacco, 'La storia del reliquario Bessarione dopo il rinvenimento del verso della croce scomparsa', *Saggi e memorie di storia dell'arte* 18 (1992), pp. 85–95

Polacco 1994
 Renato Polacco, 'La stauroteca del cardinal Bessarione' in Venice 1994, pp. 369–78

Popham 1931
 A. E. Popham, ed., *Italian Drawings exhibited at the Royal Academy, Burlington House, London, 1930*, London 1931

Popham 1936
 A. E. Popham, 'Sebastiano Resta and his collections', *Old Master Drawings* 11, no. 41 (1936), pp. 1–19

Popham and Pouncey 1950
 A. E. Popham and Philip Pouncey, *Italian Drawings in the Department of Prints and Drawings in the British Museum: The Fourteenth and Fifteenth Centuries*, 2 vols., London 1950

Pouncey 1938
 Philip Pouncey, 'The Miraculous Cross in Titian's Vendramin Family', *Journal of the Warburg and Courtauld Institutes* 2 (1938–9), pp. 191–3

Preto 1975
 Paolo Preto, *Venezia e i turchi*, Florence 1975

Pullan 1971
 Brian Pullan, *Rich and Poor in Renaissance Venice: The Social Institutions of a Catholic State, to 1620*, Oxford 1971

Raby 1980
 Julian Raby, 'El Gran Turco: Mehmed the Conqueror as a patron of the arts of Christendom', D.Phil. thesis: Oxford University, 1980

Raby 1980a
 Julian Raby, 'Cyriacus of Ancona and the Ottoman Sultan Mehmed II', *Journal of the Courtauld and Warburg Institutes* 43 (1980), pp. 242–6

Raby 1981
 Julian Raby, 'Mehmed II Fatih and the Fatih album', *Islamic Art* 1 (1981), pp. 42–9 [Colloquies on Art and Archaeology in Asia, no. 10]

Raby 1982
 Julian Raby, *Venice, Dürer and the Oriental Mode*, London 1982

Raby 1982a
 Julian Raby, 'A sultan of paradox: Mehmed the Conqueror as a patron of the arts', *Oxford Art Journal* 5 (1982), pp. 3–8

Raby 1983
 Julian Raby, 'Mehmed the Conqueror's Greek scriptorium', *Dumbarton Oaks Papers* 37 (1983), pp. 15–34

Raby 1987
 Julian Raby, 'Pride and prejudice: Mehmed the Conqueror and the Italian portrait medal', *Studies in the History of Art*, vol. 21 (1987), pp. 171–94

Raby 1987a
 Julian Raby, 'East and West in Mehmed the Conqueror's library', *Bulletin du Bibliophile* 3 (1987), pp. 297–318

Raby 1987b
 Julian Raby, 'Mehmed the Conqueror and the Byzantine Rider of the Augustaion', *Topkapı Sarayı Müzesi: Yıllık* 2 (1987), pp. 141–52

Raby 1991
 Julian Raby, 'Picturing the Levant' in Washington 1991, pp. 77–81

Raby 2000
 Julian Raby, 'Opening gambits' in Istanbul 2000, pp. 64–79

Raby and Tanındı 1993
 Julian Raby and Zeren Tanındı, *Turkish Bookbinding in the 15th Century: The Foundation of an Ottoman Court Style*, London 1993

Rearick 2002
 W. R. Rearick, 'The Venetian selfportrait, 1450–1600' in *Le metamorfosi del ritratto*, ed. Renzo Zorzi, Florence 2002, pp. 147–80

Restle 1981
 Marcell Restle, 'Bauplanung und Baugesinnung unter Mehmet II. Fâtih: Filarete in Konstantinopel', *Pantheon* 39 (1981), pp. 361–7

Rice 1963
 David Talbot Rice, *Art of the Byzantine Era*, London 1963

Ricci 1912
 Corrado Ricci, 'Gentile Bellini a Costantinopoli', *Nuova antologia* 47, no. 162 (16 Nov. 1912), pp. 177–91

Ricossa 1988
 Sergio Ricossa et al., *Le macchine di Valturio nei documenti dell'Archivio Storico AMMA*, Turin 1988

Ridolfi 1914
 Carlo Ridolfi, *Le maraviglie dell'arte, ovvero Le vite degli illustri pittori veneti e dello stato*, 2 vols., ed. Detlev von Hadeln, Berlin 1914–24

Rizzi 1972
 Alberto Rizzi, 'Le icone bizantine e post-bizantine delle chiese veneziane', *Thesaurismata* 9 (1972), pp. 262–91

Robertson 1968
 Giles Robertson, *Giovanni Bellini*, Oxford 1968

Robinson 1967
 B. W. Robinson, 'Oriental metalwork in the Gambier-Parry collection', *The Burlington Magazine* 109 (1967), pp. 169–73

Rodini 1998
 Elizabeth Rodini, 'Describing narrative in Gentile Bellini's *Procession in Piazza San Marco*', *Art History* 21 (1998), pp. 26–44

Röthlisberger 1956
 Marcel Röthlisberger, 'Notes on the drawing books of Jacopo Bellini', *The Burlington Magazine* 98 (1956), pp. 358–64

Rogers 1987
 J. M. Rogers, 'An Ottoman palace inventory of the reign of Bayazid II' in *Comité international d'études pré-ottomanes et ottomanes, VIth Symposium*, eds Jean-Louis Bacqué-Grammont and Emeri van Donzel, Istanbul 1987, pp. 40–53

Rogers 1991
 J. M. Rogers, '"The gorgeous East": Trade and tribute in the Islamic empires' in Washington 1991, pp. 69–74

Rogers 1992
 J. M. Rogers, 'Itineraries and town views in Ottoman histories' in *Cartography in the Traditional Islamic and South Asian Sources*, eds J. B. Harley and David Woodward, Chicago 1992, pp. 228–55 [The History of Cartography, vol. 2, part 1]

Rogers 1999
 J. M. Rogers, 'Ornament prints, patterns and designs' in *Islam and the Italian Renaissance*, eds Charles Burnett and Anna Contadini, London 1999, pp. 133–65

Rosand 1982
 David Rosand, *Painting in Cinquecento Venice: Titian, Veronese, Tintoretto*, New Haven 1982

Roskill 1968
 Mark W. Roskill, *Dolce's "Aretino" and Venetian Art Theory of the Cinquecento*, New York 1968

Rouillard 1973
 C. D. Rouillard, 'A reconsideration of "La réception de l'ambassadeur Domenico Trevisano au Caire, école de Gentile Bellini" at the Louvre, as an "Audience de Vénitiens à Damas"', *Gazette des Beaux-Arts* 82 (1973), pp. 297–304

Roxburgh 1996
 David J. Roxburgh, '"Our works point to us": Album making, collecting, and art (1427–1565) under the Timurids and Safavids', Ph.D. dissertation: University of Pennsylvania, 1996

Roxburgh 1998
 David J. Roxburgh, 'Disorderly conduct?: F. R. Martin and the Bahram Mirza Album', *Muqarnas* 15 (1998), pp. 32–57

Roxburgh 2005
 David J. Roxburgh, *The Persian Album, 1400–1600: From Dispersal to Collection*, New Haven 2005

Runciman 1965
 Steven Runciman, *The Fall of Constantinople, 1453*, Cambridge 1965

Sakisian 1939
 Armenag Sakisian, 'The portraits of Mehmet II', *The Burlington Magazine* 84 (1939), pp. 172–81

Sansovino 1570
 Francesco Sansovino, *Della origine de cavalieri di M. Francesco Sansovino, Libri quattro, Ne' quali si contiene, l'inventione, l'ordine, and la dichiaratione di tutte de sorti de Cavalieri*, Venice 1570

Sansovino 1581
 Francesco Sansovino, *Venetia citta nobilissima et singolare, descritta in XIIII. libri*, Venice 1581

Sanudo 1879
 Marin Sanudo, *I diarii di Marin Sanuto*, eds Rinaldo Fulin et al., 58 vols., Venice 1879–1903

Sanudo 1980
 Marin Sanudo, *De origine, situ et magistratibus urbis Venetae, ovvero la città di Venetia (1493–1530)*, ed. Angela Caracciolo Aricò, Milan 1980

Sarre 1906
 Friedrich Sarre, 'Eine Miniatur Gentile Bellinis gemalt 1479–1480 in Konstantinopel', *Jahrbuch der Königlich Preußischen Kunstsammlungen* 27 (1906), pp. 302–6

Sarre 1907
 Friedrich Sarre, 'Eine Miniatur Gentile Bellinis: Nachtrag', *Jahrbuch der Königlich Preußischen Kunstsammlungen* 28 (1907), pp. 51–2

Sarre 1909
 Friedrich Sarre, 'The miniature by Gentile Bellini found in Constantinople not a portrait of Sultan Djem', *The Burlington Magazine* 15 (1909), pp. 237–8

Sathas 1890
 C. N. Sathas, *Documents inédits relatifs à l'histoire de la Grèce*, vol. 9, Paris 1890

Sauvaget 1945
 Jean Sauvaget, 'Une ancienne représentation de Damas au Musée du Louvre', *Bulletin d'études orientales* 11 (1945–46), pp. 5–12

Scarpa 1997
 Pietro Scarpa, 'Per una lettura della *Predica di San Marco ad Alessandria* di Gentile Bellini' in *Storia dell'arte marciana: i mosaici*, ed. Renato Polacco, Venice 1997, pp. 235–55

Scarpellini and Silvestrelli 2003
 Pietro Scarpellini and Maria Rita Silvestrelli, *Pintoricchio*, Milan 2003

Schedel 1493
 Hartmann Schedel, *Registrum huius operis Libri cronicarum cum figuris et ymaginibus ab inicio mundi*, Nuremberg 1493

Schéfer 1895
 Charles Schéfer, 'Note sur un tableau du Louvre naguère attribué à Gentile Bellini', *Gazette des Beaux-Arts* 14 (1895), pp. 201–4

Schioppalalba 1767
 Giovanni Battista Schioppalalba, *In perantiquam sacram tabulam graecam insigni Sodalitio Sanctae Mariae Caritatis venetiarum ab amplissimo cardinali Bessarione dono datam dissertatio*, Venice 1767

Schulz 1978
 Juergen Schulz, 'Jacopo de' Barbari's View of Venice: map making, city views, and moralized geography before the year 1500', *The Art Bulletin* 60 (1978), pp. 425–74

Schulze Altcappenberg 1995
Hein-Th. Schulze Altcappenberg, *Die italienischen Zeichnungen des 14. und 15. Jahrhunderts im Berliner Kupferstichkabinett: kritischer Katalog*, Berlin 1995

Schwoebel 1967
Robert Schwoebel, *The Shadow of the Crescent: The Renaissance Image of the Turk (1453–1517)*, Nieuwkoop 1967

Setton 1978
Kenneth M. Setton, *The Papacy and the Levant (1204–1571), Volume II: The Fifteenth Century*, Philadelphia 1978

Shalem 1998
Avinoam Shalem, *Islam Christianized: Islamic Portable Objects in the Medieval Church Treasuries of the Latin West*, Frankfurt 1998

Sohrweide 1970
Hanna Sohrweide, 'Dichter und Gelehrte aus dem Osten im osmanischen Reich: ein Beitrag zur türkisch-persischen Kulturgeschichte', *Der Islam* 46 (1970), pp. 263–302

Somers 1717
A Collection of Prints and Drawings of the late Right Honourable John Ld Sommers, to be sold by Auction on Monday the Sixth of May, 1717, at Mr. Motteux's Auction-Room in the Little Piazza at Covent-Garden, London 1717 [copy in the British Library]

Soranzo 1915
Giovanni Soranzo, ed. *Cronaca di anonimo veronese, 1446–1488*, Venice 1915

Soudavar 1992
Abolala Soudavar, *Art of the Persian Courts: Selections from the Art and History Trust Collection*, New York 1992

Soykut 2001
Mustafa Soykut, *Image of the "Turk" in Italy: A History of the "Other" in Early Modern Europe, 1453–1683*, Berlin 2001 [dissertation: Hamburg, 2000]

Soykut 2003
Mustafa Soykut, 'The Turk as the "great enemy of European civilisation"' in *Historical Image of the Turk in Europe: 15th Century to the Present: Political and Civilisational Aspects*, ed. M. Soykut, Istanbul 2003, pp. 45–116

Spandouginos 1997
Theodoros Spandouginos [Theodore Spandounes], *On the Origin of the Ottoman Emperors*, ed. Donald M. Nicol, Cambridge 1997

Spinale 2003
Susan Spinale, 'The portrait medals of Ottoman Sultan Mehmed II (r. 1451–81)', Ph.D. dissertation: Harvard University, 2003

Spinale 2003a
Susan Spinale, 'Reassessing the so-called "Tricaudet medal" of Mehmed II', *The Medal* 42 (2003), pp. 3–22

Strazzullo 1975
Franco Strazzullo, 'Lavori eseguiti in Castelcapuano nell'anno 1488 per conto del duca di Calabria', *Napoli nobilissima* 14 (1975), pp. 143–50

Suriano 1900
Francesco Suriano, *Il trattato di Terra Santa e dell'oriente*, ed. Girolamo Golubovich, Milan 1900

Suzuki 1996
Yoko Suzuki, *Studien zu Künstlerporträts der Maler und Bildhauer in der venezischen und venezianischen Kunst der Renaissance*, Münster 1996 [dissertation: Frankfurt, 1995]

Syson 1994
Luke Syson, 'The circulation of drawings for medals in fifteenth-century Italy' in *Designs on Posterity: Drawings for Medals*, ed. Mark Jones, London 1994, pp. 10–26

Syson 2004
Luke Syson, 'Bertoldo di Giovanni, republican court artist' in *Artistic Exchange and Cultural Translation in the Italian Renaissance City*, eds Stephen J. Campbell and Stephen J. Milner, Cambridge 2004, pp. 96–133

Syson and Gordon 2001
Luke Syson and Dillian Gordon, *Pisanello, Painter to the Renaissance Court*, exh. cat. National Gallery, London, 2001

Tanındı 2000
Zeren Tanındı, 'Additions to illustrated manuscripts in Ottoman workshops', *Muqarnas* 17 (2000), pp. 147–61

Tarawneh 1994
Taha Thalji Tarawneh, *The Province of Damascus during the Second Mamluk Period (784/1382–922/1516)*, Al Karak 1994

Tempestini 1992
Anchise Tempestini, *Giovanni Bellini: catalogo completo dei dipinti*, Florence 1992

Testi 1909
Laudedeo Testi, *La storia della pittura veneziana*, 2 vols., Bergamo, 1909–15

Thackston 2001
Wheeler M. Thackston, *Album Prefaces and Other Documents on the History of Calligraphers and Painters*, Leiden 2001

Thenaud 1884
Jean Thenaud, *Le voyage d'Outremer (Egypte, Mount Sinay, Palestine) de Jean Thenaud suivi de la relation de l'ambassade de Domenico Trevisan auprès du Soudan d'Egypte, 1512*, ed. Charles Schéfer, Paris 1884

Thiriet 1959
Freddy Thiriet, *La Romanie vénitienne au Moyen Age: le développement et l'exploitation du domaine colonial vénitien (XIIe–XVe siècles)*, Paris 1959

Thornton 1997
Dora Thornton, *The Scholar in his Study: Ownership and Experience in Renaissance Italy*, New Haven 1997

Thuasne 1888
Louis Thuasne, *Gentile Bellini et Sultan Mohammed II: notes sur le séjour du peintre vénitien à Constantinople (1478–1480)*, Paris 1888

Tiepolo and Tonetti 2002
Maria Francesca Tiepolo and Eurigio Tonetti, eds, *I greci a Venezia: atti del convegno internazionale di studio*, Venice 2002

Tietze and Tietze-Conrat 1944
Hans Tietze and E. Tietze-Conrat, *The Drawings of the Venetian Painters in the 15th and 16th Centuries*, 2 vols., New York 1944

Trésor de numismatique 1834
Trésor de numismatique et de glyptique: médailles coulées et ciselées en Italie aux XVe et XVIe siècles, vol. 1, Paris 1834

Trinchera 1866
Francesco Trinchera, *Codice aragonese: o sia lettere regie, ordinamenti ed altri atti governativi de' sovrani aragonesi in Napoli*, vol. 1, Naples 1866

Tucci 1985
Ugo Tucci, 'Tra Venezia e il mondo turco' in *Venezia e i turchi: scontro e confronti di due civiltà*, ed. Alberto Tenenti, Milan 1985, pp. 38–55

Ünver 1995
A. Süheyl Ünver, 'Türk pozitif ilimleri tarihinden bir bahis: Ali Kuşcı ve eserleri', in A.S. Ünver, *Istanbul risaleleri*, Istanbul 1995, vol. 2, pp. 203–90

Ünver 1995a
A. Süheyl Ünver, 'Fatih devri saray nakışhanesi ve Baba Nakkaş çalışmaları' in A.S. Ünver, *Istanbul risaleleri*, Istanbul 1995, vol. 4, pp. 249–80

Ünver 1995b
A. Süheyl Ünver, 'Fatih'in çocukluk defteri: Un cahier d'enfance du Sultan Mehemmed le Conquérant "Fatih"' in A.S. Ünver, *Istanbul risaleleri*, Istanbul 1995, vol. 4, pp. 341–52

Vallet 1999
Éric Vallet, *Marchands vénitiens en Syrie à la fin du XVe siècle*, Paris 1999

Vasari 1966
Giorgio Vasari, *Le vite de' più eccelenti pittori, scultori, e architettori nelle redazioni del 1550 e 1568*, eds Rosanna Bettarini and Paola Barocchi, 6 vols., Florence 1966–87 [online edn: biblio.cribecu.sns.it]

Vast 1878
Henri Vast, *Le cardinal Bessarion (1403–1472)*, Paris 1878

Vecellio 1590
Cesare Vecellio, *De gli habiti antichi, et moderni di diverse parti del mondo*, Venice 1590

Venice 1974
Venezia e Bisanzio, exh. cat. Palazzo Ducale, Venice, 1974, introduction by Sergio Bettini

Venice 1993
Da Candia a Venezia: icone greche in Italia, XV–XVI secolo, exh. cat. Museo Correr, Venice, 1993, ed. Nano Chatzidakis

Venice 1994
Bessarione e l'Umanismo, exh. cat. Biblioteca Nazionale Marciana, Venice, 1994, ed. Gianfranco Fiaccadori

Venturi 1891
Adolfo Venturi, 'Costanzo, medaglista e pittore', *Archivio storico dell'arte* 4 (1891), pp. 374–5

Venturi 1898
Adolfo Venturi, 'Disegni del Pinturicchio per l'appartamento Borgia in Vaticano', *L'arte* 1 (1898), pp. 32–43

Venturi 1907
Lionello Venturi, *Le origini della pittura veneziana, 1300–1500*, Venice 1907

Venturi 1926
Adolfo Venturi, 'Scelta di rari disegni nei musei d'Europa', *L'arte* 29 (1926), pp. 1–18

Vermeule 1987
Cornelius C. Vermeule III, 'Graeco-Roman Asia Minor to Renaissance Italy: medallic and related arts', *Studies in the History of Art*, vol. 21 (1987), pp. 263–81

Vickers 1978
Michael Vickers, 'Some preparatory drawings for Pisanello's medallion of John VIII Palaeologus', *The Art Bulletin* 60 (1978), pp. 417–24

Villa 1985
Massimo Villa, 'Gentile e la politica del "sembiante" a Stambul' in *Venezia e i Turchi: scontri e confronti di due civiltà*, Milan 1985, pp. 160–85

Villot 1853
Frédéric Villot, *Notice des tableaux exposés dans les galeries du Musée impérial du Louvre*, Paris 1853

Voltolina 1998
Piero Voltolina, *La storia di Venezia attraverso le medaglie*, 3 vols., Venice 1998

Wace and Clayton 1938
A.J.B. Wace and Muriel Clayton, 'A tapestry at Powis Castle', *The Burlington Magazine* 73 (1938), pp. 64–9

Ward 1993
Rachel Ward, *Islamic Metalwork*, London 1993

Ward et al. 1995
Rachel Ward et al., '"Veneto-Saracenic" metalwork: an analysis of the bowls and incense burners in the British Museum' in *Trade and Discovery: The Scientific Study of Artefacts from Post-Medieval Europe and Beyond*, eds Duncan Hook and David Gaimster, London 1995, pp. 235–58

Warnke 1993
Martin Warnke, *The Court Artist: On the Ancestry of the Modern Artist*, Cambridge 1993

Washington 1973
Exhibition Catalogue of Turkish Art of the Ottoman Period, exh. cat. Freer Gallery of Art, Washington, 1973, by Esin Atıl

Washington 1991
Circa 1492: Art in the Age of Exploration, exh. cat. National Gallery of Art, Washington, 1991–92, ed. Jay A. Levenson

Weiss 1964
Roberto Weiss, 'The adventures of a first edition of Valturio's *De re militari*' in *Studi di bibliografia e di storia in onore di Tammaro de Marinis*, Verona 1964, vol. 4, pp. 297–304

Weiss 1966
Roberto Weiss, *Pisanello's Medallion of the Emperor John VIII Palaeologus*, London 1966

Weiss 1967
Roberto Weiss, 'Two unnoticed "portraits" of Cardinal Bessarion', *Italian Studies* 22 (1967), pp. 1–5

Welch 1997
Evelyn S. Welch, *Art and Society in Italy, 1350–1500*, Oxford 1997

Woods 1999
John E. Woods, *The Aqquyunlu: Clan, Confederation, Empire*, Salt Lake City 1999

Woods-Marsden 1998
Joanna Woods-Marsden, *Renaissance Self-Portraiture: The Visual Construction of Identity and the Social Status of the Artist*, New Haven 1998

Woods-Marsden 2000
Joanna Woods-Marsden, 'Visual constructions of the art of war: images for Machiavelli's *Prince*' in *Perspectives on the Renaissance Medal*, ed. Stephen K. Scher, New York 2000, pp. 47–73

Wright 2000
Alison Wright, 'The memory of faces: choices in portraiture' in *Art, Memory, and Family in Renaissance Florence*, eds Giovanni Ciappelli and Patricia Lee Rubin, Cambridge 2000, pp. 86–113

Wright 2005
Alison Wright, *The Pollaiuolo Brothers: The Art of Florence and Rome*, New Haven 2005

Zele 1989
Walter Zele, 'Aspetti delle legazioni ottomane nei *Diarii* di Marin Sanudo', *Studi veneziani* 18 (1989), pp. 241–84

Zorzi 1981
Alvise Zorzi, 'Marco Polo e la Venezia del suo tempo' in *Marco Polo: Venezia e l'Oriente*, ed. Alvise Zorzi, Milan 1981, pp. 13–40

Zorzi 1994
Marino Zorzi, 'Cenni sulla vita e sulla figura di Bessarione' in Venice 1994, pp. 1–32

Zorzi 1994a
Marino Zorzi, 'Bessarione e Venezia' in Venice 1994, pp. 197–228

Zucker 1993
Mark J. Zucker, *The Illustrated Bartsch*, vol. 24: *Early Italian Masters: Commentary*, pt 1, New York 1993

Exhibited Works

Objects are exhibited in both the Isabella Stewart Gardner, Boston, and The National Gallery, London, unless noted otherwise.

BERLIN, STAATLICHE MUSEEN ZU BERLIN, KUPFERSTICHKABINETT

Gentile Bellini, *Self-portrait* (cat. 31)
Master of the Vienna Passion, *El Gran Turco* (cat. 14)

BOSTON, ISABELLA STEWART GARDNER MUSEUM

Gentile Bellini, *Seated Scribe* (cat. 32)
Venetian, *Salver* (cat. 4), BOSTON ONLY

BUDAPEST, SZÉPMŰVÉSZETI MÚZEUM

Gentile Bellini, *Portrait of Caterina Cornaro* (cat. 8)

CAMBRIDGE (MASSACHUSETTS), HOUGHTON LIBRARY, HARVARD UNIVERSITY

Giovanni Andrea Vavassore, *Map of Byzantium or Constantinople* (cat. 1), BOSTON ONLY

CHATSWORTH, DUKE OF DEVONSHIRE COLLECTION

Gentile Bellini, *Procession before Santa Maria della Carità* (cat. 9), LONDON ONLY

FRANKFURT AM MAIN, GRAPHISCHE SAMMLUNG IM STÄDELSCHEN KUNSTINSTITUT

Workshop of Gentile Bellini, *Standing Man* (cat. 28)
Workshop of Gentile Bellini, *Standing Young Man (called an Albanian)* (cat. 29)

KUWAIT, DAR AL-ATHAR AL-ISLAMIYYAH AT THE KUWAIT NATIONAL MUSEUM

Persian, *Seated Artist* (cat. 33)

LONDON, THE BRITISH MUSEUM

Gentile Bellini, *The Procession in Piazza San Marco* (cat. 10)
Gentile Bellini, *Seated Janissary* (cat. 25)
Gentile Bellini, *Seated Woman* (cat. 26)
Bertoldo di Giovanni, *Medal of Mehmed II* (cat. 22, OBVERSE EXHIBITED)
Vittorio Gambello, *Portrait Medal of Gentile Bellini* (fig. 45)
Pisanello, *Medal of Emperor John VIII Palaiologos* (fig. 26)
Cretan, *Madre della Consolazione* (cat. 13)
Florentine, *Storage jar with 'El Gran Turco'* (fig. 27), LONDON ONLY
Mamluk, *Candlestick* (fig. 5), LONDON ONLY
Veneto-Byzantine, *Saint Jerome* (fig. 15), LONDON ONLY

LONDON, COURTAULD INSTITUTE OF ART GALLERY

Mahmud al-Kurdi, *Box with Lid* (cat. 3)
Iranian, Turkish or Mamluk, *Bucket* (fig. 13), LONDON ONLY
Venetian, *Dish* (fig. 14), LONDON ONLY

LONDON, THE NATIONAL GALLERY

Gentile Bellini, *Cardinal Bessarion with the Bessarion Reliquary* (cat. 6)
Gentile Bellini, *The Virgin and Child Enthroned* (cat. 11), LONDON ONLY
Gentile Bellini, *Portrait of Mehmed II* (cat. 23)
Giovanni Bellini, *The Doge Leonardo Loredan* (fig. 20), LONDON ONLY
Workshop of Giovanni Bellini, *The Circumcision* (fig. 12), LONDON ONLY

LONDON, VICTORIA AND ALBERT MUSEUM

Gentile Bellini, *Medal of Mehmed II* (cat. 20, OBVERSE EXHIBITED)
Bertoldo di Giovanni, *Medal of Mehmed II* (cat. 21, REVERSE EXHIBITED)
Costanzo di Moysis, *Medal of Mehmed II* (cat. 17, OBVERSE EXHIBITED)
Italian, *Woven silk fragment*, LONDON ONLY

OXFORD, THE ASHMOLEAN MUSEUM

Gentile Bellini, *Medal of Mehmed II* (cat. 19, REVERSE EXHIBITED)
Giovanni Bellini, *Virgin and Child* (cat. 12)
Costanzo di Moysis, *Medal of Mehmed II* (cat. 18, REVERSE EXHIBITED)
Cretan, *The Raising of Lazarus* (cat. 7)
Italian, *Medal of Mehmed II as a Young Man* (cat. 15)

PARIS, MUSÉE DU LOUVRE

Gentile Bellini, *Young Greek Woman* (cat. 24)
Workshop of Gentile Bellini, *Standing Turk* (cat. 27)
After Gentile Bellini, *Standing Young Turk* (cat. 30)
Follower of Gentile Bellini, *Reception of the Venetian Ambassadors in Damascus* (cat. 22), LONDON ONLY

VENICE, GALLERIE DELL'ACCADEMIA

Byzantine, *Cover of the Reliquary of Cardinal Bessarion* (cat. 5, fig. 18), LONDON ONLY

WASHINGTON, DC, NATIONAL GALLERY OF ART

Costanzo di Moysis, *Medal of Mehmed II* (cat. 16), BOSTON ONLY

WINDSOR CASTLE, ROYAL COLLECTION

After Giovanni Mansueti, *Three Mamluk Dignitaries* (fig. 8), LONDON ONLY

Photographic Credits

Index

References in [square brackets] refer to catalogue entries. Those in *italics* refer to figures.